Seattle NEON
Signs of the Emerald City

Matt Hucke

First Edition

EVERYTHING GOES MEDIA

www.everythinggoesmedia.com
www.seattleneonbook.com

Seattle Neon: Signs of the Emerald City
Matt Hucke

Published October 2022 by Matt Hucke

Distributed by Everything Goes Media

www.seattleneonbook.com
www.everythinggoesmedia.com

Publisher's Cataloging-in-Publication data

Names: Hucke, Matthew R., author.
Title: Seattle neon : signs of the Emerald City / Matt Hucke.
Description: Includes bibliographical references and index. I Milwaukee, WI: Everything Goes Media, 2022.
Identifiers: LCCN: 2022942514 I ISBN: 978-1-7341452-5-0
Subjects: LCSH Neon signs--Washington--Seattle--Pictorial works. I Seattle (Wash.)--Pictorial works. I Signs and signboards--Pictorial works. I BISAC PHOTOGRAPHY / Subjects & Themes / Regional I PHOTOGRAPHY / Subjects & Themes / Street Photography I DESIGN / Graphic Arts / Branding & Logo Design I DESIGN / Graphic Arts / Commercial & Corporate I HISTORY / United States / State & Local / Pacific Northwest (OR, WA) I TRAVEL / United States / West / Pacific (AK, CA, HI, OR, WA)
Classification: LCC F899.S4 .H83 2022 I DDC 917.9777--dc23

Cover and interior design by Todd Petersen.

Printed in the United States of America.

27 26 25 24 23 22 1 2 3 4 5 6 7 8 9 10

Contents

denotes unofficial area/neighborhood name

For my mom, Sue Hucke,
my first supporter,
my first teacher,
my first best friend

Introduction

Seattle is losing its character. Decades-old businesses are being driven out of the city by rent increases, by skyrocketing land value, by petty crime, by the pandemic, or by the twenty-first century rendering old business models obsolete. Beloved neighborhood institutions are disappearing at a furious pace—this very day, as I write, is the last day of service at Beth's Cafe, open since 1954. Everywhere you look, unique buildings and businesses have vanished, to be replaced with generic and interchangeable mid-rise apartment buildings, or glass skyscrapers that look no different from those in every other major city in the world. (By the end of the day, I discovered that Red Mill Totem House had also just closed.)

Our neon heritage, too, is disappearing. Some of the best and most historic pieces—the Rainier Brewery "R," the pink elephants of Elephant Car Wash, the Buckaroo Tavern's cowboy—have been taken from their original locations, but can still be found on display in museums or in buildings owned by neon enthusiasts. Others have gone dark or vanished, including several that I photographed in the early stages of this project—Key Arena, Ballard Automotive Repair, Bick's Broadview Grill, The Bit Saloon, Hau Hau Market—and some that I never got a chance to see in action, such as Seal's Motel, Ramona Cleaners, Icon Grill, Buca di Beppo's Chianti bottle, and the Guild 45th Theatre. I expect there will be other heartbreaking losses before this work is in your hands.

For three years, I've walked the major streets of every neighborhood in Seattle, by day and by night, seeking the best neon art—commercial art, some might sneer, but art nonetheless. Neon is uniquely handcrafted. Every piece of glass has been bent by a skilled artisan to precisely the shape and length required. When all or part of a sign inevitably stops working, usually after decades of exposure to the elements, replacement tubes are fashioned using the same difficult and labor-intensive techniques as used to craft the original. Neon is not cheap, or disposable, or forgettable—neon is an investment. Neon is a statement that a business expects to survive long enough to be worth the effort.

British chemists Sir William Ramsay and Morris Travers first identified the noble gases neon, krypton, and xenon in 1898 in their London laboratory, chilling air samples to a liquid state then slowly warming them to separate the gases at each element's boiling point. When they placed a sample of neon in a glass vessel and electrified it for spectroscopic analysis, they were amazed to discover that it glowed a brilliant red, like nothing seen before. They chose the name "neon" for this element, from the Greek word for "new," and this discovery earned Ramsay the 1904 Nobel Prize in Chemistry.

Georges Claude of France was the first to use electrified neon for advertising purposes, beginning with the Paris Motor Show in 1910, then a Cinzano vermouth sign in 1919. By the twenties, his company, Claude Neon, was the holder of multiple patents protecting neon sign components, and had started doing business in the United States. About 1924, a Packard dealership in Los Angeles became the first commercial user of a neon sign in this country. These early neon installations were said to stop traffic because they were so brilliant even in daytime.

Seattle's streetscape in the early twentieth century was dominated by signs illuminated with hundreds of incandescent light bulbs. By the early thirties, the knowledge and skills to work with neon had reached Seattle, and the awe-inspiring new technology was employed for small signs like the one at Blue Moon Tavern (1934) as well as huge high-profile projects like Pike Place Market (1935).

"Neon" is the popular term for illuminated gas in glass, though many so-called neon signs contain no neon at all. Neon gas glows a brilliant orange-red, and the earliest neon signs were exclusively this color. Argon, the noble gas below neon on the periodic table, emits a pale blue-green light. In the twenties, Georges Claude patented a new method, using an electrified mixture of argon and mercury vapor that produces ultraviolet light. This ultraviolet then stimulates a fluorescent coating on the inside of the glass tube to create light in the chosen color. This is what we see in most "neon" signs to this day—fluorescent coatings, on the inside surface of the glass tubes, energized by the argon and mercury vapor within. Using this technique, hundreds of colors are now available.

I am a photographer, not a chemist. In the interest of simplicity and avoiding repetitive (and likely erroneous) chemistry lectures, I have elected to use "neon" and "neon sign" without further explanation throughout the text.

Notes on Geography and Structure

This book includes neon within the city limits of Seattle and in unincorporated White Center. Entries are organized geographically, using the district and neighborhood names and boundaries identified by the Seattle City Clerk's office. Some of these districts have no official name (instead having labels like "Area 6" or "No Broader Term" on official maps), but I have provided an unofficial descriptive name for these. To keep chapter sizes reasonable, I've split Downtown into three parts, and in other parts of the city have merged the smallest districts into adjacent ones.

Headings within each chapter give the neighborhood names, again taken from the city clerk's maps. Within each neighborhood, I've attempted to present the locations in an order suitable for a walking tour—generally, beginning with those closest to where the previous section left off, or closest to the city center, then proceeding outward, away from downtown. This ordering is imperfect, however, as some entries have been reordered for better narrative flow or for page layout considerations. If you're planning a self-guided tour, it's best to enter the addresses into your online mapping tool of choice first, and then determine the best order.

In some neighborhoods, businesses are found at the edges, not the middle. Neon signs on one side of the street can belong to a different district than those on the other side, and are therefore presented in different chapters. This is particularly noticeable along North Aurora Avenue, one of the most neon-rich streets in Seattle, which is also the boundary between four different city districts.

I have deviated from strictly following the map in a few cases—neon-using businesses that make a strong claim to belong to a particular neighborhood are listed in that chapter, even if technically outside the boundaries, when the difference is only a block or two. In this situation, I feel the business owner is better positioned to say what neighborhood they belong to than I am.

Each entry also includes a year. Whenever possible, I've used the year that the business responsible for the neon started or moved to that location—though the building may be older, or someone else may have taken over since. The exact year that the neon sign was installed is generally not available, often

Seattle NEON

unknown even to the current owners.

Some of this neon is in the rougher parts of the city. If you're going to an unfamiliar location, I suggest an initial visit during daylight hours. Return after dark only if it feels safe, and always be aware of your surroundings.

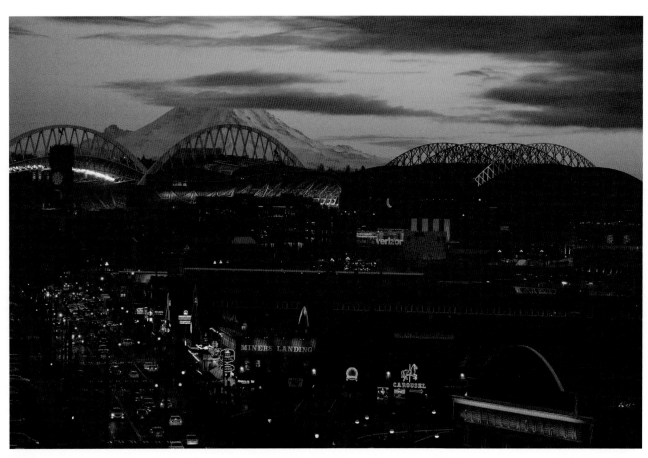

1.

Downtown Core

Central Waterfront

"Keep Clam" was the motto of eccentric businessman and folk singer Ivar Haglund, who was born into the family that had purchased Alki Point from pioneer Doc Maynard. Gifted with an entrepreneurial spirit, Haglund opened Seattle's first public aquarium in 1938 on Pier 54, charging tourists a nickel apiece to see his captive sea creatures. Realizing that these visitors also wanted to be fed, Ivar soon added a fish-and-chips restaurant, **Ivar's Fish Bar**. In 1946, he opened a fine-dining restaurant on the same pier, **Ivar's Acres of Clams**. The "Acres of Clams" name came from an 1870s song about Puget Sound, and Ivar recorded his own rendition for the restaurant's radio commercials.

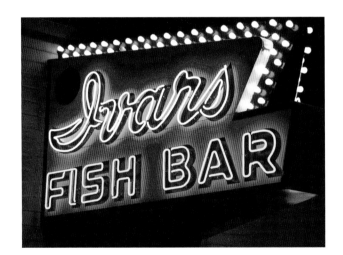

Ivar Haglund was a natural showman, a prankster, and a man who would always find a way around obstructionist bureaucrats. He talked and sang on his own radio show, staged octopus wrestling events and clam eating contests, and walked his pet seal to a downtown department store to meet Santa Claus. When a railway tanker car's hose burst and spilled a thousand gallons of maple syrup into the street, Ivar was there, wearing a captain's hat, hip boots and an oversized bib, spooning the stuff onto a stack of pancakes. When the owner of the adjacent pier posted signs asking people to refrain from feeding seagulls, Ivar responded with signs encouraging feeding the seagulls—a tradition that continues at Pier 54 today.

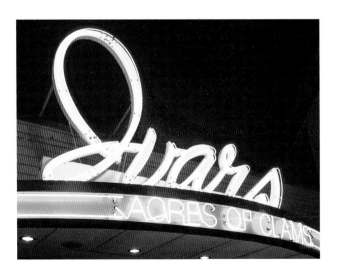

The newspapers dubbed Ivar the "Crown Prince of Corn" and "Mayor of the Waterfront." He died in 1985, aged 79. Ivar's restaurants continue to operate in the spirit of their "flounder," with one notable jape occurring in 2009: the supposed discovery of underwater billboards that had promoted the restaurant to submariners in the fifties. These were, instead, a modern creation with retro graphics, artificially aged and sunk just a short time before.

Seattle NEON

The vintage neon at **Ivar's Fish Bar** and the early signs at **Acres of Clams**, since replaced, were created by Bea Haverfield, the mid-century "Queen of Neon," who is best known for her Elephant Car Wash design (*see* Belltown). (1001 Alaskan Way, ivars.com, 1938)

Al Ashberg started Souvenir Shirts at 6th and Pike in 1989, using heat transfers to print T-shirts at the time of purchase. When his son Jay joined the business in 1992, they moved to 1st and Pike, across from the Pike Place Market entrance, and changed the business name to **Seattle Shirt Company**. In 2013, they added a waterfront location at Pier 55, identified by this neon shopping bag. (1101 Alaskan Way, seattleshirt.com, 2013)

Miner's Landing at Pier 57 is a major tourist attraction with multiple shops, seafood restaurants, a carousel, the "Wings over Washington" flying theater ride, and neon everywhere you look.

Pier 57 was built in 1902 and soon acquired by the Chicago, Milwaukee and St. Paul Railroad, giving it the nickname "Milwaukee Pier." Later, it became a steamship terminal and fish

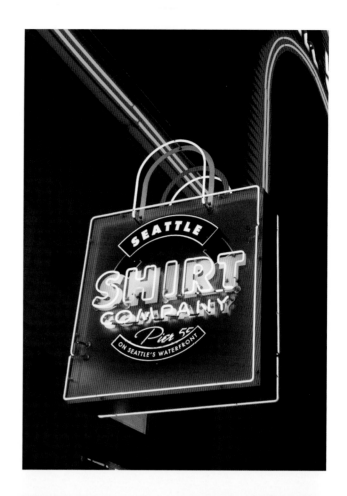

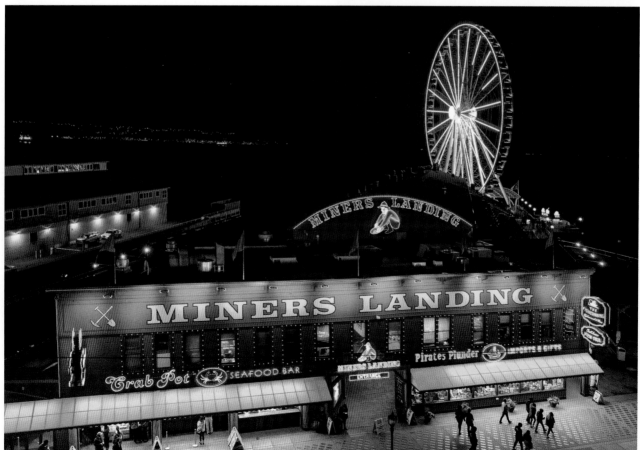

processing plant. Businessman Hal Griffith purchased the pier in the 1980s to create Miner's Landing. For many years, Griffith had envisioned a Ferris wheel on the waterfront, and in 2012 this became a reality. 175 feet tall and carrying over 300 passengers at a time, the "Great Wheel" displays an ever-changing LED light show on its spokes and rim, often with colors chosen to celebrate a holiday or sporting event, or synchronized to show a symbol that remains stationary even as the wheel turns.

The photo of the pier's front was taken from the Alaskan Way Viaduct, which was decommissioned and demolished in 2019. After it closed to vehicular traffic, the public was invited to walk the upper surface of the elevated double-decker highway during a one-day farewell festival, and an estimated one hundred thousand people took advantage of the opportunity. As darkness fell and the crowd thinned, I ducked under the yellow caution tape and crouched at the guardrail to get one last shot of Miner's Landing from a vantage point that would soon no longer exist. (1301 Alaskan Way, minerslanding.com, seattlegreatwheel.com, 1989)

The photo in the Introduction shows Miner's Landing, identifiable by the "Carousel" sign on the north side. Behind it, outlined with red neon, is Pier 56, home to Elliott's Oyster House. Next is Pier 55, with its blue outline and neon shopping bag, and then Ivar's Acres of Clams and Ivar's Fish Bar on Pier 54.

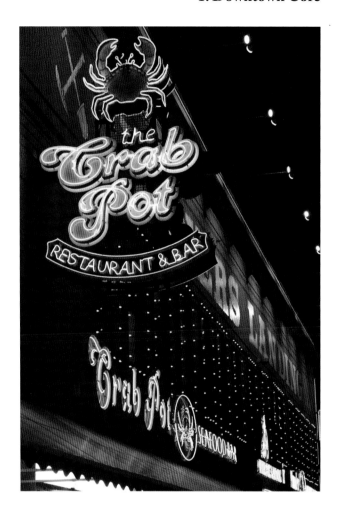

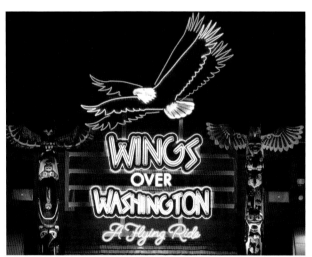

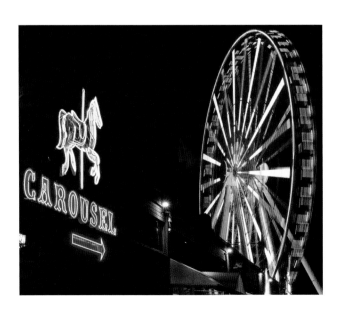

Central Business District

Construction was already underway on Leonard Diller's new hotel when the Great Seattle Fire consumed his first hotel, the Brunswick. As it was just north of the zone of total destruction, the new **Diller Hotel** was spared. Work resumed almost immediately, and the Diller opened June 6, 1890, the first anniversary of the fire. A thoroughly modern building, it had running water, toilets, and the city's first elevator. As required by hastily written new laws, the Diller was built with fire resistant brick and stone. The bricks came by ship from Japan, because Seattle's post-fire building boom meant local bricks were in short supply.

The Diller Hotel included a ground floor bar. When the state of Washington banned alcohol sales in 1916 (four years before the Volstead Act brought nationwide Prohibition), this became an illegal speakeasy, behind a fake storefront that disguised it as a Chinese laundry.

The Diller became apartments in the late twentieth century. In 2009, the modern **Diller Room** opened in the hotel's former lobby. A craft cocktail bar with weekly Tiki nights, the Diller Room celebrates the Diller Hotel's history, keeping intact the original pressed tin ceiling and other turn-of-the-century details. (1224 1st Ave., dillerroom.com, 2009)

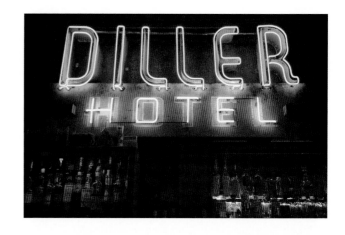

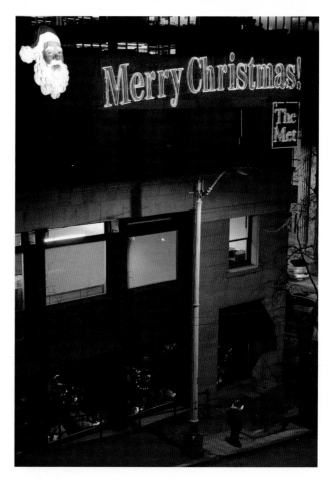

Present only during the holiday season, the neon "Merry Christmas" is hoisted to the top of the **Metropolitan Grill** building by National Sign Corporation (*see* Westlake) each year. The high-end steakhouse attracts the rich and famous—Bill Gates and Bill Clinton dined together there, surrounded by Secret Service, and it's a favorite of Mariners players too. (820 2nd Ave., themetropolitangrill.com, 1983)

Fifteen civic leaders founded Seattle's branch of the **Young Men's Christian Association (YMCA)** in 1876, intending to bring civilization to the rough-and-tumble frontier city. Dexter Horton, Seattle's first banker and the group's primary organizer, served as the chapter's first president. The

group began with Bible study and temperance lectures, then embraced the immigrant community, providing a multilingual library and job search assistance. The YMCA operated Seattle's first gymnasium—to the dismay of Horton, who preferred to focus more on the spiritual than the physical.

In 1907, the YMCA moved to this new seven-story brick-and-stone building, with gymnasium, swimming pool, and classrooms. The city landmark features ornate stone entryways, decorated with carved foliage and "Young Men's Christian Association" and "Central Branch" in elegant engraved script. (909 4th Ave., seattleymca.org, 1876)

The space in the Mann Building that houses **The Triple Door** has been a theater since 1926, when it was known as the Embassy and hosted vaudeville performances. Eventually it became a cinema showing mainstream films, and then, as the character of downtown changed, pornography. In 1999, the theater, by then unused for over a decade, was purchased by Rick and Ann Yoder and converted to an intimate space for live music performances with cocktails and dinner. (216 Union St., thetripledoor.com, 1999)

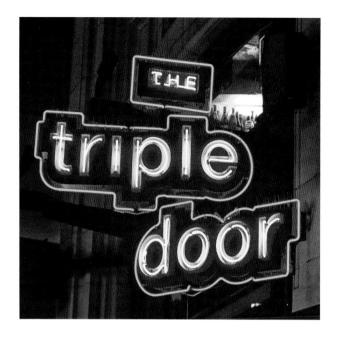

The landmark Skinner Building was constructed in 1926 to house the **5th Avenue Theatre** alongside retail and office space, a project set into motion by the president of Pacific Northwest Theatres, Harry C. Arthur. Arthur's lavish new movie palace was modeled on Imperial Chinese architecture, with intricately carved wooden ceilings, embroidered panels and tapestries, and guardian lions and other sculptures. Most splendid of all was an octagonal caisson ceiling, an oversized replica of the ceiling of the Imperial throne room in the Hall of Supreme Harmony, with a "Pearl of Perfection" chandelier hanging from the mouth of a dragon. The new theater opened with a massive celebration in 1926, with more than fifty thousand revelers filling the surrounding streets.

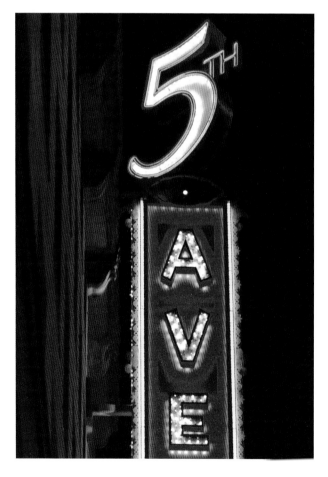

5th Avenue Theatre had been designed for both film and vaudeville, but the decline of vaudeville and the rise of television caused audiences to dwindle. In 1978, the theater shut down and the University of Washington, which owned the building, considered demolition. A group of business leaders rallied to save the theater, and in doing so found its new purpose: Broadway musicals, which then regularly bypassed Seattle on their tours. The historic theater was refurbished and adapted, re-opening in 1980 with a performance of *Annie*. While continuing to host touring

Broadway shows, in 1989, 5th Avenue Theatre began producing their own original musicals.

Historic photographs of the opening night festivities show a five-story vertical sign, with a tilted "5th" over a vertical "AVENUE," all of it brilliantly illuminated with Edison bulbs, and a rectangular canopy below. About 1942, this was replaced with neon, an updated and enlarged version of the same basic design. During the 1980 renovations, this was scrapped, as it was found to be corroded beyond repair. The theater went without a suitable sign until 2009, when architecture firm NBBJ created a new design, inspired by the two historic marquees and the Chinese-influenced interior detailing. The new vertical sign uses only low-power LEDs, which mimic the look of neon and incandescent bulbs alike. To this classic styling, they've added a bold new feature: the "5th" at the top now rotates. (1308 5th Ave., 5thavenue.org, 1926)

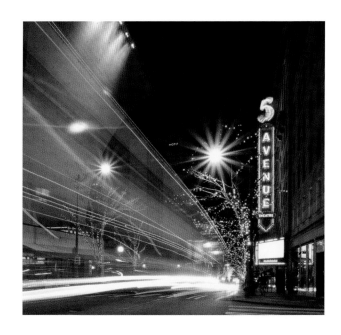

National restaurant chain **Daily Grill** set up across from the Washington State Convention Center in 2007, wrapping their corner of the Sheraton building with green neon and artwork depicting a lively mid-century gathering. They departed in early 2020. (formerly 629 Pike St., dailygrill.com, 2007)

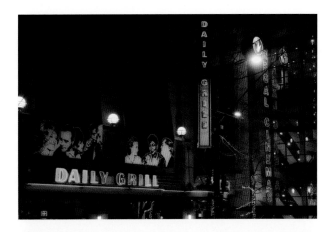

On the other side of Pike Street, **Regal Meridian & 4DX** is a 16-screen theater built as a Cineplex-Odeon in 1996, then purchased by national giant Regal in 2006. The downtown setting required the architects to go vertical—the entrances and ticket counters are the only thing at ground level, with a series of escalators taking customers up through several levels of screens and snack bars (all individually marked with neon). In recent years, the cinema has installed their proprietary "4DX" technology, with premium seats that tilt and shake, and nozzles that spray water and scented air to match the action on screen. (1501 7th Ave., regmovies.com, 1996.

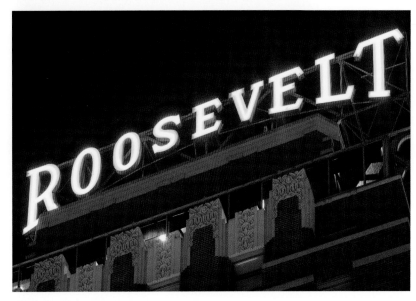

President Theodore Roosevelt's 1903 visit to Seattle (*see* Belltown) inspired the name of the 18-story **Roosevelt Hotel**, designed in the Art Deco style by accomplished architect John

Graham, Sr., the tallest hotel in Seattle from its completion in 1930 until the 1960s. The rooftop neon sign, identical on either side, faces north and south. Old photos and post card illustrations reveal that this initially read "Hotel Roosevelt" as two separate lines of text, but the top portion was removed in the seventies or eighties.

Roosevelt's neon can be seen on film in *The Fabulous Baker Boys* (1989), in the background of a scene at the Cloud Room at the Camlin, and the hotel is further mentioned several times as a performance venue for the lead characters.

A 1962 remodel modernized the entrances and lobby, leaving little of the original ornament intact. In 2015, the hotel was purchased by Provenance Hotels, who launched another major interior redesign. When the Roosevelt reopened, it was on a first-name basis as **Hotel Theodore**. On the ground floor, a new "Rider" restaurant and bar is named for Teddy's "Rough Riders" cavalry regiment. (1531 7th Ave., hoteltheodore. com, 1929)

Puget Sound Savings & Loan executives Edmund Campbell and Adolph Linden combined their fortunes and their names to create the **Camlin Hotel** in 1926. Borrowing $866,000, they hired Portland architect Carl Linde to build an 11-story Tudor Revival skyscraper, then one of the tallest buildings in the city, with an ornate terra cotta facade. For a planned second Camlin hotel, they purchased an adjacent lot.

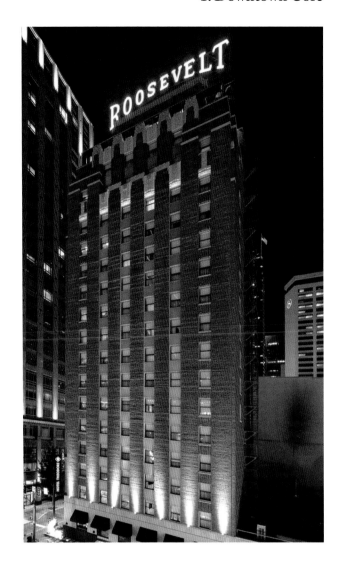

The only flaw in Campbell and Linden's plan was that the loan had not actually been authorized, as an internal review revealed months before the hotel's opening. To avoid scandal, the board of directors offered a deal: sign over the hotel and everything else they owned, and keep quiet. They accepted, and the bank took possession, even allowing the dirty duo to keep their jobs. But other shady dealings caught up with them a few years later, and both were convicted and imprisoned at Walla Walla.

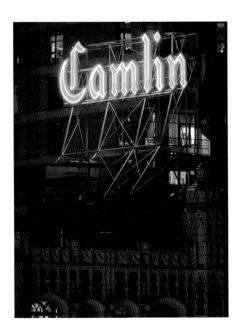

In 1947, the top floor became the swanky Cloud Room lounge, offering the highest dining room in the city and live music with star performers like Frank Sinatra, Dean Martin, and Elvis Presley.

Old photos reveal that the rooftop sign was present in the 1920s, with the same lettering style as today, though likely not lit with neon as the technology was then in its infancy. It was one-sided, facing west, towards the back of the hotel. The present version is dual-sided, facing north and south, and has existed in this form since at least the 1960s. However, as a much

taller building now obscures the view from the north, only the south face of the Camlin sign is now illuminated

The former hotel is now a timeshare resort, **WorldMark The Camlin**. The Cloud Room shut down in 2003, converted to four penthouse suites. (1619 9th Ave., worldmarktheclub.com, 1926)

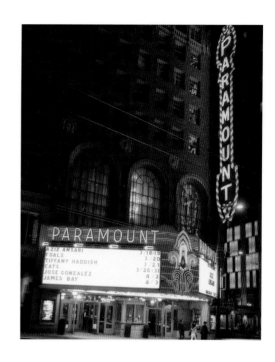

As the public became accustomed to moviegoing in the twenties, Paramount Pictures Corporation sought to build a theater in every major city in the United States. Seattle's first Paramount Theatre opened in 1921 on 45th Street (*see* Wallingford). In 1928, Paramount's Publix Theatre chain worked with local investors to create something far more magnificent: the 3,000-seat **Seattle Theatre**, equipped for both movies and vaudeville shows. This gorgeous new movie palace included a richly decorated Beaux Arts interior of crystal chandeliers, plaster moldings, gold leaf and tapestries, furniture and artwork, much of it inspired by the Palace of Versailles. On the corner of the nine-story building (the upper floors were apartments) hung an enormous vertical sign with lighted letters reading "SEATTLE." A rectangular marquee sheltered the entryway.

Two years later, it was renamed **Paramount Theatre**, as the studio wanted this name for the grandest

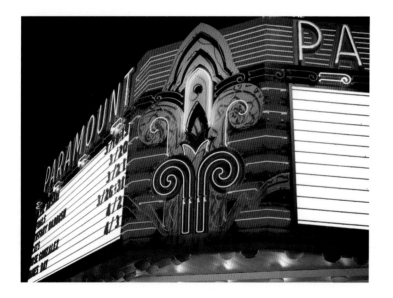

of their theaters in each city, and the one in Wallingford became Bruen's 45th. But this was the start of the Great Depression, and as many could not spare the cost of a ticket, attendance was poor. The theater shut down for weeks at a time, and dropped the vaudeville shows entirely.

New owners acquired the theater in the 1950s, though it retained the Paramount name—by then, the vertical sign had been replaced with one that read "PARAMOUNT" in neon, and a new triangular marquee had replaced the earlier rectangular one. The new owners retooled for live music, and in the seventies and eighties it hosted rock concerts. Pink Floyd, Queen, and the Grateful Dead played here, the Guess Who recorded a live album, and Madonna launched her 1985 debut "Virgin Tour" at the Paramount.

After decades of abuse, grime, and neglected maintenance, the Paramount was falling apart and threatened with demolition. Microsoft vice president Ida Cole came to the rescue, purchasing it in 1993 and pouring millions of dollars into repairs, restoration, and improvements. In 2002, she donated the Paramount to Seattle Theatre Group, who operate it today, along with two other historic properties.

In October 2009, the vertical sign was replaced with an exact replica of the 1940s original. The neon letters remain neon, but the nearly 2,000 incandescent chase lights at the edges have been upgraded to LEDs that use one-tenth the power. Below this is the 1950s triangular marquee, with neon "PARAMOUNT" above each letter board, a rapidly animated multicolor fleur-de-lis at its center, and blue neon tubes filling the remaining surface. (911 Pine St., stgpresents.org, 1928)

First Hill

This elegant ten-story building is on the western flank of First Hill, where the grade is so steep that Union Street skips a block, with a stairway taking its place. Originally designed to appeal to young people who worked downtown, **The Cambridge Apartment Hotel** was Seattle's first apartment hotel, in which long or short-term apartment leases were available with hotel-like service and ease of booking. It was the first high-rise on First Hill overlooking downtown, and was, at the time of its construction, the largest residential building in Seattle. For these reasons, the Cambridge is now listed on the National Register of Historic Places.

A large rooftop sign reading "The Cambridge," similar to the one at the Roosevelt Hotel, was removed in the 1970s. Vintage postcards reveal that the smaller scale neon at the street-level corner, shown here, was installed no later than 1961. Now managed by the nonprofit Bellwether Housing, **Cambridge Apartments** provides housing to persons with incomes below the median. (903 Union St., bellwetherhousing.org, 1923)

The neon sign at the **Baroness Hotel** provides a clue to the building's original name use—like the nearby Cambridge, this too was an "apartment hotel." The three words on its neon sign were once illuminated in green, red, and white, respectively, but only the "Apt." has been lit in recent years—ironically, the one word that is least relevant today, as the Baroness operates as a regular short-

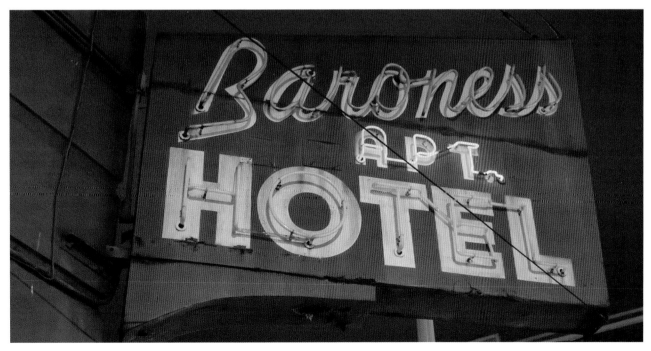

term-stay hotel. With comparatively low rates for downtown, it's especially popular with the families of patients at Virginia Mason hospital across the street. (1005 Spring St., baronesshotel.com, 1931)

Alex Rosenast and Jill Young-Rosenast, erstwhile owners of Temple Billiards (*see* Pioneer Square), created **Garage Billiards** on First Hill as a pool hall and restaurant, drawing from Broadway's history for a name—the building had been part of Seattle's "auto row," when roughly three quarters of early twentieth century auto dealers and repair shops were clustered around Broadway and Pike. An opportunity to expand came a few years later, when they and pool hall manager Mike Bitondo discovered—through a chance meeting at a Mariners game—that the owner of the neighboring building was looking to sell. Buying the former aquarium shop, they converted it to a 14-lane bowling alley, with the combination now called **Garage Billiards and Bowl**. It's now part of Bowlero, the world's largest bowling center operator. (1130 Broadway, bowlero.com, 1996)

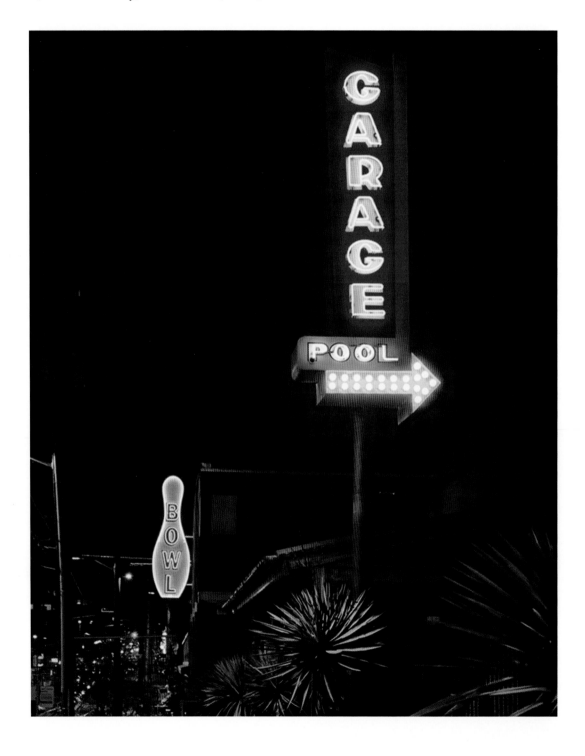

2.

Pioneer Square and International District

Pioneer Square

In Pioneer Square, downtown Seattle's oldest neighborhood, one finds buildings dating to just after the Great Seattle Fire of 1889, when a pot of glue boiling over in a carpentry shop led to the destruction of 25 city blocks. Because of Pioneer Square's status as a city-designated historic district, many of these 1890s buildings retain their original architectural details.

Pioneer Square was the site of Henry Yesler's saw mill, which employed many of the men who lived nearby. Yesler Way, originally Mill Street, was commonly called "Skid Road," as here the logs would skid from the hillsides in the east, down to the waterfront mill to be cut into lumber and loaded onto ships.

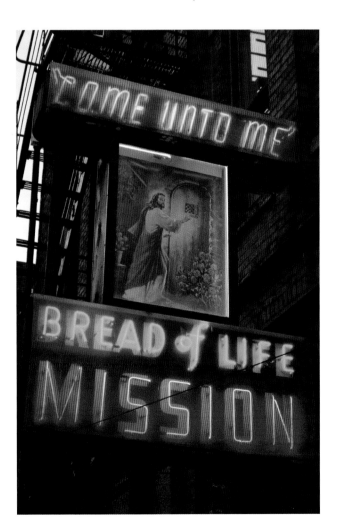

As the neighborhood fell on hard times after the closing of the mill, "Skid Road" morphed into "Skid Row," which then became a popular label for the roughest part of any city.

Pioneer Square today is at the epicenter of Seattle's housing crisis, with hundreds living on the streets and sidewalks. **Bread of Life Mission** has been here since 1939, serving the population experiencing homelessness with beds, food, clothing, and Christian counseling and addiction recovery programs. In 1944, the non-denominational service organization purchased a large building on the corner of 1st Avenue and South Main, where they remain today. Their neon sign proclaims "Come Unto Me," and is inset with a painting of Jesus knocking at the door. (97 S. Main St., breadoflifemission.org, 1939)

Built in 1914, the four-story Yesler Hotel became a Skid Row flophouse by the 1930s. Bart Seidler purchased the shabby old building in 1984, and continued to operate it as a low-rent hotel for a decade before closing in 1994 for ten months of renovations. It reopened as **Pioneer Square Hotel**, a boutique hotel aimed at professionals and tourists, with a lobby of lovely dark wood and vintage furniture and fixtures. (77 Yesler Way, pioneersquare.com, 1914)

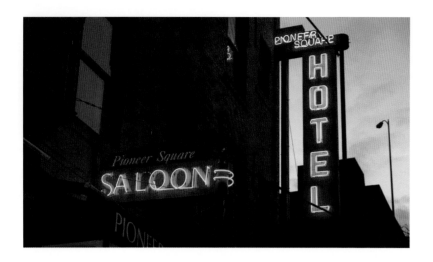

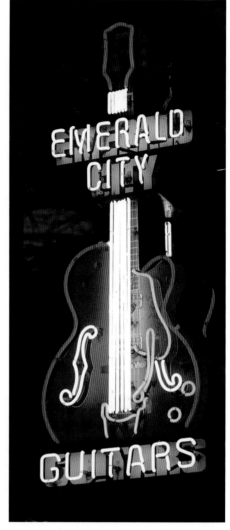

Music industry veteran Jay Boone created **Emerald City Guitars** in 1996. The shop sells vintage electric, acoustic, and bass guitars; amplifiers; and accessories. Their inventory includes hundred-year-old antique instruments and 1950s and 60s electric models from Fender and Gibson, some with distinguished pedigrees and mid-five-digit price tags. (83 S. Washington St., emeraldcityguitars.com, 1996)

As the neon in the window proudly proclaims, **The Central Saloon** is "Seattle's Oldest Saloon," opening three years after the Great Seattle Fire destroyed much of Pioneer Square. Originally, this was the Watson Bros. Famous Restaurant. By 1901, it was known as the Seattle Bar, then became Central Cafe just in time for Prohibition—a name it retained until the 1970s, and one you can still see in the hexagonal tiles in front of the doors.

The 1980s brought a focus on live music, and led to Central Saloon becoming the "birthplace of grunge." It was here that Nirvana played their first Seattle show in 1988, and where they first connected with Sub Pop Records, who released their Bleach album the following year. Alice in Chains, Mother Love Bone, Soundgarden, Mudhoney, and the Melvins all played at the Central before rising to international fame.

The 2013 music video for "Voices" by Alice in Chains was filmed at the Central and other Seattle

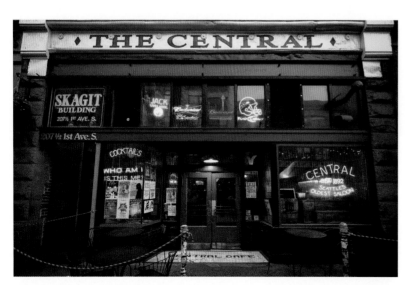

businesses connected to the band's history. The video features several neon signs made with the song's lyrics, one of which still hangs in Central Saloon's window—"Who am I, is this me?" (207 1st Ave. S., centralsaloon.com, 1892)

Rooms haven't been as cheap as 75 cents at **The State Hotel Seattle** for over half a century—but the neon sign advertising that price is kept lit and well-maintained, protected by law as part of the Pioneer Square Preservation District. It's attached to the Terry-Kittinger

building, built in 1891 in the Romanesque style. Though it presents a uniform facade of gorgeous brick arches and stonework, the structure is actually a "joint block," with the north half and south half built at the same time for two different owners, and with separate entrances and stairs to the upper levels of each. In 1909, the northern portion became a low-budget hotel, called the State Hotel or Delmar Hotel. As this was a block from Skid Road, the rock bottom prices persisted well into the mid-century, until the hotel closed after a fire in 1967.

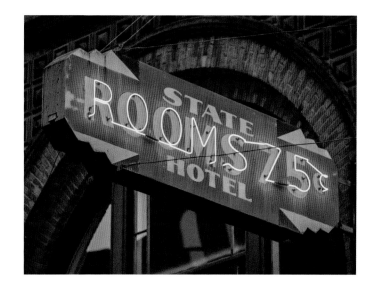

The historic building was sold and restored in 1991, with the upper floors converted to loft apartments. Two of these, directly behind the arched windows, are available as short term rentals, with nightly rates starting at two hundred times the price advertised by the neon. (114½ 1st Ave. S., thestatehotelseattle.com, 1909)

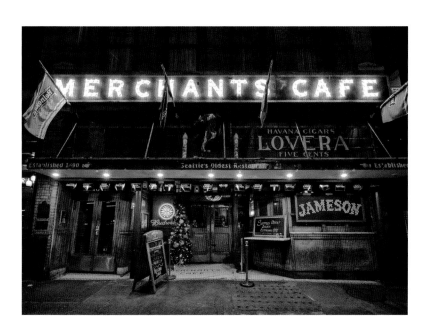

There's no neon on the exterior of Seattle's oldest restaurant, **Merchants Cafe**. Instead, this is presented here as a rare surviving example of a once ubiquitous form of electric sign, in which the letters are formed from a large number of incandescent bulbs. Neon arrived in the United States in the mid-twenties, so visually stunning that early neon signs literally stopped traffic. In the thirties and forties, as the technology became more widespread and affordable, most of the earlier illuminated signs like this one were replaced with the new "liquid fire." (109 Yesler Way, merchantscafeandsaloon.com, 1890)

Patrick and Chrystal McCoy started **McCoy's Firehouse Bar & Grill** in 1998, filling it with memorabilia from Pat's firefighting career. Their one-story building was originally a three-story hotel and brothel, losing its upper floors in the 1949 Olympia earthquake. In 2001, the Nisqually earthquake caused the building to shift about six inches, separating one wall from the roof—they had to shut down for nine months of costly repairs. This time, a video camera over the bar recorded the quake as it happened, and you can watch the recording on their website.

The interior brick walls of McCoy's hold an impressive collection of firefighting equipment and protective gear, with uniform patches from around the world donated by customers. There's plenty of neon

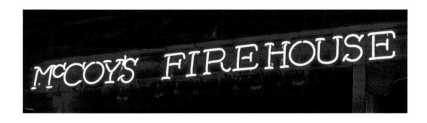

inside and in the windows, including beer logo signs, neon martini glasses, neon firefighters' helmets, and a neon-enhanced poster of Marilyn Monroe. (173 S. Washington St., mccoysfirehouse.com, 1998)

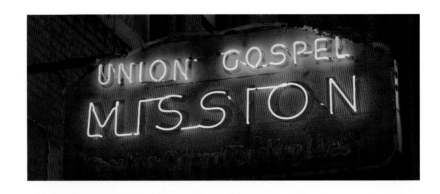

"Reaching out and touching lives" is the third line of text, now dark, on the neon sign over the sidewalk at **Union Gospel Mission**. Dr. Francis Peterson started the mission as a soup kitchen in 1932, not far from Seattle's "Hooverville" on the tide flats to the west. The mission added a men's shelter in the thirties and a women's shelter in 1940. Since then, Union Gospel Mission has expanded to provide all sorts of services to those in need—food and beds, of course, but also job search assistance, counseling, addiction recovery, medical, dental, legal, and even veterinary services. (318 2nd Ave. Ext. S., ugm.org, 1932)

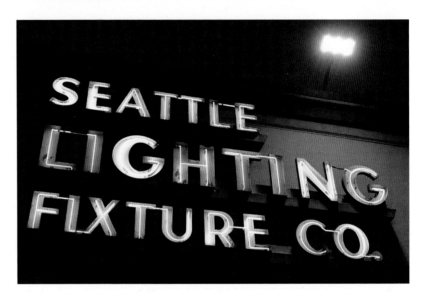

Walter Funsinn and Joseph Schomer started **Seattle Lighting Fixture Company**, now known as **Seattle Lighting**, in 1917. Their lamp showroom is in the Metropolitan Building of 1906, originally

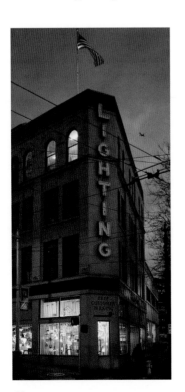

built with a rectangular plan and a front on 3rd Avenue South. This was substantially altered in 1928, when the Second Avenue Extension South project cut through the neighborhood with a new diagonal street, a four-block extension of downtown's Second Avenue. That project lopped off most of the front of the building, resulting in a trapezoidal shape. Walk to the south end of the block to see a second neon sign, white channel letters reading "Seattle Lighting Fixture Co." (222 2nd Ave. Ext. S., seattlelighting.com, 1917)

Another structure dating back to just after the fire, the **Cadillac Hotel** provided long-term accommodations for laborers employed at the nearby docks and railways. It operated as a hotel until 1970. That year, a fire at the Ozark Hotel in Belltown killed 20, prompting the city to require all hotels to install modern sprinkler systems—a far too costly improvement for a creaky old nineteenth-century hotel; many workingmen's hotels in Pioneer Square and Chinatown simply shut down completely rather than pay millions to upgrade, displacing thousands of long-term residents.

In 2001, the Cadillac Hotel building was home to the Fenix Underground nightclub when the Nisqually Earthquake caused the top of the structure to collapse, requiring years of extensive repair and reinforcement work. Historic Seattle and the National Park Service paid for

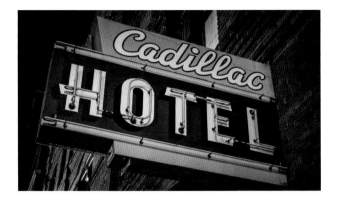

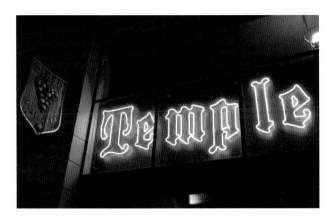

the upgrades, and the former hotel then became **Klondike Gold Rush National Historical Park**, commemorating Seattle's role as the gateway to Alaska and the Yukon, and proving that a national park doesn't necessarily have to be outdoors. (168 S. Jackson St., historicseattle.org, 1889)

Temple Billiards has this eye-catching blue neon sign over the door. You'll find plenty of neon inside, too, including a clock on the main level and a neon "Pharmacy" sign in the basement bar. Alex Rosenast, creator of the famed but short-lived RKCNDY nightclub, opened Temple Billiards in 1994, selling it a few years later to focus on his Garage Billiards and Bowl (*see* First Hill). (126 S. Jackson St., templebilliards.com, 1994)

Great Northern Railway magnate James J. Hill, known as the "Empire Builder," sought to establish his own route from the Midwest to Seattle, to compete with the railways that serviced Tacoma and instead establish Seattle as the dominant city in Washington. Hill built **King Street Station** in 1906 in the "Railroad Italianate" style, its design influenced by the great railway stations of London and the bell tower of St. Mark's Basilica in Venice. Five years later, Union Pacific built their own equally impressive Union Station on the other side of the tracks, and the two would operate side-by-side for 50 years.

Passenger rail travel declined in the 1960s as airline tickets became more affordable. Union Station closed as all service was consolidated at King Street Station. The interior of the station was "modernized"—marble walls and glass mosaic tiles were removed, fluorescent lights replaced bronze chandeliers, and, worst of all, the ornate plaster ceiling over the passenger waiting area was hidden above suspended acoustical panels.

By the turn of the century, overcrowded roads were making railway travel desirable again. In 2008, the city purchased the ugly and decrepit station from its then-owner, BNSF Railroad, for one dollar, then poured $56 million into repairing it and restoring it to its early-1900s glory. The hideous drop ceiling and fluorescent lamps were ripped out, the cracked terrazzo floors and plaster moldings repaired, and period-appropriate new chandeliers installed. King Street Station reopened in 2013, servicing Amtrak trains—including the Chicago-to-Seattle Empire Builder route, named after James J. Hill. (303 S. Jackson St., seattle.gov, 1906)

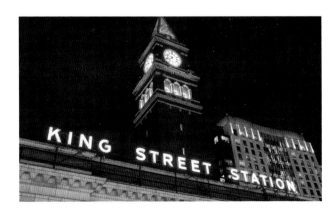

Chinatown / International District

The neon signs at **Bartell Drugs** are the first thing arrivals in the International District see upon emerging from the light rail station across the street. Fittingly, the writing is Chinese—the characters for "medicine" and "bureau." A family-owned regional chain, Bartell has locations throughout Seattle, but only here have they embraced the traditional character of the neighborhood in such a warm and glowing way. (400 S. Jackson St., bartelldrugs.com, 2016)

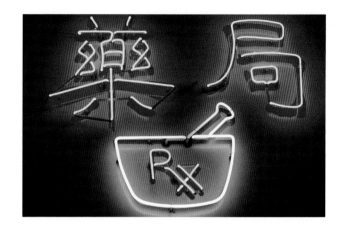

Designated a national historic landmark, **Panama Hotel** is famous as the location of the last surviving *sento* (Japanese public bath) in the United States, and as the setting for Jamie Ford's 2009 novel *Hotel on the Corner of Bitter and Sweet*. The bathhouse, Hashidate Yu, is no longer functioning, but has been preserved as a historic site, with public tours occasionally offered. Other relics here are more grim—through a glass panel set into the floor of the hotel's tea shop, one can see luggage and other belongings that were left behind when the United States government forced Japanese-Americans into internment camps during World War II, a crime against humanity that must never be forgotten. (605 S. Main St., panamaseattle.com, 1910)

Across 6th Avenue from the Panama Hotel is a neon rice bowl with chopsticks and wisps of steam—or perhaps flames. This is the former site of **The Standard Cafe**, which operated in the early 2000s. It's now Artform, a custom framing shop, and the bowl remains, though its neon is no longer working. (527 S. Main)

Named for the Northern Pacific Railway, the **N-P Hotel** was built in 1914 for travelers arriving at

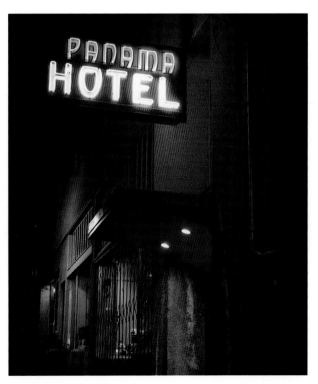

King Street Station and Union Station. Brothers Niroku "Frank" and Shihei "George" Shitamae lived in and managed the hotel, becoming its owners in 1939. Though the building is now low-income apartments and the hotel is defunct, the two-story neon sign is kept in good repair due to the neighborhood's status as a historic district. The north side of the sign is blank, and only the south side, facing Jackson Street, is illuminated. (306 6th Ave. S., 1914)

New Star Seafood Restaurant serves Cantonese cuisine with an emphasis on seafood, including crabs and lobsters plucked live from the tank. (516 S. Jackson St., newstarseafood.com, 2000)

Built in 1962, **Four Seas Restaurant** was an integral part of the Chinatown community and a favorite haunt of civil rights activist "Uncle Bob" Santos, who died in 2016. "Dynasty Room," advertised here in neon, was the lounge area in the back of the restaurant, warmly decorated in old wood and Chinese carvings. In 2017, after 55

years in business, Four Seas closed for good, with plans announced for a residential development on the site. A pop-up bar called "Dynasty Room" then operated in the space for a year or two, until the old restaurant was demolished in April 2021. The sign was rescued, taken to Western Neon for repair, and will be on display at the new building, to be called "Uncle Bob's Place." (formerly 714 S. King St., 1962)

The **Republic Hotel** was built in 1920 as a Single Room Occupancy hotel, one of many in the district that provided long-term housing for immigrant laborers. Gambler and jazz club owner E. Russell Smith (nicknamed "Noodles" for his habit of holding back just enough cash from the gambling table so that he could have a bowl of noodles afterwards) purchased the hotel and renamed it the **Golden West Hotel**, notable in that segregated era for renting rooms to Black and Asian guests alike.

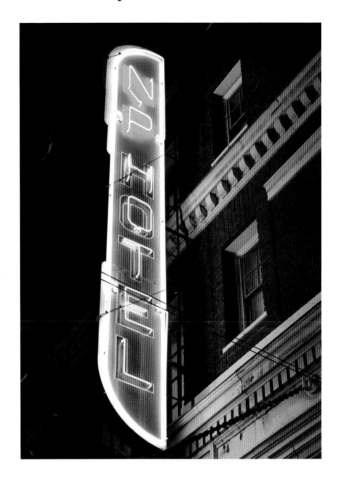

The second floor features a metal balcony running the entire length of the building on the west side. Behind it, flanking the door, are Chinese characters in neon, advertising a **Double Dragon Restaurant**. More neon, depicting birds and flowers, appears over the ground-floor entrance belonging to the **Chew Lun Benevolent Association**, which had their meeting hall on the second floor. In 2017, the former hotel, then apartments for low-income seniors, was shuttered and abandoned, and it is now in a state of decay. (416 7th Ave. S., 1920)

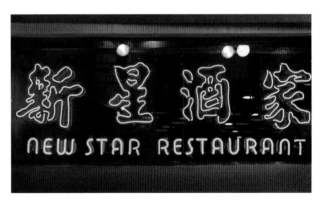

Pho Bac became **Pho Ba** a few years ago, a name change effectuated by simply enclosing the letter "C" on the neon sign in a box with a cut-out noodle bowl on its front, thus avoiding confusion with the boat-shaped Pho restaurant further east on Jackson. This little pho shop, which has received glowing reviews for their superior beef broth, is on a rear corner of the Hotel Milwaukee. (415 7th Ave. S., by 2005)

By the estimates of 1900s newspapermen, Goon Dip was the wealthiest Chinese west of the Mississippi. After making his fortune as a labor contractor in Portland, Goon came to Seattle in 1909, accepting an appointment by the Chinese government as honorary consul for the Alaska-Yukon-Pacific Exposition. Educated, charismatic, perfectly fluent in English, and with

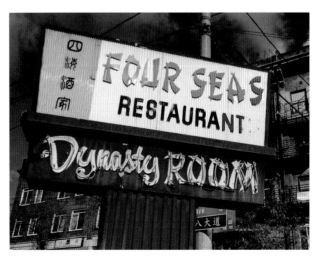

a reputation for kindness and philanthropy, Goon was able to make inroads with Seattle's business leaders like no one else.

At the time of his arrival, Seattle's original Chinatown was then being demolished, as it was in the path of the new railway tracks, and Goon played a major role in creating the new China-town, centered around his new residential hotels on King Street, the West Kong Yick and East Kong Yick (the present Wing Luke Museum). In 1911, he began construction on a larger and more elegant hotel, the 150-room **Hotel Milwaukee**, one block west of the Kong Yick buildings. The Milwaukee provided both hotel rooms and apart-

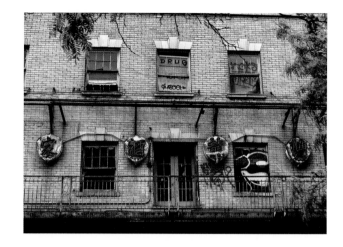

ments, with separate entrances for the two functions. The Goon family themselves resided on the west side of the building's top floor, with an Irish-American bodyguard living in a room across the corridor.

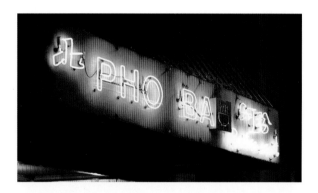

Goon Dip died in his apartment in the Milwaukee Hotel in 1933.

Today, the building is entirely apartments on the upper levels, with restaurants and retail on the ground floor. If you're a fan of "ghost signs"—faded paint on the walls of buildings—look for the one advertising Milwaukee Cafe on the north side of the building. (668 S. King St., 1911)

Taking the name from a Hawaiian phrase mean-ing "good food," Wai Chow Eng opened the original Kau Kau restaurant on 2nd Avenue downtown in 1959. At the time, there was no Chinese barbecue closer than Vancouver, but Eng changed that. The restaurant was enough of a success that he opened another, **Kau Kau BBQ Market & Restaurant**, on King Street in 1974. Though the downtown loca-tion has closed, the Chinatown location continues to thrive today, under the stewardship of Eng's daughter and son-in-law. The barbecue sauce recipe remains a closely-guarded secret. (656 S. King St., kaukaubbq.com, 1974)

Hotel Milwaukee and Kau Kau can both be seen in the 2000 action movie *Get Carter*, as a car chase takes place at King Street and Maynard Alley—Sylvester Stallone and his gangster adversaries drive through this intersection several times, filmed from different angles, to appear as if the chase continued through multiple blocks. The now-vanished neon of the defunct **Fortune City** restaurant, formerly at the southwest corner of Hotel Milwaukee, is prominently seen in the film. Kau Kau's neon at the time consisted solely of window signs; the neon on the awning was added later.

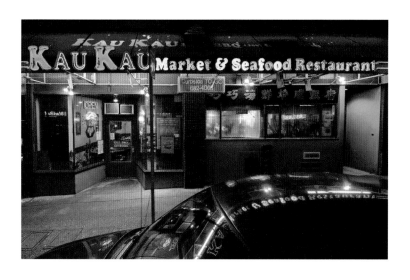

Tai Tung is Seattle's oldest continuously operating Chinese restaurant. It was a favorite hangout of actor and kung fu master Bruce Lee, who had a preferred booth in a rear corner, with a curtain that could be drawn so no one would bother him. Lee always ate the same dishes, oyster sauce beef and garlic shrimp, which the waiters would bring him without being asked.

In 1973, shortly before the release of *Enter the Dragon*, Lee died suddenly in Hong Kong at the age of 32. Tai Tung continues to maintain this table in his memory, decorated with a vase of flowers, autographed photos and posters of Lee and his works, and even a cardboard standee of a shirtless Lee in a fighting stance. It's a popular stop for tour groups from the Wing Luke Museum, which ends the tour with dinner at the movie star's table.

Tai Tung Restaurant has been operated by the Chan family for its entire run. Its neon sign was removed and discarded in the 1960s, but in 2017, third-generation owner Harry Chan replaced it with an exact replica. (655 S. King St., taitungrestaurant.com, 1935)

The present **Hong Kong Bistro** opened in 2009. They sell all sorts of Cantonese dishes, but the star attraction is the dim sum, which you can order from photographic menu cards on the tables. Hong Kong Bistro's magnificent three-story vertical neon sign dates back to an earlier Hong Kong restaurant at that

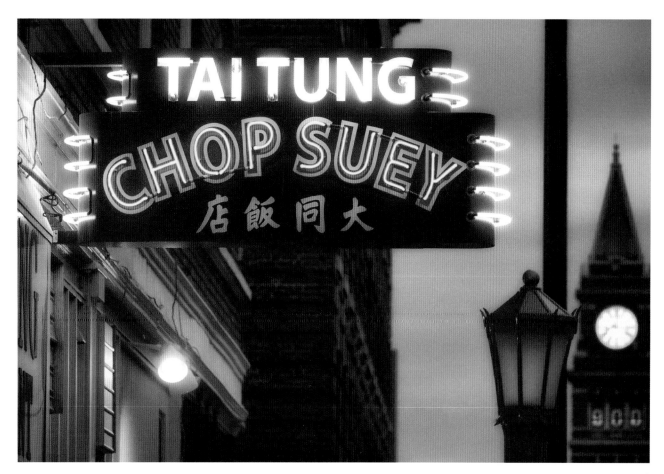

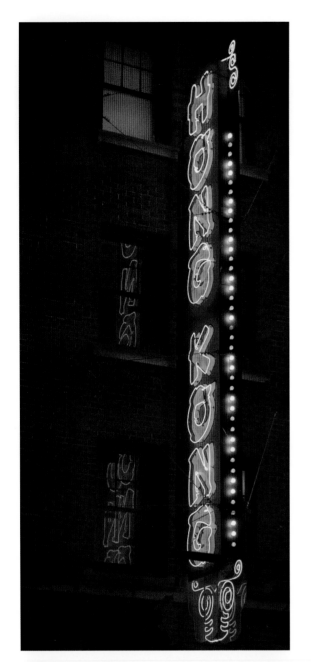

location. Ruby Chow, the great Chinese-American restaurateur who would go on to employ Bruce Lee in her kitchen, tended bar at the original Hong Kong in the forties. (507 Maynard Ave. S., hongkongbistroseattle.com, by 1943)

From the Chinese character meaning "good" comes the name of **Hau Hau Market**, a thriving grocery store on the east side of the International District, separated from most of the historic district by Interstate 5. The market's interior space is not large, but they make the most of it by putting up a huge tent in the parking lot, each day hauling out the entire produce section to be sold in the open air. Though functioning perfectly only a short time before, the neon was removed in 2019. (formerly 412 12th Ave. S., by 2007)

Bich Kieu Jewelry is a fourth generation family-owned business—though only in the United States since 1991, as owner Pham Lang comes from a long line of jewelers in Vietnam. The Seattle store takes its name from their original location in Saigon. "Thrift Shop" rapper Macklemore is one of Bich Kieu's frequent customers. (423 Rainier Ave S, 1991)

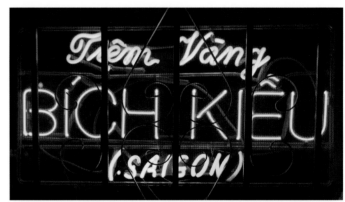

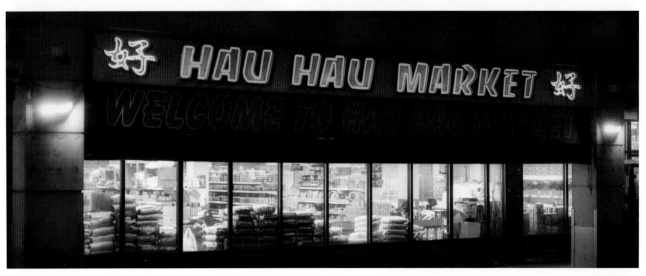

3.
Pike Market and Belltown

Pike Place Market Historic District

Drawing an estimated ten million visitors annually, **Pike Place Market** is Seattle's leading tourist attraction as well as the oldest continuously operating public market in the United States. Seattle City Council established the market in 1907, inviting farmers to sell produce directly to the public on Pike Place, a short wood-plank road at the western end of Pike Street. On its first day of operation, about eight farmers drove their wagons here and found a crowd of thousands of customers. All of their produce sold out by noon.

Work immediately commenced on buildings on either side of Pike Place. These would keep the merchandise out of the rain and provide indoor stalls that could be rented to sellers. In only three months, the Main Arcade was completed, opening with much fanfare (including an orchestra). Built on a steep hillside, the building is entered on an upper level from the Pike Place side, with shoppers then descending stairs to reach the shops on the lower floors.

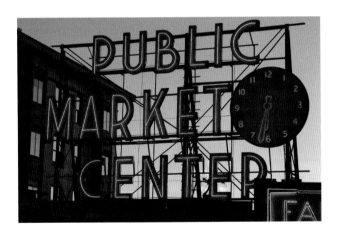

The world-famous Public Market Center neon sign and clock were designed by architect Andrew Willatsen and installed about 1935. A former student of Frank Lloyd Wright, Willatsen came to Washington as a young man, accepting employment with a Spokane-based firm that assigned him to work in Seattle. In 1910, he designed the Sanitary Market building, so called because of its concrete floors, glass display cases, and modern refrigeration system. Willatsen would remain affiliated with the market, supervising alterations and improvements, until his retirement in the 1960s. (85 Pike St., pikeplacemarket.org, 1907)

At the north end of the Main Arcade building is a second "Public Market" rooftop sign, facing Pine Street. Underneath is a neon fish advertising **City Fish Seafood Market** on the upper level of the arcade. This began as the city-owned Municipal Fish Market, set up in 1917 to mitigate wartime fish shortages and price-gouging. It became **City Fish Market** when transferred to

private ownership in 1923. (1535 Pike Place, cityfish.com, 1918)

An old-school newsstand with an astounding selection of magazines, **First & Pike News** closed on the last day of 2019 after 40 years in business. Lee Lauckhart, who had worked at his father-in-law's newspaper stand in New York City during the 1970s, teamed up with Sabetai Nahmias, an old-timer who held a license to sell papers at 1st and Pike, creating the new "Read All About It" newspaper stand in the market. At its peak, the newsstand carried 180 newspapers and over 2000 magazines. These numbers dwindled in the 2010s as many papers and magazines ceased publication, described by Lauckhart as a "digital onslaught." (formerly 93 Pike St., 1979)

The three Pappadakis brothers started **Athenian Seafood Restaurant and Bar** as a bakery and luncheonette in 1909. After the end of Prohibition, it became a tavern and then a full restaurant called Athenian Inn. Bob and Louise Cromwell purchased the restaurant in 1963, with Bob running the kitchen and Louise mingling with the customers. After Bob's death, Louise managed the restaurant solo, becoming a familiar and respected figure around the market until her own death in 2011.

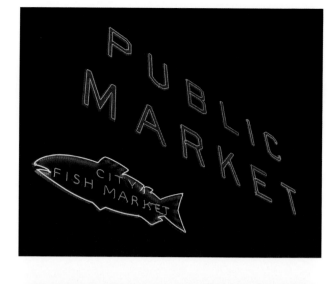

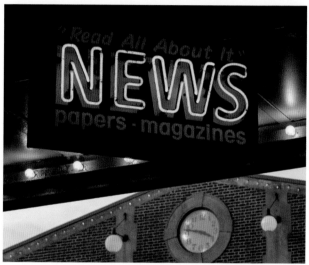

Athenian's neon sign in the Main Arcade was prominently featured in the film *Sleepless in Seattle*. Another scene took place at the restaurant's counter, where Tom Hanks dined with Rob Reiner—there's still a plaque affixed to it, reading "Tom Hanks Sat Here." At director Reiner's invitation, Louise Cromwell appeared as an extra in the scene. (1517 Pike Place, athenianseattle.com, 1909)

Within the main arcade are a wealth of vintage neon signs, preserved as historic artifacts, though the companies they once advertised are long gone. One of these belonged to Loback Meat Company, a butcher shop that was active here from 1946 to 1989.

Directional and informational signs within the market buildings are done in a charming early

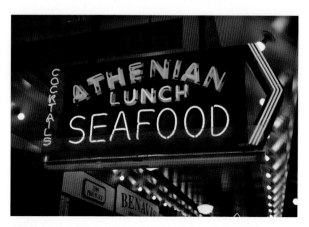

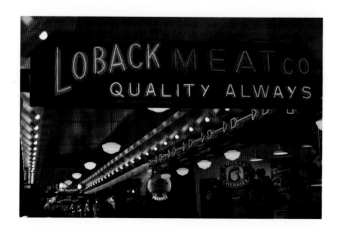

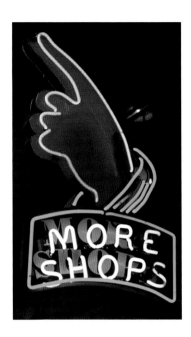
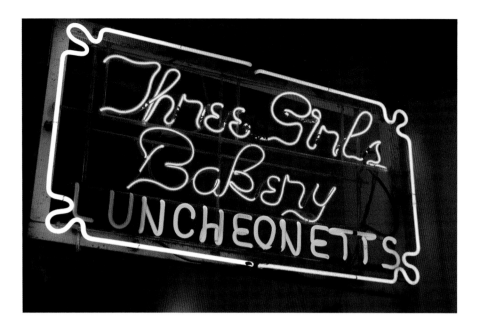

twentieth-century style, several with illustrated hands pointing the way to "more shops."

In 1912, a "Mrs. Jones" and two friends received the first business license issued to a women-owned company in Seattle. They proceeded to open **Three Girls Bakery** in the Corner Market building, becoming the oldest continuously operating Pike Place Market vendor. Now owned by the Levy family since 1979, Three Girls Bakery sells pastry and sandwiches in the Sanitary Market building. (1514 Pike Place, Stall #1, threegirlsbakery.com, 1912)

For decades, the street level storefront at Post Alley and Pine Street provided an emblematic picture of Seattle: a neon coffee cup emanating neon vapors, with the Public Market and City Fish Market signs rising from the rooftop behind, and usually a ferry boat in the distance. In 2013, the iconic neon cup came down as **Seattle's Best Coffee**, which had been bought out by Starbucks, departed the space they'd occupied for nearly 30 years. (formerly 1530 Post Alley, seattlesbest.com, 1984)

Rachel's Ginger Beer stepped in to fill the void, mounting a neon ginger beer bottle in exactly the same spot. Traveling in England in the 2000s, Rachel Marshall had become a fan of non-alcoholic ginger beer—far more flavorful stuff than ginger ale—and upon returning to the United States found the available options unsatisfying. After years of experimentation, she perfected a winning recipe and began supplying farmers markets, then brought "RGB" to the coveted Post Alley corner.

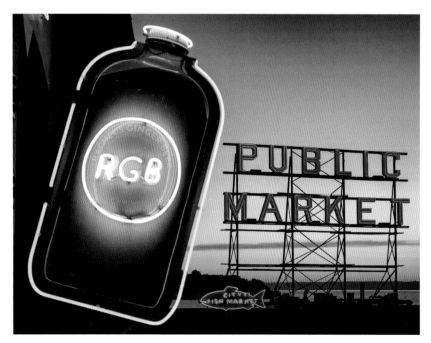

RGB's neon signs are unusual in that they are round in cross-section, like a bottle, rather than presenting a simple flat surface to the viewer. This requires the glass tubes to be bent on a more complex curve to align with the surface. (1530

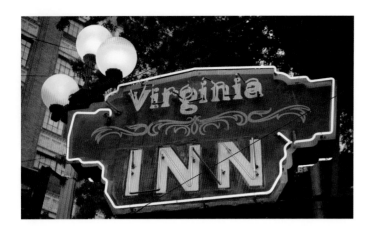

Post Alley, rachelsgingerbeer.com, 2013)

Virginia Inn predates Pike Place Market by four years, but is within the historic district, which makes it the market's oldest eating and drinking establishment. The "V.I." started as Virginia Bar in 1903, part of the newly built Livingston Hotel. During Prohibition it became a soft drink parlor and card room. Many of the early architectural details are preserved, including the hexagonal floor tiles and mahogany bar.

Virginia Inn appeared on film in *Singles* as the scene of Campbell Scott and Kyra Sedgwick's "water" date, with the camera accompanying them outside as conversation continued under the neon sign. (1937 1st Ave., virginiainnseattle.com, 1903)

This bus shelter stands at the north end of the historic market district. As an entry point to the market, it's decorated with an appropriate amount of neon. (Pike Place at Virginia Street, by 2008)

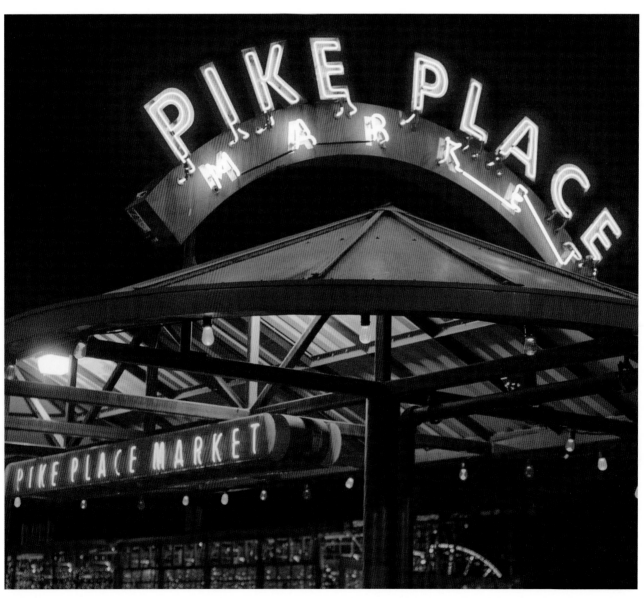

Pike Market (Neighborhood)

Just outside the market's historic district is Tom Douglas's **Seatown Market & Fish Fry.** The neon window signs at the southwest corner, shown here, are at the approximate location of the front door of the first Starbucks coffee shop, which from 1971 to 1976 occupied the corner storefront of the Rhode Island Building. When that building was demolished, Starbucks moved half a block south, into the Soames-Dunn building within Pike Place Market—a location now visited by swarms of selfie-snapping tourists every day as the "original Starbucks." (2010 Western Ave., seatownrestaurant.com, 2010)

A relic of 1st Avenue's seedier past as a red light district, **Deja Vu Showgirls Seattle** stands across from the Sanitary Market, showing tourists a side of Seattle that the city council isn't quite as eager to have on display. Neon and video screens obscure most of the 1920s terra cotta facade. (1510 1st Ave., dejavushowgirls-seattle.com, 1987)

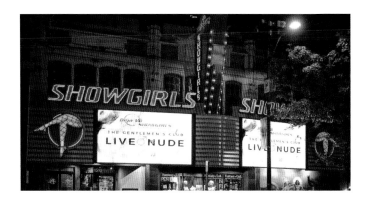

No luxury hotel in Seattle is better positioned than **Green Tortoise Hostel,** on the corner opposite the Market's main entrance. Green Tortoise began in 1973 as an inexpensive, "alternative" long-distance bus service, attracting a customer base of hippies and other counterculture folk. In 1993, the bus company established their first hostel in Seattle, initially on Queen Anne, moving to this primo location in 2006. The hostel offers dorm-like rooms with beds as low as $30, storage lockers, and private bathrooms. (105 Pike St., greentortoise.net, 1993)

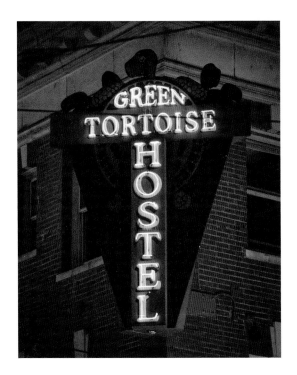

Since 1939, **The Showbox** has at times been a music venue, comedy club, cabaret, ballroom, movie theater, and—during one particularly bleak period—a furniture shop. Michael Lyons, who operated a number of taverns and theatres in the thirties, purchased the former Angeles Saloon building across the street from his Lyons Music Hall, transforming the interior space into a splendid Art Deco nightclub, the "Palace of the Pacific," with a movie screen, a pipe organ, a stage, and dance floor. The Show Box hosted nationally known performers, including Duke Ellington, Dizzy Gillespie, Muddy Waters, the Ramones, the Police, and local acts such as Soundgarden, Pearl Jam, Macklemore, and Seattle-born striptease artist Gypsy Rose Lee.

In 2018, a threat to the historic theater emerged, as the owner of the land and building prepared to sell the site to a development company that would construct a 44-story luxury apartment tower on the site. The music community and historical preservationists mobilized, forming "Friends of the Showbox" to petition the city to intervene. The city council temporarily expanded the Pike Market Historic District to include the Showbox, and declared it an official landmark, prompting the property owner to file a lawsuit to undo the designation. After much courtroom drama, in late 2019, Seattle Theatre Group and Historic Seattle partnered to make an offer to buy the property. While the parties involved were embroiled in this struggle, COVID forced the theater to shut down for over a year. The eventual fate of the Showbox has not yet been determined.

The Show Box originally had a huge neon marquee, spanning the width of the building, with "Show Box" (originally written as two words) above the letter boards on either side, and thousands of light bulbs on the bottom. The present marquee and vertical sign date to the 1990s, when the Showbox took its present name after some years as an improv comedy club.

On the south side of the marquee, neon letters point the way to Kerns Music Shop—another historic name revived by the Showbox management. Trombonist "Jumpin' Johnny" Kerns operated a music store next to the theater and had a knack for getting big stars to make an appearance—including Frank Sinatra and Nat King Cole, who sang for Kerns's customers. The modern Kerns Music Shop is a small and intimate bar, where Showbox patrons can have pre-show drinks. (1426 1st Ave., showboxpresents.com and friendsoftheshowbox.org, 1939)

Immediately south of Pike Place Market, **The Pike Pub & Brewery** is a huge space with plenty to do and see, all of it focused on beer. The site includes the Pike Pub, a seafood restaurant called Tankard & Tun, an on-site brewery with scheduled public tours, and a beer museum full of historic memorabilia and artifacts—including beer logo neon signs, their own as well as other brands'. (1415 1st Ave, pikebrewing.com, 1989)

The run-down Eitel Building, constructed as medical office space in 1904, had been mostly

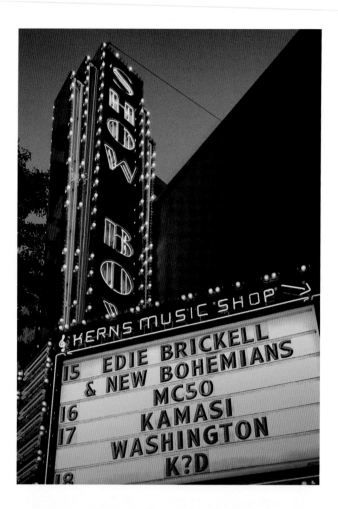

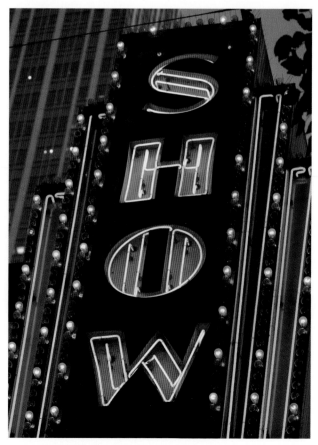

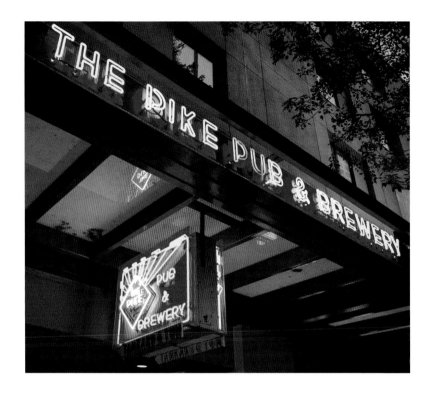

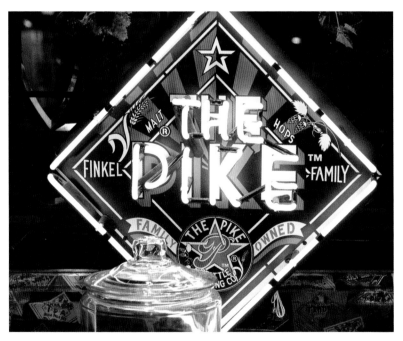

vacant since the 1970s. Damaged by an earthquake, infested with pigeons, and with boarded-up windows on the upper levels, it was generally described as an "eyesore." In 2018, after extensive renovations and a thorough scrubbing, it became **The State Hotel**, featuring all-new interiors, a mural by Shepard Fairey, and a rooftop bar with an unmatched view of the Market and the waterfront. The hotel includes a restaurant, Ben Paris, named for a famed sportsman, conservationist, and entrepreneur, who operated Ben Paris Cigars, Lunch & Cards on that same location in the 20s and 30s. Paris fought for the right to sell beer on Sundays, taking his case to the state Supreme Court—where he lost. (1501 2nd Ave., statehotel.com, 2018)

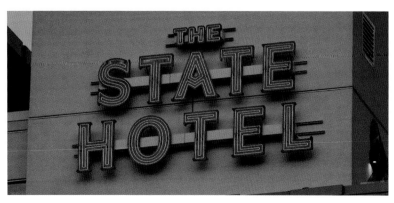

Belltown

Built entirely over water, **The Edgewater** hotel was constructed on a pier for the 1962 World's Fair. Though initial plans called for it to be demolished within a decade, an event in 1964 earned the hotel a permanent place in the story of Seattle. That year, The Edgewater agreed to host four young guests who had been turned away by the more established (and more uptight) hotels: the Beatles, who stayed here under exceptionally tight security before and after their Seattle Center Coliseum performance (*see* Seattle Center in Queen Anne).

The lads from Liverpool famously fished from the window of their suite, room 272. You can stay there today, for a premium price, but you'd find that everything inside it has been changed—immediately after the band departed, all the furniture was removed, mixed in with identical pieces, then randomly redistributed to other rooms, and the carpet the Beatles walked on was cut up into small squares and sold as souvenirs. It's still worth it, because the suite is full of Beatles photographs and memorabilia.

Led Zeppelin slept here in 1969. Their stay, too, involved a fish, allegedly used to perform a perverse act on a groupie—the infamous, and perhaps apocryphal, "mud shark" incident.

The three-sided "E" logo on the roof, a familiar sight on the waterfront for generations, had glowed red with neon since 1962. In December 2017, the glass tubes were replaced with neon-look LED lighting, seen here. This produces a variety of colors, and though usually red, can change for holidays or sporting events. (2411 Alaskan Way, edgewaterhotel.com, 1962)

Emerson Robbins, whose family had been in the jewelry business in Washington and California since the 1920s, opened **E.E. Robbins** in 2000 with a novel idea—selling only engagement and wedding rings. To promote the business, Robbins ran a contest, offering prizes for creative and romantic proposal stories. The best of these were published as a book in 2006: *Popping the Question, Seattle Style*. In 2013, Robbins merged his two Seattle stores with the family business, Robbins Brothers. (2200 1st Ave., robbinsbrothers.com, 2000)

A single unblinking eye, ringed in red neon, hangs outside **Cyclops Cafe and Lounge**. Cyclops began as the Free Mars Cafe, created by an artists' collective known as SCUD, the Subterranean Cooperative of Urban Dreamers. In 1984, SCUD renovated a derelict flophouse where Jack Kerouac had once stayed, redecorated by gluing hundreds of metal Jello molds to the exterior walls, and opened Free Mars Cafe. Customers Gina Kaukola and John Hawkley purchased the business in 1990, renaming it Cyclops, and installed the iconic eye over the front door. Cyclops relocated to their present 1st Avenue address in

1998, when the "Jello Mold Building" was torn down for condos. (2421 1st Ave, cyclopsseattle.com, 1984)

Game room owner Jeff Rogers and artist Joe Nix collaborated to bring **Jupiter Bar** to life, with a goal of celebrating and sustaining Belltown's community of artists and musicians, servers and bartenders. The interior features works from over 20 artists as well as a huge collection of pinball machines and arcade games. (2126 2nd Ave., jupiterbarseattle.com, 2017)

In 1903, James Moore purchased the magnificent but incomplete Denny Hotel—empty for a decade after a recession interrupted construction—finished it, renamed it the Washington Hotel, and hosted President Theodore Roosevelt

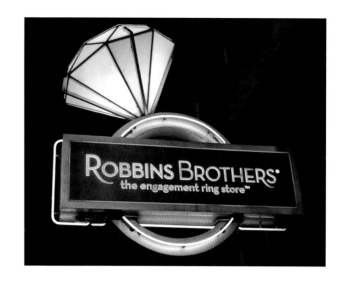

as the first guest. Over the next two years, Moore planned upgrades to his now-successful hotel, including an adjoining theater. As the hotel was on the summit of steep Denny Hill, and the site of the theater was far below, Moore envisioned hotel guests reaching the theater through a rooftop entrance from the landscaped garden above.

The city had other plans—Denny Hill, all of it, was an impediment to traffic flow and the northward expansion of downtown, and it had to go. The Washington Hotel was doomed, and it would be demolished as the hill underneath was carted away. Instead, Moore altered the plans for his new theater, combining it with a new hotel built at ground level, and allowed the hotel atop Denny Hill to be torn down after only two years in business.

Moore Theatre and Moore Hotel opened in time for the Alaska-Yukon-Pacific Exposition of 1909. The theater was leased to famed impresario John Cort, showing live music, comedy, and drama performances. In 1975, with live performances in decline, the Moore was converted to a movie palace and renamed the Moore Egyptian. The following year it became the birthplace of Seattle International Film Festival, and

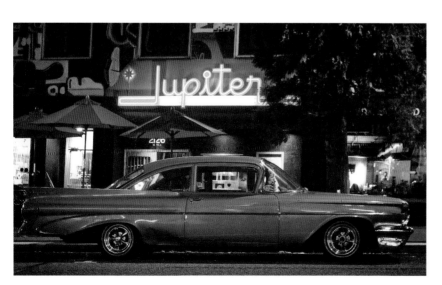

it was during the fourth annual festival, in 1979, that the Moore hosted the world premiere of Ridley Scott's *Alien*.

Today the Moore is Seattle's oldest operating theater, showing live performances once again under the supervision of Seattle Theatre Group, which also operates the Paramount and Neptune (*see* Downtown Core *and* University District). (1932 2nd Ave., stgpresents.org, 1907)

A classic dive bar located in the Moore Hotel building, **Nitelite Lounge** closed in 2016 for renovations. Workers repairing the facade of the hotel carefully erected scaffolding around the vintage neon sign, but when they departed in 2019, the Nitelite remained closed, and the neon stayed dark. To see it in action, watch the music video for "Voices" by Alice in Chains, where it appears, mostly lit, just after a shot of the Moore Theatre marquee. (1920 2nd Ave., thenitelitelounge. business.site, 1960)

After 30 years, **Bergman Luggage** was one of many businesses to flee downtown Seattle in 2020 due to looting, burglaries, and an atmosphere of squalor that made employees and customers fear for their safety. This, their flagship store, was well known for the huge neon signs stretching across the east and south sides of the building. A smaller neon sign with a clock hung over the sidewalk at the corner. (formerly 1901 3rd Ave., bergmanluggage.com, circa 1990)

Now serving low-income households, **The Fleming Apartments** was built in 1918 and originally housed sailors, which gave it an uncommon design feature: ramps instead of stairs,

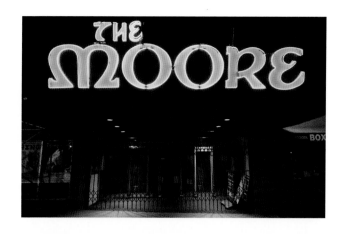

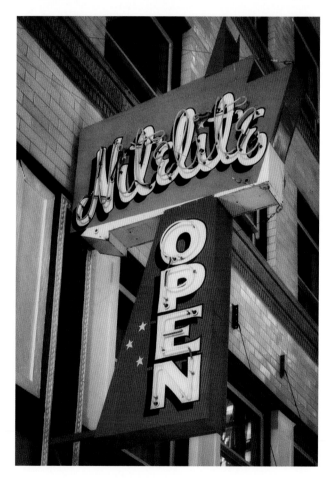

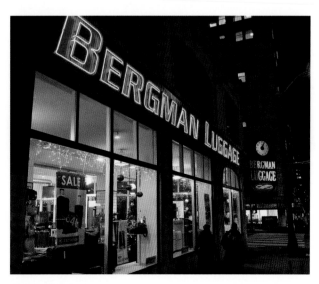

so that seamen could drag their heavy sea bags to their rooms. (2321 4th Ave., capitolhillhousing. org, 1918)

As their own neon proclaims, **The 5 Point Cafe** has been cheating tourists and drunks since 1929. Over the years, the Belltown dive has repeatedly been in the news—by being the first business in the world to ban Google Glass wearers, by engaging in a Twitter feud with a member of Rage Against the Machine who didn't want to stand

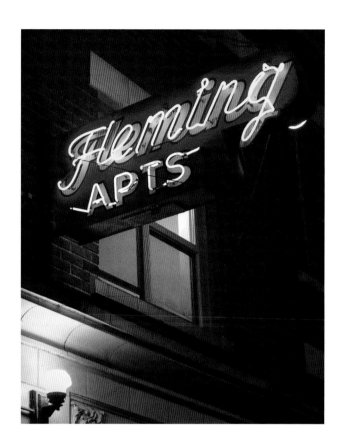

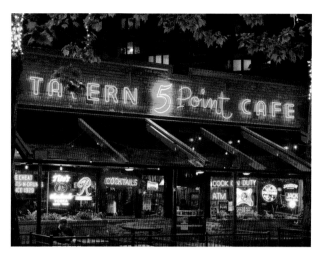

in line with the hoi polloi, by cutting down city-owned trees that blocked the view of the neon signs, and by installing a periscope to provide a view of the Space Needle—in the men's room, over a urinal.

C. Preston Smith and wife Frances, who had met while working at Mannings Cafe, opened the 5 Point Cafe in Belltown in 1929, and the Mecca Cafe in Uptown a year later (*see* Queen Anne). When Prohibition ended in 1933, the Smiths' establishments quickly pivoted to serve beer, but like other drinking establishments kept the "Cafe" in their names.

The 5 Point also operated a laundromat in the storefront immediately north, 5 Point Laundromat, with its own neon sign over the windows, but this closed by 2011. Around 2015, the cafe moved and updated their neon sign—this had previously been lower on the building, where the awning is now, and included a neon martini glass. The sign was moved upward and the martini replaced with new neon reading "Tavern." (415 Cedar St., the5pointcafe.com, 1929)

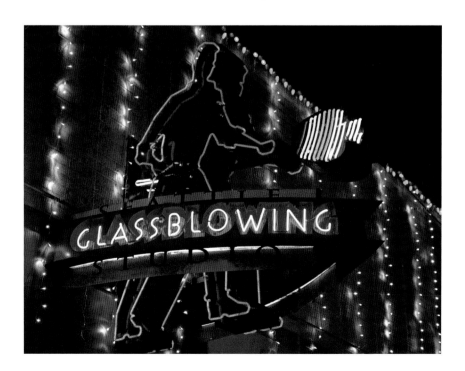

A glass artist since 1976, Cliff Goodman created **Seattle Glassblowing Studio** in 1991. The studio sells works of glass art created by professionals working in view of the public. Customers wishing to commission a custom piece can watch it being made, in the studio or online. They offer plenty of hands-on educational opportunities as well: classes, workshops, and private lessons, in which a novice glassblower can create a vividly colored ornament, float, pumpkin, paperweight, or bowl of their own design. (2227 5th Ave., seattleglassblowing.com, 1991)

Top Pot Doughnuts took its name from a salvaged neon sign, which you will find at their original Capitol Hill location (see Broadway in Capitol Hill). Their Belltown shop, next to the monorail tracks on 5th Avenue, also features repurposed vintage neon—the cowboy riding the bucking horse, which is animated and alternates between two poses, originally came from Western Outfitters Bar-B-Q Ranch in Yakima. (2124 5th Ave., toppotdoughnuts.com, ca. 2003)

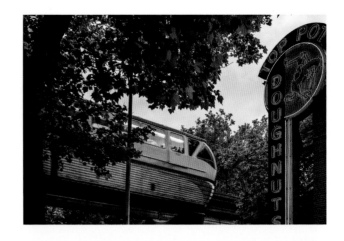

Winner of the James Beard Award, chef and cookbook author Tom Douglas opened his first restaurant, **Dahlia Lounge**, a block south of this location in 1989, offering intricate dishes showcasing Pacific Northwest seafood, with produce from Douglas and wife Jackie Cross's own Prosser Farm. When Dahlia became a success, rather than simply cloning it, Douglas began to explore new concepts—creating Palace Kitchen, Lola, Serious Pie, Cantina Lena, and more, many of them within a few blocks of Dahlia Lounge, and Seatown Market next to Pike Place (*see previous section*).

Coronavirus put an end to indoor dining in 2020, and even the best restaurants were dealt a severe blow. In March of 2021, Douglas announced that Dahlia Lounge, then closed for a full year, would not be reopening with that name and menu, but two of his other restaurants—**Dahlia Bakery and Serious Pie** (a pizzeria) would be taking over the space.

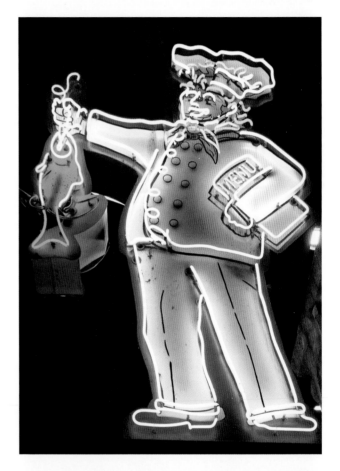

The neon chef, modeled on Chef Douglas himself, holds a fish with an animated tail that rapidly flips between three positions. (2001 4th Ave., tomdouglas.com, 1989)

After 19 years, **Icon Grill** was unceremoniously kicked out at the beginning of 2017, their attempts to renew the lease rejected by the landlord. The grill was then abandoned and boarded up. Icon had been known for their neon marquee, which occasionally displayed relevant messages—like, "Thanks, it's been a riot," after the 1999 WTO protests. The marquee appeared briefly on film in *Life or Something Like It* (2002), followed by a scene inside the grill, where Angelina Jolie's character receives an ominous sign of her own impending doom.

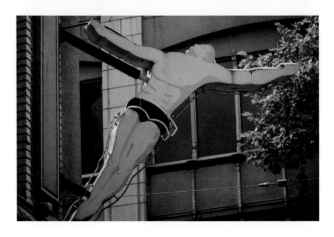

Icon's other neon art is a figure of a diving man. In the 1950s, neon divers were frequently

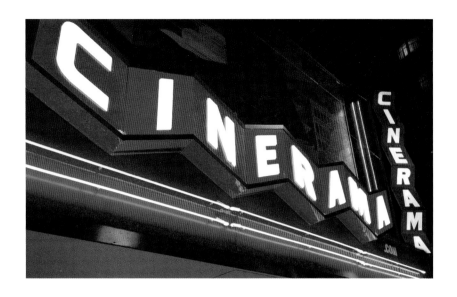

used by motels to advertise that they had a swimming pool (*see* Fremont *and* Ballard *for examples*), but these were invariably women—a male neon diver is a rarity. Three years after the grill's abrupt shutdown, the diver was still there, abandoned, but it disappeared by the summer of 2021. A 48-story residential and hotel tower is planned for the space. (formerly 1933 5th Ave., 1997)

Seattle Cinerama, then called **Seattle's Martin Cinerama**, was built to deliver the latest in movie projection technology, the Cinerama process, which used three perfectly synchronized projectors to illuminate a huge, deeply curved screen, providing filmgoers with a more immersive experience than ever before. But the format never became widespread, and as the popularity of suburban multiplexes grew in the 60s and 70s, Seattle Cinerama went into a long decline, poorly maintained and showing cheaper second-run films.

In 1997, when plans were announced to convert the decrepit theater to another use, Microsoft billionaire Paul Allen stepped in, purchasing and restoring Cinerama with new screens, a splendid new interior, and original movie costumes and props from Allen's personal collection on display in glass cases in the lobby. The new Cinerama would show classics as well as current releases, and became cherished by film enthusiasts. Just as well received was the concession stand's famous chocolate popcorn.

Paul Allen died in 2018, and without his stewardship, Cinerama's continued existence was no longer a certainty. The theater closed suddenly in early 2020, supposedly for another round of renovations. With Coronavirus entering the scene a month later, the work was canceled and the closure extended indefinitely. (2100 4th Ave., cinerama.com, 1963)

Quebec-born lumber baron Joseph Vance constructed a number of buildings in 1920s Seattle, including the Joseph Vance Building on 3rd Avenue, the Seattle Engineering School (later MarQueen Hotel) in Lower Queen Anne, and this ten-story Beaux Arts style hotel in the Denny Triangle. Originally to be called the Earl Hotel, after one of his sons, he instead used that name for another property and named this the **Vance Hotel**.

A rooftop neon sign originally read "VANCE HOTEL" in white letters outlined with magenta—"Vance" above

"Hotel," both words equal in size. The Vance rebranded as **Hotel Max** in 2005, updating the rooftop neon with the new name but keeping the classic look. Because the back side of the sign now faces a taller building, it is no longer illuminated and did not receive the full upgrade; the "Vance" was simply removed, leaving only "Hotel." (620 Stewart St., hotelmaxseattle.com, 1926)

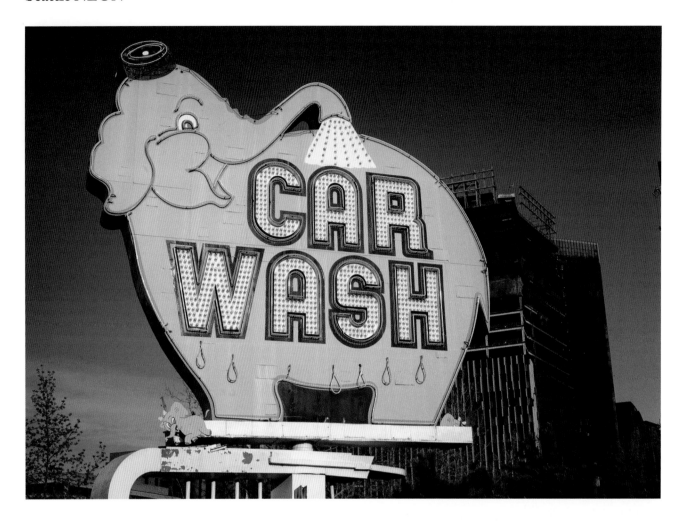

In November 2020, the best-known and best-loved neon sign in Seattle was cut in half, loaded onto a flatbed trailer, and removed from the corner of Denny and Battery where it had rotated for more than 60 years. The smaller neon elephant at the south end of the lot had been removed a few weeks before. Everything left behind was demolished.

Eldon Anderson; his wife, Virginia; and Eldon's brother, Dean, started **Five Minute Car Wash** in 1951 on 4th Avenue South (*see* Industrial District). Theirs was the first hands-free automated car wash anywhere—the Andersons are credited with inventing the system that pulled cars through the tunnel as water nozzles, soap dispensers, and big spinning brushes did all the work. In 1956, they opened their second car wash here in Belltown at a highly visible location, under the Post-Intelligencer neon globe and at the foot of Aurora Avenue. Younger brother

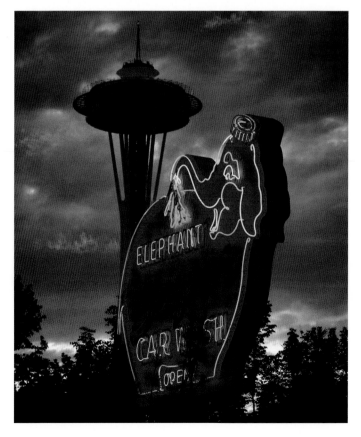

Archie Anderson had joined the company by then, and suggested a new name: **Elephant Car Wash,** because elephants could spray water with their trunks, and would be an eye-catching and memorable mascot.

To make the elephant idea a reality, the brothers engaged the Campbell Neon company and its lead designer, Bea Haverfield. Born Beatrice Kiva in 1913, Haverfield was by the 50s an experienced neon artist, having previously designed the Ivar's Acres of Clams, Dick's Drive-In, and Chubby & Tubby neon signs.

The big elephant sign would be Haverfield's greatest achievement, and had all the "bells and whistles" a neon fan could wish for. It was pink, a color chosen by the signmakers for its fun and whimsical connotations. The sign would rotate, displaying different designs on either side, with "CAR WASH" spelled out with hundreds of blinking light bulbs on one side, and "Elephant Super Car Wash" in pink, green, and orange neon on the other. And at the base, four tiny elephants two wearing bows—symbolized Bea's four children. At the south end of the lot, they placed another, smaller elephant, and another copy went on the roof of the original Industrial District car wash. Over the decades, more elephants were installed

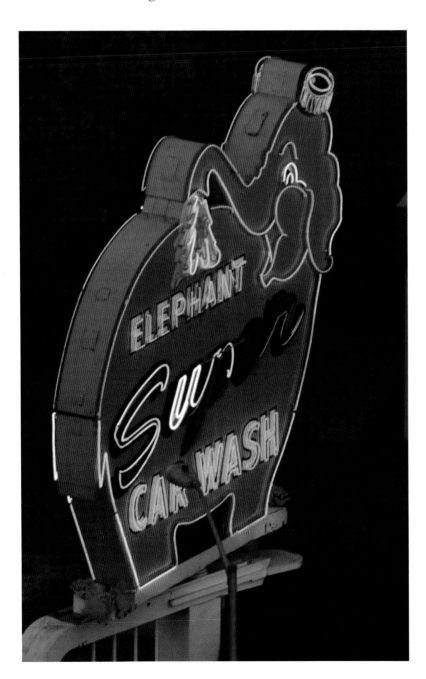

at their other locations in Western Washington, and one notable location further away—Rancho Mirage, California. This one still stands, but new owners have replaced the pink neon with blue and changed the text to "Rancho Super Car Wash."

Elephant Car Wash closed their Belltown location in 2020, citing the high cost of doing business there. Their original 4th Avenue South car wash closed in July 2021. They remain active at multiple suburban locations. Bea Haverfield retired from the neon business in 1968 after injuries from a car accident made the work difficult; she died at age 83 in 1996.

Both of Belltown's neon elephants will be on display again, not far from their historic locations. After removal from the car wash site, they were taken to Western Neon's workshop for restoration. Although full details are not yet available, the smaller elephant will likely be installed in the lobby of a nearby office building. The big elephant, the only one of its kind, was donated to the Museum of History and Industry (*see* South Lake Union *in* Cascade) and will be a welcome addition to their collection of Seattle artifacts. (formerly 616 Battery St., elephantcarwash. com, 1956)

4.

Cascade

Westlake

National Sign Corporation has been in the sign-making business for over 100 years, much of their output involving neon. They've worked on historic and iconic Seattle neon, including the many pieces at Miner's Landing, the Robbins Brothers diamond, the Public Market sign at Pike Place, Capital Industries, Majestic Bay Theatre, Franz Bread, and the Met's Christmas display.

The sign over their own door on Westlake Avenue is new, installed for National Sign's 2015 centennial. In addition to neon letters in a stylish Art Deco font, it features a color-cycling LED skyline and a clock with illuminated hour and minute hands, making it a showcase piece for the multiple technologies they offer. To see the other neon sign prepared for their anniversary festivities, you'll have to go across the street and look into an upper-story window. (1255 Westlake Ave. N., nationalsigncorp.com, 1915)

Marina Mart offers boat moorage with all the amenities—shore power, running water, storage lockers, and showers—plus shops and office space. The mart's central tower was designed as a lighthouse, with

red and green lights imitating channel markers, and neon on the three landward sides. (1530 Westlake Ave. N., marinamart.com, 1941)

Formerly Dexter and Hayes Public House (named for the street corner), this little brick building now sells intoxication of a different sort as **Pot Shop Seattle**. (1628 Dexter Ave. N., potshopseattle.co, 2016)

China Harbor Restaurant occupies an enormous building on pilings over the water of

Lake Union, originally constructed in 1961 for Seattle Elks Lodge No. 92. In 1994, the Elks departed for a new home in Lower Queen Anne, as their former home was clad in dramatic black tile and red neon and became China Harbor. The restaurant includes a huge dining room with a view of the lake and two ballrooms for private events with up to 500 guests. (2040 Westlake Ave. N., china-harborseattle.com, 1994)

South Lake Union

In the year of the Century 21 Exposition, the Imperial 400 Motel opened in a prime location three blocks from the Seattle Center campus and the Space Needle. The hotel chain did not survive the 1960s, and their Seattle motel changed hands several times, eventually becoming the Seattle Pacific Hotel. In the late 2010s, the then run-down hotel closed for an extensive multi-year renovation project, coinciding with the city's own major construction work that tore up Aurora Avenue to build the entrance and ventilation system of the State Route 99 Tunnel.

The new owners, the Nariya family, hired architects and artists to redesign and rebuild in a way that would celebrate its 1962 origin and World's Fair connection. Though fully modernized, the Civic Hotel uses design elements from the sixties, with furniture in the Mid-Century Modern style, bright bold colors, and rotary-dial telephones (albeit with modern electronics) in the guest rooms. Neon, of course, was the perfect crowning touch. Looming behind the neon sign are the ventilation stacks, illuminated by color-cycling floodlights, that remove vehicle exhaust gases from the tunnel. (325 7th Ave. N., civicseattle.com, 1962)

Fat City European Auto Repair was built in 1914 as Chief Seattle Garage, with the then-innovative feature of an L-shaped interior with entrance at one end and exit at the other, so that customer cars would not have to turn around or drive in reverse.

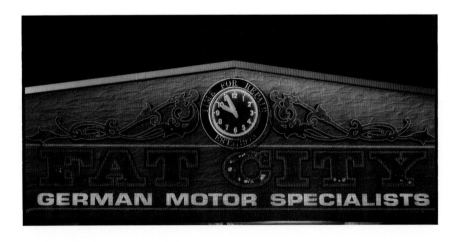

Though in the path of the Seattle Center Monorail when the elevated railway was built in 1962, the garage escaped demolition by being small enough to fit under the tracks, which pass over a corner of the roof. The building eventually became a paint shop before being acquired by Fat City in 1994, extensively modernized, and returned to its original function as a mechanic's workshop. (508 Denny Way, fatcity.net, 1994)

Troy Laundry provided dry-cleaning services until it shut down in 1985, selling their 1927 brick and terra cotta building to the Seattle Times. The building was sold again in 2011 to developers who then gutted it but preserved the landmark facade, using it to shelter a pedestrian walkway that leads to the entrances of the two skyscrapers built on the site. Troy Laundry's rooftop neon sign was repaired and relocated indoors, suspended from the former laundry's ceiling. Much of the Troy Block complex is now Amazon office space. (300 Boren Ave. N., troyblockseattle.com, 1927)

Located in the former Naval Reserve Armory on the south shore of Lake Union, the **Museum of History and Industry (MOHAI)** is preserving Seattle's history by safeguarding several neon treasures. Rainier Brewery's original neon "R" may be found inside, occupying a preeminent position atop a tower of exhibits at one end of the Grand Atrium. This steel sign, 12 feet tall, stood over the brewery next to Interstate 5 from 1953 to 1999, but was removed when the brewery was sold and became a Tully's Coffee roasting plant. Western Neon restored the badly damaged sign after its removal, repairing crushed legs and patching several bullet holes, after which it was brought to the museum. The sign presently atop the former brewery is a replica (*see* International District).

MOHAI has several other historic neon signs in their collection, including the Klose-In Motel from Aurora Avenue and Bob Murray's Dog House, but these are not currently on public display. In 2020, MOHAI acquired the Elephant Car Wash sign (*see* Belltown), which is presently being restored by Western Neon for future display. Their greatest challenge will be relocating and restoring the Post-Intelligencer Globe from its present home on the waterfront (*see* Interbay). The museum has expressed an interest in acquiring the globe, but transportation and restoration are immense. (860 Terry Ave. N., mohai.org, 2012)

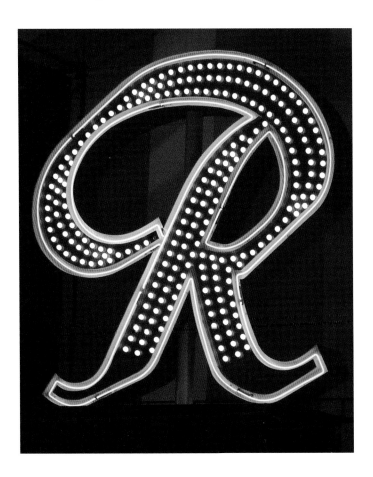

The "Blue Flame Building" on Mercer was the headquarters of **Washington Natural Gas Company** from 1964 until 1997, when they became part of Puget Sound Energy (PSE). Atop the four-story Brutalist concrete building stood a 26-foot-tall rotating flame, illuminated with 180 blue neon tubes and 660 white light bulbs. Upon selling the building and departing the site in 2001, PSE removed the neon and donated it to MOHAI, which intended then to put it on display. But as MOHAI were themselves about to move to a new location, this plan flickered out, and in 2010 they gave the flame back to the power company.

The former gas company headquarters is now the Brotman Building, part of the University of Washington's biomedical research complex. As of 2021, the flame is in storage at a PSE facility in Georgetown. While it is safe and intact, there are presently no plans for public display. (formerly 815 Mercer Street, pse.com, 1964)

Eastlake

Patrick's Fly Shop is named for its original owner, Roy Patrick, author of *Tie Your Own Flies*. They sell all the equipment a fly fisher needs, from rods and reels to wading pants, and offer classes in fly tying and casting as well as multi-day expeditions to fly-fishing destinations alongside expert instructors. (2237 Eastlake Ave. E., patricksflyshop.com, 1946)

Chef Antolin Blanco of Barcelona came to Seattle in 1993, opening **Pomodoro Ristorante**. The restaurant takes its name from the Italian word for "tomato" and features twin neon signs, one at either end of the canopy. (2366 Eastlake Ave. E., pomodoro.net, 1995)

At **Little Water Cantina**, the neon sign includes arrows that light up in sequence, pointing the way to the patio. If you prefer to sit inside, you can instead admire the glowing wall of 800 recycled tequila bottles. (2865 Eastlake Ave. E., littlewatercantina.com, 2011)

Eastlake Bar & Grill features American cuisine, a patio with potted palm trees and a thatched outdoor bar, and views of Lake Union. (2947 Eastlake Ave. E., neighborhoodgrills.com, 2004)

You'll find two neon signs at **Lake Union Cafe**. Large letters on the rooftop could once be seen across the water, but this fixture has

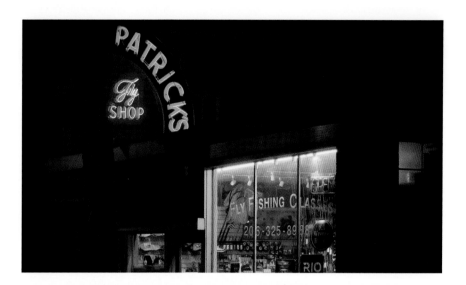

not been working for many years. On the front of the building is another neon sign, a favorite backdrop for newly married couples posing for photos—for the cafe is now a private event space, open for business only when a wedding reception or corporate event is scheduled. That's also the only time you'll find this neon lit up, so try a Friday or Saturday evening in the summer if you want to see it in action. (3119 Eastlake Ave. E., lakeunioncafe.com, 1927)

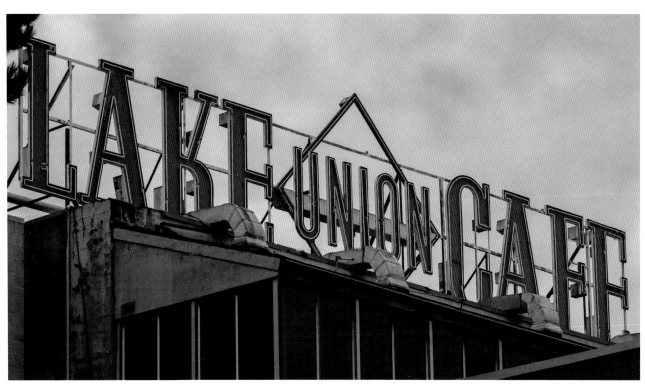

5.
Capitol Hill

Broadway

Stately Corinthian columns are certainly an unusual choice for a bar entrance, but they make a bit more sense at a funeral home. What is now **The Pine Box** was built in 1923 as the new home of the **E.R. Butterworth & Sons** funeral business. Edgar Ray Butterworth, hatmaker, lawyer, and cattleman, entered the funeral trade in 1870s Kansas by happenstance, when he hastily crafted a coffin for a stranger's wife and child using his own wagon as a source of lumber. Settling in Washington, he prospered as a coffin maker, eventually purchasing an undertaking business.

Butterworth was an innovator and funeral pioneer, an early adopter of embalming techniques, a popularizer of open casket services and limousine motor hearses, and among the first to use the newfangled words *mortuary* and *mortician*. In 1923, two years after Edgar's death, his five sons moved the family mortuary from their original 1st Avenue building (now Kells Irish Pub) to this Capitol Hill location. The new building was posh and state-of-the-art, with onsite crematory and columbarium, luxurious furnishings and interior details, a 150-seat chapel with pipe organ and choir loft, leaded glass windows, and elegant dark woodwork. The funerals of many of Seattle's most prominent citizens were held here, including action movie hero Bruce Lee in 1973.

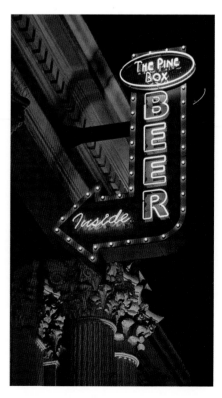

A national conglomerate purchased the Butterworth funeral home in 1998, putting an end to 112 years as a family-run business. They sold the building a few years later, and much of it was then converted to office use. Butterworth's chapel became **The Chapel Bar** from about 2003 to 2011. In 2012, The Pine Box took over the space, purging the "German disco" stylings of the Chapel Bar for a look more harmonious with the building and its original purpose—crafting their bar, tables, and church-pew seats using reclaimed wood from the mortuary's work area below the stairs. The arched ceilings, choir loft, ornate woodwork, chandeliers, and light fixtures have all been lovingly preserved. (1600 Melrose Ave., pineboxbar.com, 2012)

Cannabis vendor **Uncle Ike's** opened their fifth dispensary (their second on Capitol Hill) here in 2020. The rooftop sign, created by Western Neon, uses an uncommon technique in which the open end of a glass tube with a fluorescent coating in one color is welded to the open end of a tube with a different coating, allowing the same argon gas to glow in different colors along the tube's length. Like all of Uncle Ike's signs, the lettering is based on the handwriting of pioneering neon artist Bea Haverfield.

(1411 E. Olive Way, ikes.com, 2020)

Originally built as a tire shop in 1919, this building had to have a corner lopped off in the 1920s as Olive Way was rerouted up the hill. In 1924, it became a grocery store, McRae's Public Market, with several ownership and name changes over the decades to come. In the 1980s, it was Malstrom's Market, with video rentals a major draw. Eventually it became City Market, part of a regional chain now owned by Kroger. (1722 Bellevue Ave. E., citymarket.com, ca. 1990)

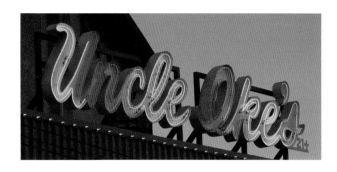

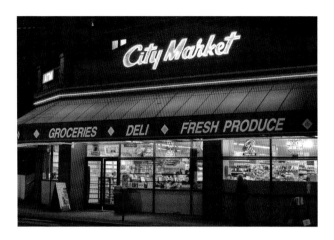

Like all the best used bookshops, **Twice Sold Tales** has cats—currently there are four of them, living in a maze of floor-to-ceiling bookshelves densely packed with an estimated 40,000 volumes. Jamie Lutton started selling books from a cart at Broadway Market in 1987, opening a full-size bookshop at Broadway and John in 1990. When that location was condemned for the impending construction of the Capitol Hill light rail station in 2008, Lutton moved her books and her cats to a former dental office two blocks away, the shop's present home. Look for an engraved brass plaque on a closet door inside, dedicating "the contents of this catbox" to a particular newspaper editor who wrote an uncomplimentary review of the shop back in 2003. (1833 Harvard Ave., twicesoldtales.com, 1990)

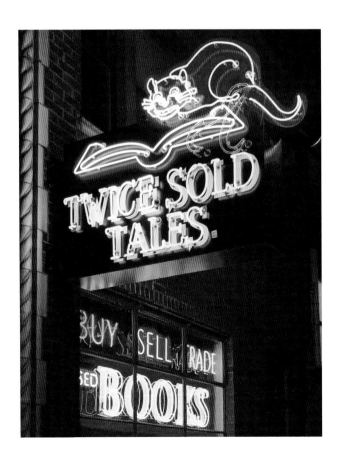

In 1975, Darryl MacDonald and Dan Ireland leased the historic Moore Theatre (*see* Belltown), spruced it up, and called it "The Moore-Egyptian" as a homage to the many faux-Egyptian theatres of the 1930s. Cinema enthusiasts with a taste for foreign and classic films, the following year they and Jim Duncan started the Seattle International Film Festival, an event that ran for two weeks at the Moore in May of 1976. The annual festival quickly grew in popularity and prestige—the fourth festival, in 1979, opened with the world premiere of *Alien*.

When the Moore canceled their lease in 1981, Ireland and MacDonald picked up their equipment and their Egyptian decor and relocated to this former Masonic Temple on Capitol Hill, renaming it "The Egyptian." Now called **SIFF Cinema Egyptian** and offering year-round SIFF programming, the theatre is one of three permanent homes for the festival—another is the historic Uptown Theatre (*see* Queen Anne). Look for two identical "Egyptian" neon signs on either side of the ornate entrance, and a "Cafe Cairo"

neon at the concession stand inside. (805 E. Pine St., siff.net, 1981)

The brilliant multicolored neon palette and tube of paint hang over the sidewalk at **Blick Art Materials,** part of a national art supply company that's been in business since 1911. Blick occupies the entire ground floor of a 1925 Chrysler dealership, a terra cotta building with huge arched windows, that provided auto sales and service until 1989. In 1997, when the building housed a record store, a life-size bronze statue of Seattle native Jimi Hendrix was installed on the sidewalk in front. Though the music store moved, Jimi is still there. (1600 Broadway, dickblick.com, 2010)

Century Ballroom offers ballroom dance classes and events—swing, tango, waltz, foxtrot, and more. Owner Hallie Kuperman has been teaching dance since 1991, and also manages a restaurant in the same building, The Tin Table, which provides food for the ballroom's dine-in events.

Those in need of additional dance instruction should consult the sidewalk at Broadway and Pine, one block west. There, you'll find a large number of bronze footprints inlaid in the concrete, illustrating eight different dance steps; this is a publicly funded 1982 work by artist Jack Mackie, called *Dancers Series: Steps.* (915 E. Pine St., centuryballroom.com, 1997)

24-hour diner **Lost Lake Cafe & Lounge** opened in 2013 in the same 100-year-old building as Comet Tavern (*see next entry*). They serve breakfast all day, traditional American diner food with a large selection of vegan and vegetarian alternatives, beer, wine, and cocktails. Inside, the space is divided into a bright and modern restaurant section and a boozier lounge area with wood-paneled walls, landscape paintings, and taxidermied animals. Lost

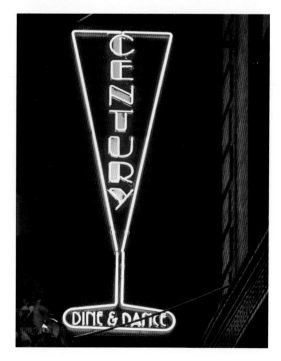

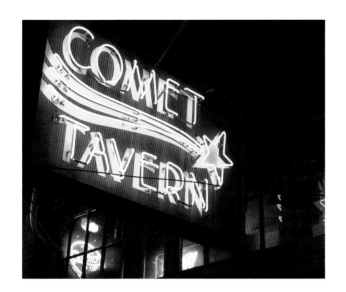

Lake also includes a Twin Peaks styled bathroom with red walls, black fixtures, and black and white zigzag tile floor. (1505 10th Ave., lostlakecafe.com, 2013)

Grungy old **Comet Tavern** had a long-standing reputation as a filthy dive when it shut down in 2013, likely due to money troubles. Originally an Irish bar called "The Wee Dock and Doris," this became Comet Tavern in the 1950s. By the 60s, its windows would be painted black, providing patrons with a dark and hidden refuge. In 1976, the tavern expanded into the adjacent corner storefront, formerly a hardware store.

After its abrupt shutdown, Comet Tavern was purchased by the owners of Lost Lake, which had recently opened on another side of the same building, fixed up, and given a good scrubbing. Neon enthusiasts will be pleased to find the usual beer logo signs inside, a large "Cocktails" sign over the bar, and something really special: a 7-foot neon "C" on the wall,

part of the original 1930s Public Market Center sign at Pike Place Market, given to the Comet after it was replaced in 1998. (922 E. Pike St., thecomettavern.com, circa 1953)

The old **Poquito de Mexico** restaurant was fondly remembered for the tree growing through the dining room and for its owner, Hugh Pankey, who would walk among the guests while strumming his guitar. A native of San Antonio, "Hoss" Pankey brought his version of Tex-Mex cuisine to Seattle, operating the original Poquito at 8202 Greenwood Ave. N. from 1962 until the 1980s. Decades later, the neon sign was rescued and restored, inspiring the name of the new **Poquitos** on Capitol Hill. They've since opened a second location in Bothell, with a neon sign that's a faithful replica of Hugh's original. (1000 E. Pike St., vivapoquitos.com, 2011)

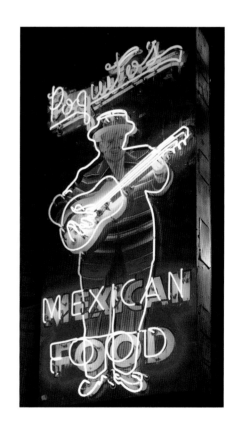

Three friends, none of them named Rudy, started **Rudy's Barbershop** to be as much a hangout as a barber and tattoo shop. As the founders were brainstorming names, a graffiti artist they'd hired suggested "Rudy's," for the orange-hat-wearing friend of *Fat Albert*, then proceeded to spray paint the name in big black letters on the wall.

The concept (minus the tattoo part, which was quickly dropped) caught on, and Rudy's rapidly expanded, opening additional locations around Seattle and other cities (*see also* West Seattle). But to do this they'd had to make a deal with the devil—a venture capital firm that brought

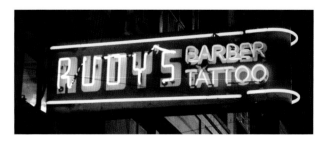

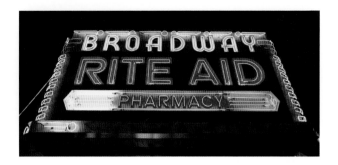

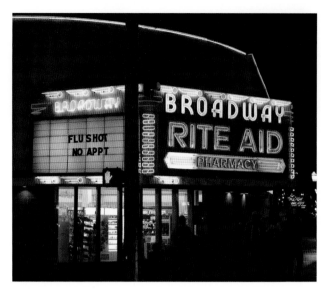

big money and bad ideas. After the corporate overlords drove Rudy's to bankruptcy in 2020, the two surviving founders and their accountant pulled off a daring rescue operation—beating the capitalists in bankruptcy court and buying their company back. (614 E. Pine St., rudysbarbershop.com, 1993)

Not your ordinary national chain drugstore, **Broadway Rite Aid** includes a neon marquee, a relic of the building's original use. The Society Theatre opened here in 1911, offering "high class photoplays, singing, and music," and was one of the first theatres equipped with a soundproof "cry room" where mothers could care for screaming infants and still see the screen. The Society Theatre became **Broadway Theatre** in 1921. By 1935, the entrance had been moved from the east face to the southeast corner, over which hung a vertical neon sign. This was replaced with the spectacular neon marquee in the late 1940s, with "Broadway" across the center and a larger neon "B" over each side panel.

Facing competition from the new Capitol Hill Cinemas at Broadway Market, Broadway Theatre shut down in 1990. Seattle drugstore chain Pay 'n Save, which occupied an adjacent storefront, announced plans to expand into the former theatre space. As Pay 'n Save became Rite Aid, the marquee was reworked with new neon for the new name—but keeping the original "Broadway" intact. (201 Broadway E., riteaid.com, 1911)

Neon outlines the roof of **Broadway Place**, a commercial building adjoining Rite Aid. The lettering style and random lines and curves are reminiscent of 1980s video cassette packaging. Under the neon are two restaurants and two shops, including Trendy Wendy. (209–215 Broadway E., ca. 1980s)

Trendy Wendy sells "all things glamorous and fun"—club, rave, drag, burlesque, and fetish wear for a wide range of body sizes. The owners of **Trendy Wendy** have been on Capitol Hill since 1992, operating Broadway Boutique and Rockin' Betty's, consolidating the three shops into this one when forced out by new construction. (211 Broadway E., 2002)

Julia's on Broadway is home to Le Faux,

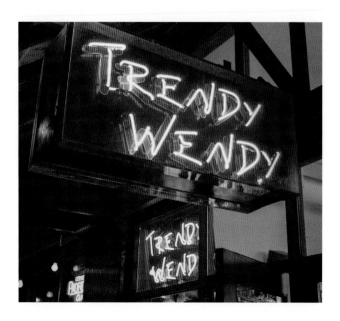

Seattle's longest running drag show and the largest celebrity impersonation show in the country, with world-class talent and Vegas-level costumes and production values. Some of their performers have appeared on *RuPaul's Drag Race*, with former Le Faux host Jinkx Monsoon winning season five's contest. The venue is named for Julia Miller, who started the first Julia's restaurant on Eastlake Avenue in 1978, selling to former employee Karsten Betd and Le Faux producer, Eladio Preciado, in the 1990s. Betd and Preciado opened the Broadway location in 2001. (300 Broadway E., juliasonbroadway.com, 2001)

In 1928, Arthur Gerbel built **Broadway Central Market** as a public market, much like the more famous Pike Place Market, with independent vendors to provide everything a neighborhood resident could want. It immediately went bankrupt, and the owners of the land underneath took possession, sim-

plifying the name to **Broadway Market**. In 1935, they added a huge neon sign reading "Broadway Market" vertically, with a thermometer between the words and a large neon clock at the bottom.

Public markets declined in the 1950s and 1960s as consumers switched to supermarkets. In the 1970s, Broadway Market became a Fred Meyer store, with the beautiful brick and terra cotta facade hidden beneath a layer of stucco. In 1986, new owners restored the building to its original appearance and purpose, though the giant neon sign was gone; a much smaller neon clock, mounted at the same location, replaced it. The building now includes a QFC supermarket, a second-floor gym, and a number of independent shops—if you go inside, look for a "Broadway Shoe Repair" neon on an interior wall. (401 Broadway E., regencycenters.com, 1928)

The neon sign over **Top Pot Doughnuts**, which predates the business, originally belonged to "Top Spot," a defunct Chinese restaurant in Columbia City. Brothers Mark and Michael Klebeck, who were planning a new doughnut shop and hadn't yet decided on a name, thought "Top Spot" would work, purchased the sign, and loaded it onto a pickup truck. The neon "S" did not survive the trip, so the entrepreneurs adapted and made it "Top Pot" instead. A rotating neon coffee pot replaced the "S" at the center. "Coffee shop, doughnuts, pastries" on the lower portion completed the refit. (609 Summit Ave. E., toppotdoughnuts.com, 2002)

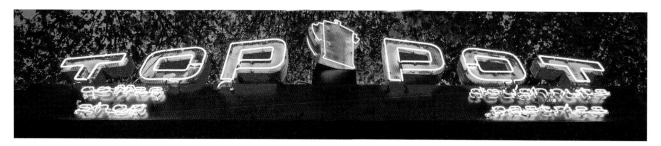

Stevens

The red chairs in the waiting area at **The Red Chair Salon** are from another "Seattle Original," the Cinerama Theater (*see* Belltown). Howie and Amy Sennet purchased the row of connected seats after Paul Allen's renovation of the historic 1963 cinema, placing them in their new hair salon in 2009. Another popular fixture here is their Labrador, Sidney, whose job duties include "Lunch Supervisor."

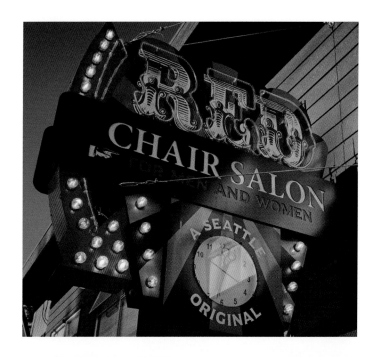

Red Chair Salon's neon sign was created from an earlier sign at the same location, advertising a jewelry shop, Diamonds, Sapphires & Rubies, Inc. This sign originally read "JEWELRY" in neon on the horizontal bar over the clock. The arrow, the "RED," and the many light bulbs were added by the salon. (324 15th Ave. E., redchairrocks.com, 2009)

An independent cooperative grocery, **Central Co-Op** started in 1978 at 12th and Denny. They built their current store on Madison Street in 1999, symbolically transferring their "culture" by carrying a tub of live yogurt seven blocks to the new location. They adopted the fork logo, shown on the neon, in the late 2000s. (1600 E. Madison St., central-coop.coop, 1978)

The Bottleneck Lounge describes itself as "on the backside of Capitol Hill"— it's on the eastern slope, away from downtown and the trendy Broadway neighborhood. Look inside for a prominently placed neon sign advertising Leinenkugel's, a Wisconsin beer that's uncommon here in Washington. According to the Bottleneck's menu, they've always got one of a rotating selection of Leinie's on hand. (2328 E. Madison St., bottlenecklounge.com, 2007)

Montlake

Cuore dell' Amante, or "Heart of the Lover," is the full name of **Amante Pizza & Pasta**. Formerly located at Olive and Denny, in the building now occupied by The Reef Cannabis, Amante was infamous for a video screen that vexed neighbors with rapidly changing messages and flashing lights, until the city demanded they tone it down. In 2018, they moved to a quieter neighborhood, dropping the video screen but keeping the neon chef. In one hand he holds a pizza, in the other, a dish of pasta, hot and steaming. (2357 10th Ave. E., amantepizzapasta.com, 2018)

Tuscan-born Carla Leonardi came to America as a small child, growing up with her parents' Italian home cooking. When she married Jordi Viladas, who had always wanted to run a restaurant, they made the leap to Seattle with this goal. They had a vision of a perfect restaurant, a one-story building made out of brick, and in 1990 found such a place available in Montlake, renting one of its three storefronts.

Jordi's mother, Ange, joined their kitchen as cook. With pasta made fresh every day, and an applewood-fueled pizza oven, **Cafe Lago** was an immediate success, as customers lined up outside for the next table. Within two years they were able to expand into the adjacent space, more than doubling capacity, and in 1998, they took over the entire building. In all this time, the menu has changed very little—the same classic dishes are ever popular. (2305 24th Ave. E., cafelago.com, 1990)

Montlake Boulevard Market should not have had to close. As the only grocery store, deli, and gas station in Montlake, it was successful and well liked by residents, who considered it the heart of the

community. Bureaucrats with spreadsheets saw it differently, as the Washington State Department of Transportation (WSDOT) realized they could shave ten million dollars from the cost of widening State Route 520 by demolishing the market and using the land as a staging area for construction equipment. In 2019, at the end of a three-year legal battle, the family-owned supermarket and their supporters in the Montlake community were defeated; the state purchased the land, shut down the market, and demolished the building. (formerly 2605 22nd Ave. E., 1936)

Portage Bay

Born in a small town in then-communist Poland, Kamila Kanczugowski learned to cook from her mother and aunt. Leaving for better opportunities abroad, she emigrated to Italy, there learning Italian recipes and the restaurant business. Kanczugowski now cooks her native cuisine as head chef and owner of **Sebi's Bistro**, which features Polish specialties such as cabbage rolls, crepes, pierogi, and hunter's stew, plus German and Italian dishes.

Sebi's Bistro occupies the ground floor of the Martello, a historic 1916 mansion built in the French château style, with a steeply angled roof and a corner tower. Before it was Sebi's, the space was Romio's Pizza and Pasta, and a neon chef over the entrance held a neon pizza while making the "chef's kiss" gesture. Before this, it was Rapunzel's, a favorite neighborhood tavern. And another piece of Seattle restaurant history was just across the street, the original Red Robin Gourmet Burgers, now demolished. (3242 Eastlake Ave. E., sebisbistro.com, 2013)

Madison Park

Bert Croshaw opened his Madison Park grocery store in 1937, one block from its present location. He moved it here in 1949, and it has remained in the family ever since, with son Roger at the helm for more than 55 years. Now known as **Bert's Red Apple Market**, it's one of three independently-owned Red Apple Markets in Seattle, and uses a neon rendition of the association's logo. (1801 41st Ave. E., bertsredapple.com, 1937)

6.

Central Area

Atlantic

Memorable to many as the restaurant shaped like a boat, **Pho Bac Sup Shop** recently expanded into a much larger space just across the parking lot. Seattle's first pho restaurant started out in 1982 as Cat's Submarine, where Vietnamese immigrants Theresa Cat Vu and husband Augustine Nien Pham sold American-style cold-cut sandwiches. On weekends, when Vietnamese people came to the neighborhood to do their shopping, Cat would make a huge pot of the traditional beef and noodle soup. Within a year, customers were asking for pho every day, and the restaurant changed its menu and its name. You'll find this delicious "Phocific Northwest" sign (with neon noodles dangling from neon chopsticks) on an interior wall of the dining room. (1240 S. Jackson St., thephobac.com, 1982)

Ford Goebel and Walt Kummerfelt purchased **Budd & Company Automotive** on Capitol Hill in 1952. Walt left the business a few years later, and it's been in the Goebel family ever since, managed now by Ford's grandson Mike. They moved to this Rainier Avenue workshop in 1979. Budd's neon sign includes a rotating section above the company name, displaying "Auto Repair" on one side and a 50s-era car on the other. (800 Rainier Ave. S., buddandcompany.com, 1952)

In 1952, **Wonder Bread** installed this 40-foot-wide neon sign atop a tower of steel girders over their 1916 factory. Its warm glow, visible from miles away, made the sign a familiar neighborhood landmark for decades. When the factory shut down in the late 1990s, the sign went dark, and local activists debated what to do. Some suggested it be given to the nearby Pratt Fine Arts Center, a non-profit, or that the "BREAD" (minus the "B") be placed at a school or library.

Legacy Residential purchased the derelict property in 2006, intending to raze the factory and build a six-story apartment building. Demonstrating an uncommon respect for the site's history, they salvaged the neon letters and engaged Western Neon to do more than 500 hours of restoration work. Contacting the Wonder Bread trademark owners, the developers received permission to light and display the sign again. In July 2009, it was hoisted by crane and installed on the roof of the new apartment building, now

known as **Pratt Park Apartments**. To complement the sign, structures on the roof (not visible from the ground) are painted white with blue, yellow, and red circles, in the style of Wonder Bread packaging. (1800 S. Jackson St., securityproperties.com, 1916)

Vietnamese restaurant **Moonlight Cafe** is widely praised for their huge vegan menu, with a stunning variety of plant-based meat substitutes, including mock lobster, pork, and beef. But they're not actually a vegan restaurant as they have an equally extensive non-veg menu as well. Inside you'll find an abstract neon artwork, a multicolored bundle of twisting and bent tubes, across the dining room wall. (1919 S. Jackson St., moonlightcafeseattle.com, 1995)

The intersection of 23rd and Jackson was suffering from an image problem in the 1990s. Prome-nade 23, the 1970s shopping center straddling 23rd on the south side of Jackson, had failed to attract anchor stores to the economically depressed neighborhood. The non-profit Central Area Development Association (CADA) thought a nationally-known coffee house could make this a pedestrian-friendly destination, but their overtures were turned down by all of them, as the location appeared unprofitable.

Undeterred, CADA constructed a small but elegant brick building with a tower on the highly visible north-east corner. Approaching the national chains again, they finally received a "yes" from Seattle's own **Starbucks Coffee**, who were doubtful of the financials but impressed by the non-profit's persistence. The coffee giant set up shop in the corner building in 1997, its first cafe in the Central Area.

As a show piece for community reinvigoration, this Starbucks also celebrates the history of Jackson Street, the center of Jazz in Seattle in the 1920s to 1940s. A neon note on the clock tower is flanked by neon saxophonists, who represent all of early twentieth-century Seattle's jazz scene rather than any specific performer. Inside, photos of African-American musicians who played the many jazz clubs on Jackson adorn the walls, some of them shot by renowned Jazz Age photographer Al Smith. (2300 S. Jackson St., cada.org and starbucks.com, 1997)

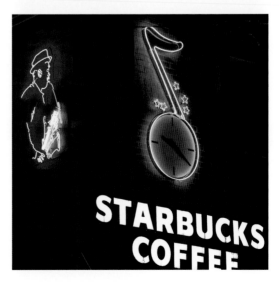

Leschi

Central Pizza is unabashedly Italian-American rather than Old World–Italian in style, serving pizza with a thin crispy crust, the slices big enough to fold in your hands. The three founders consider themselves bartenders and pizza enthusiasts, not chefs, but they put in their time to thoroughly test and tweak the recipe. They sell pizza by the slice, and it's a neon pizza slice you'll find over the front door. (2901 S. Jackson St., centralpizzaseattle.com, 2013)

Industry veterans Bart Evans and Dan Anderson started BluWater Bistro in South Lake Union in 1997 as an affordably-priced neighborhood grill. For their third location, an old friend and former employer offered an idea—they could take over the 22-year-old Leschi Lakecafe, in a beautiful quiet spot on the shore of Lake Washington. After renovations that included knocking down interior walls to open up better views of the water, it became **BluWater Bistro Leschi**. (102 Lakeside Ave., bluwaterbistro.com, 2004)

Madrona

Former Starbucks marketing manager Jody Hall started **Verite Coffee** in Madrona in 2003. Wanting something unique to go with the coffee, Hall found inspiration on a trip to New York City, there discovering a bakery with amazing cupcakes. Using some old family recipes, Hall began making and selling cupcakes at the Madrona coffee shop, which became the first cupcake specialty bakery in the West. The elaborately decorated little cakes were a smashing success, and **Cupcake Royale** took off—only ten months later, Hall was able to open a second location in Ballard.

Cupcake Royale now has five locations around Seattle, serving cupcakes baked on Capitol Hill, Stumptown Coffee from Portland, and fresh ice cream made with local ingredients. Jody Hall has been hard at work on new ventures: The Goodship, a premium cannabis edibles confectionery, and Wunderground Coffee, which combines coffee with adaptogenic mushrooms. (1101 34th Ave., cupcakeroyale. com, 2003)

The Madrona location of **Molly Moon's Homemade Ice Cream** was the first of the local chain's "micro shops," sharing space with the **Madrona Laundromat** (look for the "Laundromat" neon sign in an upper window). With no space for a kitchen, the little shop serves ice cream made at the Capitol Hill store.

Eponymous founder Molly Moon Neitzel opened her first ice creamery in Wallingford in 2008, soon expanding throughout Seattle and Bellevue. Most of these shops have identical neon signs with this design featuring Parker Posey, Molly's French bulldog/Boston terrier mix. (1408 34th Ave., mollymoon. com, 2011)

Harrison / Denny-Blaine

Chef Laurent Gabrel's **Voila! Bistrot** is an authentic Parisian bistro, small and casual. They have the requisite onion soup and mussels and crêpes, of course, but reviewers are especially enamored of the Kobe beef burger with brie and caramelized onions. (2805 E. Madison St., voila-bistrot.com, 2004)

An Italian restaurant featuring the recipes of Tuscany and the ingredients of the Northwest, **Bar Cantinetta** now has three locations around Seattle. (2811 E. Madison St., barcantinetta.com, 2013)

In 1991, David Foecke and two friends bought an abandoned 1940s laundromat building with a goal of creating Seattle's finest all-vegetarian restaurant, **Cafe Flora**. With an emphasis on organic and sustainable produce sourced from local farms, they succeeded. In 2009, Foecke sold the restaurant to his hand-picked successor, general manager Nat Stratton-Clarke, chosen as someone who would continue to uphold their principles of community involvement, relationships with farmers, environmentally sustainable practices, and showcasing the best vegetarian and vegan food from around the world. In 2017, Cafe Flora created Floret, the first vegetarian restaurant at SeaTac airport, and in 2021 they opened a bakery, The Flora Bakehouse on Beacon Hill. (2901 E. Madison St., cafeflora.com, 1991)

Mann

Schoolteachers Marybeth Satterlee and Greg Ewert founded non-profit **Coyote Central** in 1986, organizing events to stimulate middle-school kids' creativity. They connected with teachers and experts in various fields—art, photography, architecture, computers, and the sciences (Bill Nye, the Science Guy, taught for them). Originally, these meetings took place in the teachers' homes or the home of a parent, but in 2011 they acquired their dedicated permanent learning space. (2300 E. Cherry St., coyotecentral.org, 1986)

Ian Karl Eisenberg, who prefers to go by "Ike," is Seattle's "King of Pot," a headstrong and controversial businessman who always seems to draw the ire of neighbors and community activists. When recreational marijuana was first legalized in this state, Ike—whose fortune came from the phone sex industry, practically invented by his father—paid a huge undisclosed sum for a license to operate a dispensary, then raced to set it up on a piece of property he already owned, a dilapidated sandwich shop. Incensed, the pastor of the church next door filed multiple lawsuits to stop the project, but ultimately gave up, and in September 2014, **Uncle Ike's** became the second recreational cannabis shop in Seattle.

This is Uncle Ike's flagship store, occupying multiple buildings on the corner lot, all with a wealth of neon. Vintage drugstore

signs decorate the corporate offices, set apart from the retail areas by a tall security fence. The small building in front housed the "Glass & Goods" shop, where customers could purchase such apparatus as vaporizers and bongs, but this unprofitable concept gave way to a liquor store in 2021. Uncle Ike's logo appears here as two large white neon signs, with a lettering style inspired by the 1950s neon art of Bea Haverfield. (1400 23rd Ave., ikes.com, 2014)

Sea Suds Car Wash, already owned by Ike Eisenberg, rebranded as **Uncle Ike's Car Wash** a few years ago, with new neon to match his weed shop a block away. (1426 23rd Ave., 2012)

With so many people in the vicinity afflicted with "the munchies," a bakery that specializes in cookies fits right in. Pastry chef Emily Allport sold cookies at farmers' markets and pop-ups around Seattle for two years before setting up the **Lowrider Baking Company** retail shop, named for her two dachshunds. (2407 E. Union St., lowrider-cookiecompany.com, 2019)

Created with a goal of being "neighborly," **Ponder Cannabis Shop** is a bit different from other pot purveyors. Ponder is medically licensed, with certified medical cannabis consultants on hand to give advice. Reviewers describe it as feeling more like a traditional apothecary or herbalist than like an ordinary recreational weed shop. (2413 E. Union St., ponderseattle.com, 2015)

The entrance to **Kate's Day Spa** is on the back side of the building, well away from the sidewalk, but the neon draws the eye to the arched passageway that leads customers there. (2713 E. Madison St. #2, katesdayspa.com, 1988)

Minor

This is the original **Ezell's Famous Chicken**, started in 1984 by Ezell Stephens and Lewis Rudd, together with Lewis's sister and Ezell's wife, Faye Rudd. Childhood friends, Stephens and Rudd had worked at a fried chicken restaurant in their native Texas before joining the military, coming to Seattle in the seventies to achieve their dream. It took years to raise the funds and equip the restaurant, but when they finally opened to the public, the crispy chicken was an instant success, as customers lined up outside the door.

In 1990, the company was struggling after an unprofitable expansion to the University District. Salvation came when Oprah Winfrey, on her national TV show, named Ezell's as her favorite fried chicken. Stephens and Rudd flew to Chicago to cook for Oprah on her birthday. Now truly famous, the restaurant rapidly expanded, opening additional locations throughout Western Washington in the 1990s and 2000s.

Ezell and Faye divorced in 1992, with both remaining co-owners, but the relationship between the business partners soured. Ezell opened new restaurants, owned solely by himself, using the Ezell's name and recipes. His former partners ousted him from the board of directors and filed a lawsuit, claiming he had no rights to the company name. After a long battle, in 2011 Ezell walked away from his namesake company, rebranding his own restaurants as Heaven Sent Fried Chicken (*see* Lake City).

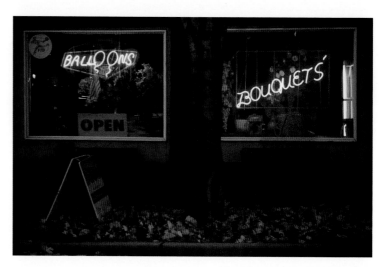

Ezell's Famous Chicken continues, minus Ezell, at its original location, where red neon tubes wrap around the building at the roofline, and a signed photo of Oprah hangs on an interior wall. (501 23rd Ave., ezellschicken.com, 1984)

As Mary Wesley planned her post-retirement future, she realized that she loved flowers, and also that there were then no Black-owned flower shops in Seattle. Wesley went back to school to study floral design and horticulture, then opened **Flowers Just-4-U** in 1984, making it her full-time work

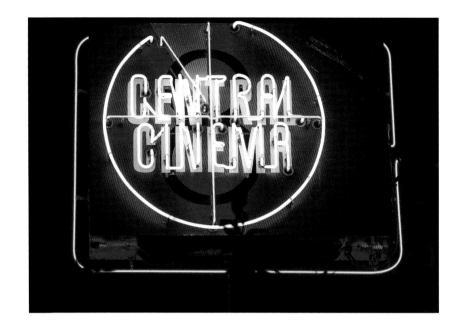

after retiring from Boeing in 1997. Flowers Just-4-U became a beloved community fixture, though its existence was threatened several times—it shut down for 18 months when the city overhauled the water mains, and then just a few years later lost its long-time home at 23rd and Jackson (across from the Starbucks with the neon saxophonist) as the building was torn down for a new apartment complex. The community rallied to "Miss Mary's" support, with a GoFundMe campaign raising $26,000 to help her move the shop to its new home, 23rd and Cherry. (701 23rd Ave., flowersjust4u.net, 1984)

Kate and Kevin Spitzer grew weary of having to travel to other neighborhoods for fun, as there was nothing interesting to do near their Central District home. When visiting friends in Portland, they enjoyed a screening of *The Exorcist* with dinner and drinks in a historic theater and pub, and realized that this was an idea that they could bring home—they even had space for it already, in the form of Kevin's sculpture studio. The Spitzers gutted the workshop and installed soundproofing, salvaged auditorium seats, tables for dining, and a new commercial kitchen, creating **Central Cinema**.

Seattle's "only dine-in cinema" opened in the summer of 2005, eschewing mainstream current releases and instead showing a wide range of classic and cult films. They host special events such as trivia nights, sing-alongs, lectures by experts explaining the science in a film, and "hecklevision," where the audience can share their snarky thoughts by sending text messages directly to the screen. Though the cinema shut

down for over a year to slow the spread of coronavirus, Central Cinema reopened with a full schedule in July 2021. (1411 21st Ave., central-cinema.com, 2005)

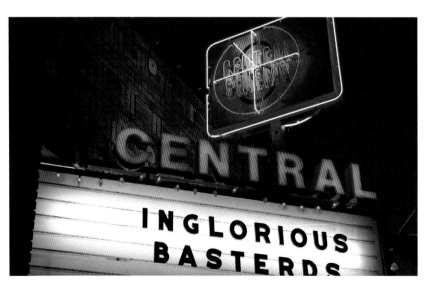

7.
Queen Anne

Seattle Center

For the Century 21 Exposition, the 1962 Seattle World's Fair, a 74-acre area on the east side of Lower Queen Anne was cleared of most existing structures and reimagined as a major tourist attraction, celebrating science, space exploration, and an optimistic high-tech future. Among the buildings designed and constructed for the fair was the Space Needle, 605 feet tall, with a rotating restaurant, an observation deck, and a natural gas beacon that would burn at night. Almout ten million people attended, including Elvis Presley, who came here to film *It Happened at the World's Fair*, getting kicked in the shin by a 10-year-old Kurt Russell.

Many of these visitors arrived in an appropriately futuristic manner: by monorail. Two stations were built, one at the center of the fairgrounds and the other downtown at Westlake Center. A German-Swedish firm, Alweg Research Corporation (named for the initials of its founder, Dr. Axel Lennard Wenner-Gren), won the contract to design the system and supply the two trains that would run on separate elevated tracks, side by side.

The World's Fair ended after six months. The monorail was built to last decades. Shortly after the fair, the city of Seattle purchased the whole operation—trains, track, and stations—and renamed it **Seattle Center Monorail**, operating it both as a tourist attraction and as a public transit service. Though various plans were proposed to extend the system to the corners of the city or even to the airport, none of these

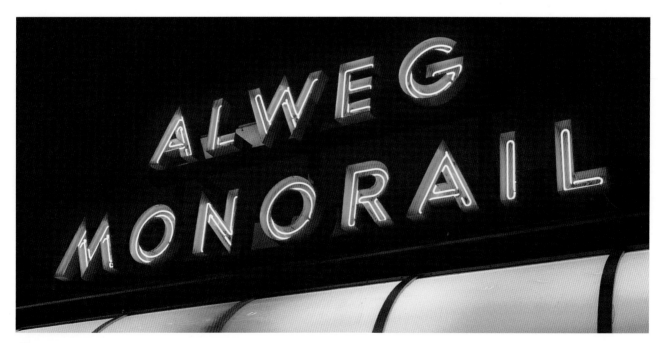

ideas ever went anywhere. (370 Thomas St., seattlemonorail.com, 1962)

Like the monorail, the former **KeyArena** was built for the 1962 World's Fair, during which it was called the Washington State Pavilion. After the fair wrapped up, the massive structure was purchased by the City of Seattle and reworked into the Seattle Center Coliseum. In 1964, it hosted the Beatles, who furtively made their escape in an ambulance to get back to the safety of The Edgewater hotel (*see* Belltown). In the decades that followed, the Coliseum became home to multiple professional sports teams including the Seattle Supersonics (NBA) and Seattle Storm (WNBA).

Key Bank purchased the coliseum's naming rights in 1995 and renamed the facility KeyArena. Years after the agreement expired, the KeyArena name and neon remained, until the arena closed for a major expansion project in 2018. To increase capacity while preserving the iconic pyramid-shaped roof, the builders installed temporary support columns and then demolished the building underneath, excavating 30 feet below the existing floor level, then rebuilding everything from this new depth.

Amazon sponsored the next change of name, announcing in June 2020 that the facility would now be called Climate Pledge Arena, in support of an initiative for carbon-neutral company operations. Weeks later, the KeyArena neon signs were removed by helicopter. Though replaced with a sign of similar size reading "Climate Pledge Arena" in green, the new lighting is LED rather than neon. The rebuilt arena will soon be home to the newly formed Seattle Kraken professional hockey team. (305 Harrison St., climatepledgearena.com, 1962)

Uptown (Lower Queen Anne)

From 1998 to 2011, a huge disc-shaped neon sign stood on the rooftop of Horizon Church at the northwest corner of Aurora and Valley, a familiar landmark along Aurora Avenue. The sign wordlessly depicted the **Pepsi Cola** logo—a section of red at the top, a wavy white horizon line, blue at the bottom. Not just an outline, the sign used neon tubes to fill every part of the space, like the ridges in a finger-print—but only on the front, facing south, as the back of the sign was attached to the support structure. This replaced an earlier neon Pepsi globe, erected in 1958, as Pepsi wanted to freshen up their look for the centennial year. In 2011, five years after a new logo rendered this design obsolete, the neon came down, replaced by a simple billboard. (formerly 622 Valley Street, pepsi.com, 1998)

Caffe Vita, now a powerhouse coffee brand with locations in Seattle, Portland, and New York City, started from this 5th Avenue storefront. Michael McConnell and Michael Prins, who had worked coffee carts and sold espresso machines together, rented this space in 1995, in a quiet and (then) inexpensive part of Queen Anne. Though the location was obscure, the coffee was excellent, and they soon had a loyal customer base that included musicians who recorded at the nearby Laundry Room Studio—members of Pearl Jam, Soundgarden, and Alice in Chains.

In 1999, Caffe Vita opened a larger shop on Capitol Hill, now their flagship cafe and roastery. While the newer cafes have animated neon signs with the Punchinello clown fully rendered in neon (*see* Seward Park *for example*), the neon at this original Caffe Vita is much smaller and simpler, with a printed clown and no animation. (813 5th Ave. N., caffevita.com, 1995)

Born in Naples, Mario Vellotti arrived in New York City in 1964, learning the pizza trade in several of that city's pizzerias before starting his own there. In 2010, he came to Seattle, opening the first **Big Mario's Pizza** on Capitol Hill—also adjacent to a Caffe Vita—then Queen Anne and Fremont. (815 5th Ave. N., bigmariosnewyorkpizza.com, 2015)

The actual Taylor Shellfish Farm isn't in Seattle—it's on scenic Chuckanut Drive, about 70 miles north. The farm welcomes

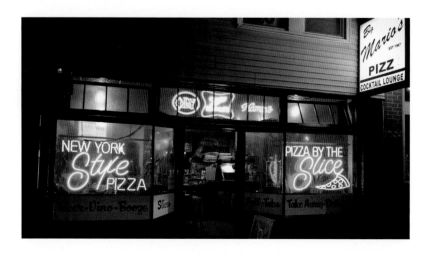

visitors, who can purchase and consume oysters right next to where they are harvested, on the edge of Puget Sound. For those who prefer something more convenient to home, they also operate two **Taylor Shellfish Oyster Bar** locations, one here and one on Capitol Hill. Both have similar neon signs, a design that includes a blue heron standing atop wood pilings, with ripples of water below. (124 Republican St., taylorshellfishfarms.com, 2014)

On the night I arrived in Seattle, just after picking up the keys to my new apartment, I walked several blocks through a light rain to the Queen Anne location of **Dick's Drive-In**, a beloved burger spot I'd read about in various city guidebooks; it was the obvious choice for my first meal as an official resident. The Queen Anne restaurant opened in 1974 as the fourth Dick's location, with a layout very different from the others—it's the only one with indoor seating, and customers order at a counter inside rather than through a window. (500 Queen Anne Ave. N., ddir.com, 1974)

Uptown Theatre opened in 1926 with a live orchestra playing Sousa's *The Stars and Stripes Forever*, followed by a showing of *The Sea Beast*, a silent film based loosely on *Moby Dick*. The new movie house had been built that year by John Hamrick, a Seattle-based entrepreneur who owned and operated numerous vaudeville theatres and cinemas throughout the Northwest, including several Blue Mouse Theatres and the lavishly decorated Oriental Theatre in Portland. An early photo shows a sign made up of incandescent light bulbs spelling out the name "Hamrick's Uptown Theatre," just above the second floor windows. By the late thirties this had been replaced with a vertical neon blade sign reading "UP-TOWN," with a letter board at the bottom listing the movies currently playing.

This sign was replaced in 1953 by a new marquee, designed by noted theatre architect B. Marcus Priteca. Directly over the main entrance, Priteca's marquee originally featured the word "Uptown" on two sides in red neon, with rows of light bulbs above and below the letter boards, and a band of neon tubing below. On the underside are neon tubes and incandescent bulbs in a geometric pattern.

In 1984, Uptown Theatre expanded by buying the building to the south, then home to the Streamline Tavern. That building was gutted, leaving only the exterior walls, and a boxy two-story concrete structure was built within, yielding two more auditoriums, which connected to a redesigned and expanded lobby in the main building. The front windows of the former tavern became a sheltered arcade where theatre patrons could stand in line, out of the rain, with an arc of red neon across the top of each section.

Eventually, the theater was purchased by Loews, and Uptown Theatre became known as AMC Loews Uptown 3. It closed, seemingly for good, in November 2010.

The theater's rescue came from the Seattle International Film Festival, now widely recognized as one of the best film festivals in the country. Though primarily known for their annual event, SIFF was increasingly putting on year-round programming, showing foreign and independent films at the Egyptian on Capitol Hill and on a single screen at Seattle Center. In 2011, SIFF leased the empty Uptown Theatre, purchasing it outright

in 2014. Priteca's 1953 marquee was refurbished and altered. The "UPTOWN" lettering was preserved, though now blue instead of red. Above it, new tubing spelled out "siff cinema" in the same color. The letters of "siff" are animated, with the bottom of each letter cut off and instead shown above, as if it were two consecutive frames of film misaligned in the projector.

As of 2021, the theater is boarded up due to the coronavirus pandemic and the annual festival has gone online for the second year. Given that it is in the hands of film buffs who are passionate about the arts and about Seattle, and not a distant corporation, one can expect that **SIFF Cinema Uptown** will be showing movies again once the crisis has passed. (511 Queen Anne Ave. N., siff.net, 1926)

Though **Mud Bay**, a natural pet care shop, features neon at most of its locations, none is quite so extreme as this, resembling a theatre marquee. That's because the building used to be a Blockbuster Video, which needed something splendid to compete with the Uptown Theatre across the street. Thankfully, the pet shop has seen fit to keep it, and display animal-inspired puns on the sides—"Live long and pawsper" being one recent example. (522 Queen Anne Ave. N., mudbay.com, 2014)

In 1930, only a year after opening the 5 Point Cafe (*see* Belltown), Preston and Frances Smith did it again with **The Mecca Cafe** in Uptown. As Prohibition was still in full force, these were "dry" establishments at first, but both converted to bars when selling beer became legal again in 1933. The Mecca's bar area is long, narrow, and cramped, as most of the interior space is now dedicated to restaurant seating. (526 Queen Anne Ave. N., mecca-cafe.com, 1930)

Pagliacci Pizza opened their Lower Queen Anne location in 1988 in a space originally occupied by Van de Kamp's Dutch Bakery, which earlier had a replica Dutch windmill above this octagonal entryway. In July 2020, Pagliacci announced that this location, already shuttered due to the pandemic, would be closing permanently. The neon letters disappeared within weeks. (formerly 550 Queen Anne Ave. N., pagliacci.com, 1988)

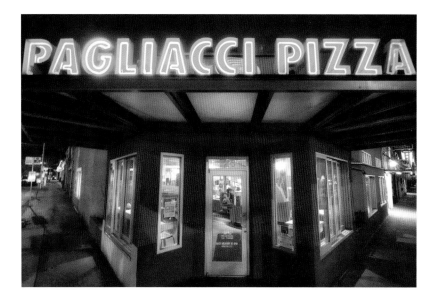

The week before Christmas, I caught Santa Claus on a smoke break in front of **Liberty Tattoo**. A few months later, the entire shop was gone—they'd had to pack up their neon and their needles and move everything to Jackson Street in the International District, when the landlord suddenly doubled the rent. (formerly 613 Queen Anne Ave. N., libertytattooseattle.com, circa 2013)

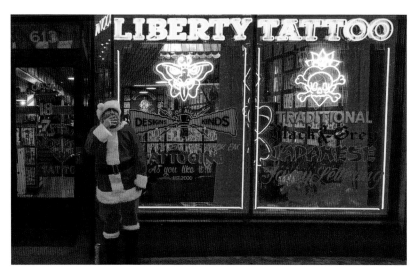

Ozzie's in Seattle is a self-described "five-star dive bar and restaurant." There's been a bar here since 1954, operating under various names. In the 1990s, it was known as Emerald Diner for a time, before becoming Ozzie's Roadhouse, then Ozzie's in Seattle. A neighborhood dive by day, on weekend nights it transforms as a younger crowd arrives to party with karaoke, DJs, and dancing. (105 W. Mercer St., ozziesinseattle.com, 1954)

East Queen Anne

Upon completion in 1930, **Galer Crest Apartments** was one of the largest buildings on Queen Anne Hill, occupying a prime spot at the south end of the business district. An early example of mixed-use development, the ground floor included an auto repair garage, barber and beauty salon, and other shops. (1428 Queen Anne Ave. N., galer-crest-apartments.business.site, 1930)

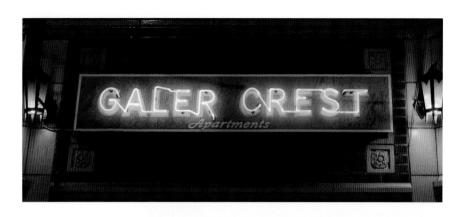

Peer in the windows of one of Galer Crest's street level storefronts, and you'll see a crowned neon skull made for **Counterbalance Barber Shop**, which has been here as long as the building has. "Counterbalance" emerged as a nickname for this part of Queen Anne Hill because the grade was so steep that the streetcar line that used to run along Queen Anne Avenue required an underground weight to counterbalance the car. (1424 Queen Anne Ave. N., counterbalancebarbershop.com, 1930)

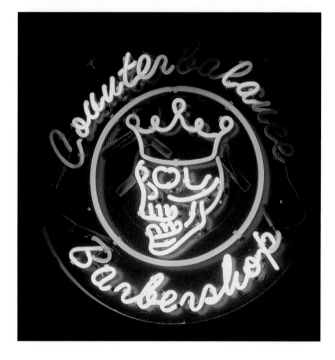

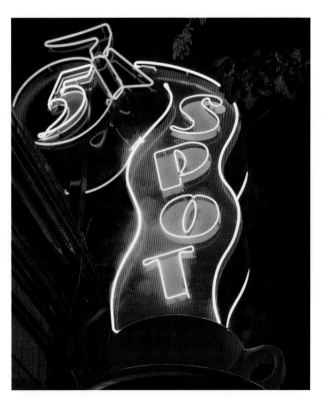

This amazing neon sign includes a unique feature: steam rising from the coffee cup. **5 Spot** changed their themed menu every four months, showcasing the cuisine of different American cities (Chicago, Portland, and New Orleans were recently featured). In business for over 30 years, 5 Spot shut down in March 2020 due to Covid-19, and its future is presently uncertain. (1502 Queen Anne Ave. N., chowfoods.com, 1989)

This vintage neon sign at the headquarters of **Reed Wright Heating Company** includes an old-style phone number in the "ATwater 3" exchange. Reed Wright began in 1938 as a coal delivery service, transitioning to heating and

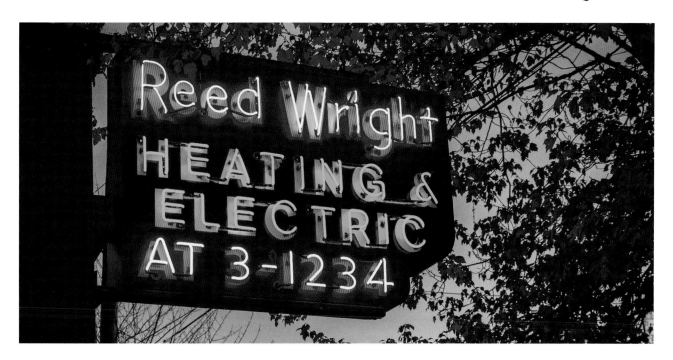

electrical contracting by the 1960s, when they did some of the electrical work at the World's Fair. (2212 Queen Anne Ave. N. #B, reedwrightheating.com, 1938)

West Queen Anne

On a ski trip in Montana, Tom Vial and Doug McClure saw how people would line up in freezing weather for even the most mediocre corporate pizza, and thought they could do better. Naming their concept for a surfer friend who had told them "life is too short for crappy pizza," the two came to Seat-tle and opened their first **Zeeks Pizza** in 1993 on Dravus Street in North Queen Anne. Later Zeeks locations, such as this one on the top of Queen Anne Hill, include neon renditions of the pizzeria's "Z" logo. (1915 Queen Anne Ave N, zeekspizza.com, 2015)

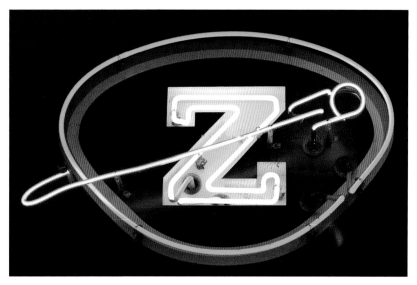

Bradlee Distributors sells luxury kitchen appliances—premium brands like Wolf and Sub-Zero—from this Elliott Avenue showroom. (1400 Elliott Ave. W., bradleedistributors.com, by 2008)

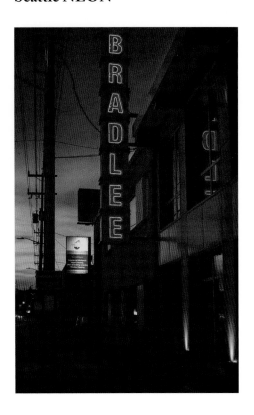

Magnolia Bridge Self Storage is about a block north of the actual Magnolia Bridge, which is a simple elevated roadway—nothing like the elegant suspension bridge illustrated on this neon sign. (1900 15th Ave. W., urbanstorage.com, by 2008)

North Queen Anne

This 1928 building at the foot of the Fremont Bridge was a bar as early as 1934, when it appeared in city guides as Albert Cruver's Tavern. In 1948, it became the 318 Tavern, serving beer and hamburgers. Owner Bill Dickinson famously quipped that he also served French Dip sandwiches, because "I ain't got nothing against those people." In 1995, the bar was purchased by bartenders Chris Gerke and Jay Farias, who renamed it **Nickerson St. Saloon**. In October 2021, "The Nick" closed permanently and will be torn down to make way for a new six-story building. (formerly 318 Nickerson St., nickersonstreetsaloon.net, 1995)

Dickinson was also fond of comparing the size of his walk-in cooler to the one across the street—at **Bleitz Funeral Home**. Built in 1921, the Tudor-style funeral chapel added a neon sign in 1937 with the text "Bleitz Funeral Parlors" along the ridge of its roof. This was eventually changed to read "Bleitz Funeral Home" in green. It was here that rocker Kurt Cobain was cremated in 1994. By 2018, the funeral home had been sold, its interior stripped to the concrete walls, and the neon sign covered; the landmark building will be restored and will become part of a new office complex. (formerly 316 Florentia Street, fremontcrossingseattle.com, 1921).

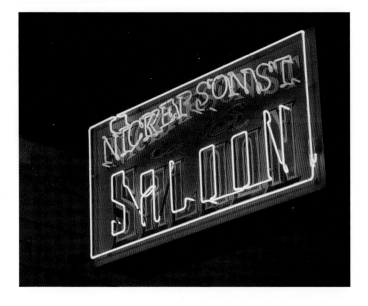

8.
Interbay and Magnolia

Interbay

In 1947, the **Seattle Post-Intelligencer** held a contest inviting readers to submit ideas for a suitable symbol to crown their new headquarters building, then under construction. The winning idea came from Jack Corsaw, an art student at UW: a 30-foot globe, with the continents and major islands outlined in green neon, blue neon lines of latitude and longitude, a rotating band around the equator with the slogan "It's in the P-I," and a bald eagle to top it off. The globe would be installed at 521 Wall St. in Belltown, about a block south of Elephant Car Wash, clearly visible to inbound travelers on Aurora Avenue.

The Post-Intelligencer moved their headquarters and their globe to this waterfront location in 1986, with their old building eventually becoming home to City University of Seattle. In 2009, the paper published its last print edition and vacated their building, leaving the neon globe behind. The globe remains an official city landmark, but is in poor condition, with much of the neon no longer functioning. MOHAI intends to take custody of the globe, but the cost to move and restore it has been estimated at half a million dollars. (101 Elliott Ave. W., seattlepi.com, 1947)

If you need a graphic big enough to see from orbit, call **SuperGraphics**. The large-format printing service decorates stadiums, airports, retail stores, and vehicles—they're credited with inventing "bus wrap" advertisements. In 2018, the company was purchased by its employees and installed an appropriately huge rooftop neon sign. (2201 15th Ave. W., supergraphics.com, 1990)

The second location of **Red Mill Burgers**

opened here in 1998. Like their first restaurant (*see* Phinney Ridge), it features a neon windmill, but with an entirely different design. You'll find a mural depicting a mill on the side of the building too. (1613 W. Dravus St., redmillburgers.com, 1998)

Just south of the Ballard Bridge, **Java Jazz** is impossible to miss, thanks to its prime location and charming "Time for Java Jazz" neon clock. One of Seattle's many drive-through coffee shops, they're known for their tradition of adding a chocolate covered espresso bean on top of every cup. (3457 15th Ave. W., by 2007)

Part of the Anthony's Restaurants group, **Chinook's at Salmon Bay** is located at Fisherman's Terminal, the home port for Seattle's commercial fishing fleet. In addition to the brilliant blue neon fish on the restaurant itself, you'll find a standing neon sign pointing the way there from the far side of Emerson Street. Chinook's was named for Chinook Salmon, a popular catch in Seattle's waters. (1900 W. Nickerson St., anthonys.com, 1990s)

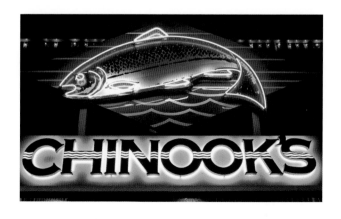

Southeast Magnolia

Master mechanic Gene Mayer got his start working on cars for his dad at the age of 12, then went on to open a garage of his own in 1973. He started **34th St. Garage** in Magnolia in 1990. (2410 34th Ave. W., 34thstreetgarage.com, 1990)

After 17 years in Magnolia, Liza and Christopher "Luigi" Serpano sold **Luigi's Pizza & Pasta** in 2011 and retired. But when the new owners messed with the classic menu, Magnolia residents stayed away in droves. Within a year, the new boss called it quits and sold Luigi's back to the Serpanos. Though their return was well-received and the restaurant prospered once more, the catastrophic year of 2020 caused Luigi's to finally shut down. (formerly 3213 W. McGraw St., 1994)

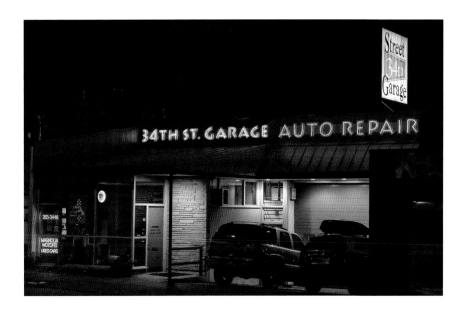

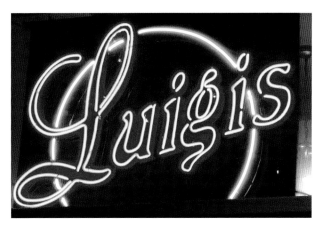

Briarcliff

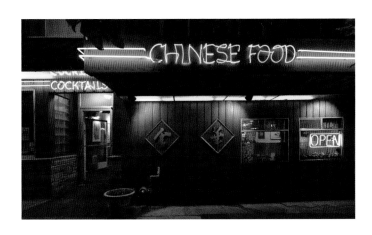

Chinese restaurant **Gim Wah** is also a classic neighborhood dive bar, serving drinks until 1 a.m. Tom Chan opened "The Gim," as locals call it, in 1980 in the old East Winds Restaurant space. (3418 W. McGraw St., 1980)

9.
Ballard

West Woodland

Family-owned **Mike's Chili Parlor** has been operating here since 1922, ladling out chili made from the same original recipe. Just about everything on the menu here features the chili, which you can get with or without beans. Their neon is attached to a ziggurat-like structure over the door, with an empty frame above that previously held an illuminated sign for 7-Up soda. (1447 N.W. Ballard Way, 1922)

Around the corner, behind Mike's and to the east, is Edith Macefield's house. When the Ballard Blocks

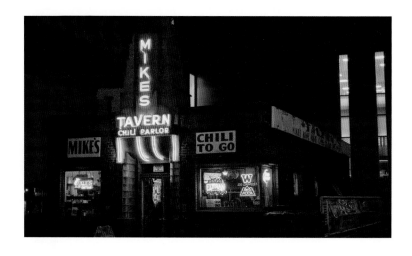

shopping center was under construction in 2006, the 85-year-old Macefield refused repeated offers to sell the house she'd lived in for decades. Eventually, the developers gave up and built around her,

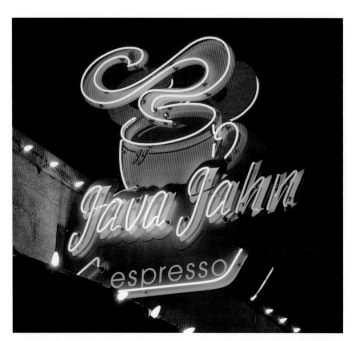

altering their plans and leaving Macefield's property untouched, but with sheer blank concrete walls five stories in height on three sides of the house. According to local legend, Edith's story inspired the Disney/Pixar movie *Up*, though in fact that script was in development before the start of the real-world drama in Ballard. After Edith died, the house was boarded up and abandoned. Though it remains vacant, the fence in front is occasionally decorated with balloons left by fans.

Java Jahn started with Ballard native Patty Jahn selling espresso from a cart next to a hardware store. Eventually, she purchased a building for the cafe's permanent home. Java Jahn is now in its 30th year. (1428 N.W. Leary Way, javajahn.com, 1991)

The impressive rooftop sign above **Seattle Gymnastics Academy** includes an animated gymnast, with three neon characters lighting up in succession to show her movement. The gym has another location in Columbia City, with an animated neon sign of a different design. (1415 N.W. 52nd St., seattlegymnastics.com, 2012)

Founded by Ole Bardahl in 1922, **Bardahl Manufacturing** produces additives for gasoline and motor oil to improve performance and clean the engine. Their animated rooftop neon was a

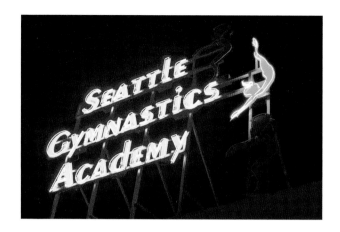

familiar landmark to northbound travelers on the Ballard Bridge until it ceased operating in 2017. When it was in working condition, the sign displayed several messages in sequence: "Add it to your gas. Add it to your oil. Add Bardahl." Sections of the Y-shaped track at the top would also light up in turn, giving the illusion of approaching headlights, until finally the outline of a car would fully illuminate. The age and size of the structure have made any efforts to get the neon lit again prohibitively expensive. (1400 N.W. 52nd St., bardahl.com, 1922)

Town and Country Markets was started by two families, the children of Japanese and Croatian immigrants, on Bainbridge Island in 1957. In 1985, they opened their first grocery store on the mainland,

calling it **Ballard Market**. (1400 N.W. 56th St., townandcountrymarkets.com, 1985)

J & J Collision has been doing auto body repair at this location since 1955, the first body shop in Seattle to provide a guarantee of their work "for as long as you own the car." (517 N.W. 65th St., jjcollision.com, 1955)

Cafe Bambino specializes in Italian coffee, under the serene gaze of a copper bambino with a cup and saucer balanced atop their head. (405 N.W. 65th St., 2003)

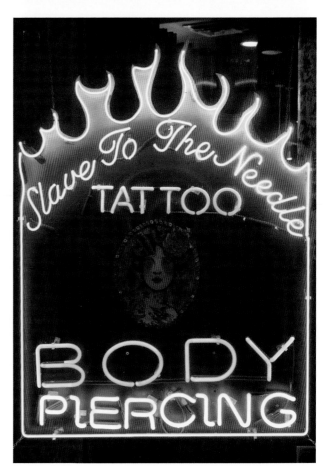

Tattoo artist Aaron Bell opened **Slave to the Needle Tattoo & Body Piercing** in 1995, the first tattoo shop in Ballard, later adding a second location in Wallingford. They're generally regarded as one of the best tattoo shops in Seattle, regularly topping the annual reader poll in Seattle Weekly, and the shop's artists—Bell in particular—have won numerous industry awards. Some of their best designs were published as a book, *Slave to the Needle*, in their twentieth anniversary year. (508 N.W. 65th St., slavetotheneedle.com, 1995)

Lockspot Cafe takes its name from the nearby Hiram M. Chittenden Locks, where tourists come to watch salmon ascending the "fish ladder." The historic cafe opened about 1920, then expanded in 1948 when the owners purchased a nearby house, lifted it up and moved it, adjoining it to their existing building. In 2019, owner Pam Hanson announced that the cafe was moving again, and they would be publishing the new address shortly—a playful way of saying that this one-block stretch of 54th Street was being renamed as N.W. Locks Place. (3005 N.W. Locks Place, thelockspotcafe.com, circa 1920)

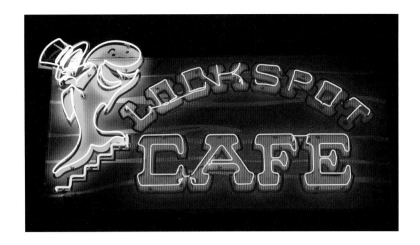

Originally built in 1939 as Northwesters' Arts and Crafts Shop, this Native American owned business shut down during World War II, due to the closing of the locks, reopening in 1948 as a fish-and-chip restaurant called Totem House. Red Mill Burgers—whose neon windmills appear in the Interbay and Phinney Ridge chapters—acquired the business in 2011 and rebranded it as **Red Mill Totem House**. The 30-foot totem

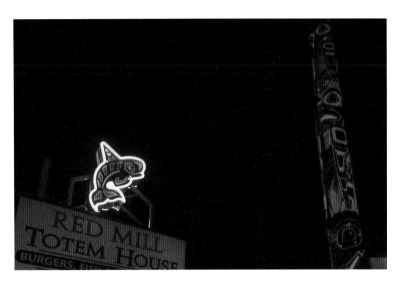

pole at the front of the painted wood structure was carved by employees of the arts shop in 1939, and was restored by Makah artist Greg Colfax when it became a Red Mill.

On Labor Day 2021, just as I was delivering the final text of this book, a contributor to Facebook's Seattle Vintage group broke the news that the Totem House was permanently closed, and Pagliacci Pizza would be taking over the location. Red Mill's other locations remain open. (3058 N.W. 54th St., redmillburgers.com, 1939)

Pacific Fishermen Shipyard

Pacific Fishermen Shipyard is both a working shipyard and an open-air neon museum. Manager Doug Dixon is a historic preservationist and a collector of Ballard memorabilia, often acquiring artifacts from defunct local businesses—as the erstwhile owners are usually willing to give them up rather than pay to have them taken down. These are then affixed to the structures inside the shipyard, where they can be seen through the fence from nearby streets. (5351 24th Ave. N.W., pacificfishermen.com, 1946)

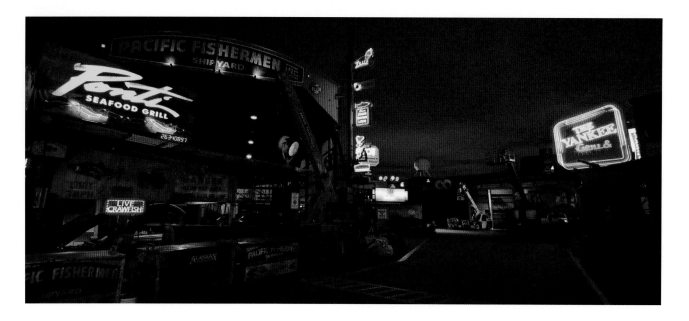

Seattle's **Original Pancake House** was originally a franchise of a Portland-based chain. In 2018, the agreement ended and the restaurant transformed into the Crown Hill Broiler—minus the animated pancake chef, now affixed to a pole at the center of the shipyard. Four yellow neon rings illuminate in rapid succession to illustrate a pancake tossed into the air, then falling back into the skillet. (formerly 8037 15th Ave. N.W., 1995)

Zesto's Burger and Fish House was a popular hangout for three generations of students at Ballard High School, just across the street. With an abundance of eye-catching decor, the burger joint included a real '57 Chevy Bel Air mounted to the

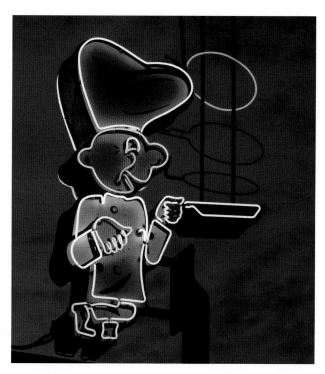

roof. The car was still in working order, as owner Charlie Pattok would occasionally demonstrate by climbing up a ladder, inserting a key, and starting the engine. The Chevy came down in 2001 and the neon in 2012, when Zesto's closed for good after 63 years. (formerly 6416 15th Ave. N.W., 1948)

Copper Gate was a Ballard tavern with Nordic-inspired cuisine, a bar in the shape of a Viking ship, erotic artwork, and a red velvet lined performance space with a doorway shaped like

a vagina—the "Pussy Room." Copper Gate shut down in 2013, with the space becoming Olaf's. (formerly 6301 24th Ave. N.W., 1946)

Mr. Dixon's collection includes two neon signs from **Ponti Seafood Grill** in North Queen Anne. The large neon letters, now mounted under the rafters of a shed at the shipyard, once were visible to southbound drivers on the Fremont Bridge. Another salvaged sign (seen at middle left of the wide-angle photo that opens this section) includes a school of animated fish, alternately lighting to portray movement. (formerly 3014 3rd Ave. N., 1991)

Sunset Hill

Ray Licthenberger moved his boat rental business to this Shilshoe Bay waterfront site in 1939, adding a coffee shop and fish-and-chip restaurant soon after, all of it built on a wooden pier. In 1952, he added this neon sign atop a tower of steel girders, visible from miles across the water, and a useful landmark to sailors looking for the entrance to Salmon Bay. When Ray sold the growing restaurant in 1973, the new owners refurbished and expanded, keeping the **Ray's Boathouse** name. In 1987, the building was completely destroyed by fire, but the neon sign survived, intact. The owners rebuilt and the restaurant continues to flourish. The letters of "RAYS" light one at a time—R, RA, RAY, RAYS—then flash off, then all flash on simultaneously. (6049 Seaview Ave. N.W., rays.com, 1939)

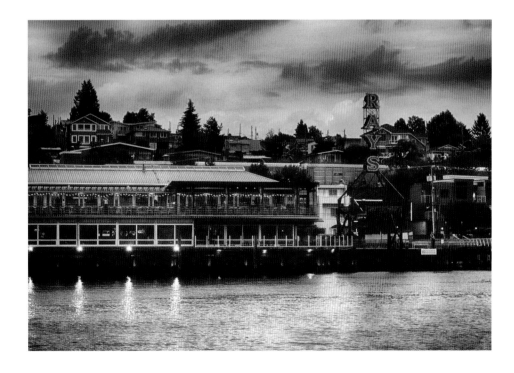

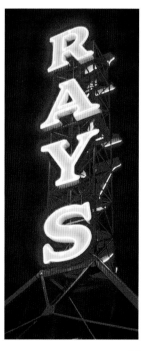

Whittier Heights

Kasbah Moroccan Restaurant became **Kasbah Moroccan Hookah Lounge** a few years ago, moving to an adjacent storefront in the same building. Originally their roofline included a number of ornamental projections in red neon, as well as neon tubes outlining each window. After their move, only the neon logo remains. (1475 N.W. 85th St., 2004)

Dorene Centioli-McTigue, her brother, and a cousin opened the first **Pagliacci Pizza** on University Way in 1979, taking the name from the Italian word for "clowns." There's nothing clownish about their recipes, however, and Pagliacci quickly rose to become Seattle's favorite local pizza chain, now with 24 locations in the city and the Eastside. (851 N.W. 85th St., pagliacci.com, 1993)

Seattle Rainbow Smiles is the office of Dr. Rick Chavez, DDS, who has been providing dental care to Ballard from this same location since 1982. (8006 15th Ave. N.W., seattlerainbowsmiles.com, 1982)

Loyal Heights

Philadelphia Church originated in 1901 as a Scandinavian congregation meeting in the minister's home. In 1906, the nondenominational church took inspiration from the Pentacostal Revival movement, growing rapidly, eventually becoming Ballard Pentecostal Tabernacle.

The present name, Philadelphia Church, comes from the Book of Revelations and was adopted in 1948. Work commenced a few years later on the new church building with its "Jesus Saves" neon sign, now by far the largest neon installation with a religious message in Seattle. (7704 24th Ave. N.W., pcseattle.org, 1951)

The Mailbox Ballard provides mailbox rental, shipping services, and an eager-to-please border collie (his name is Aero) delivering a neon envelope over the front door. Ferrol Williams opened the shop as a one-woman operation in 1996, eventually passing it to new owners Andrew and Melissa Wagenbrenner in 2017. And yes, you can bring your dog inside. (2400 N.W. 80th St., themailboxballard.com, 1996)

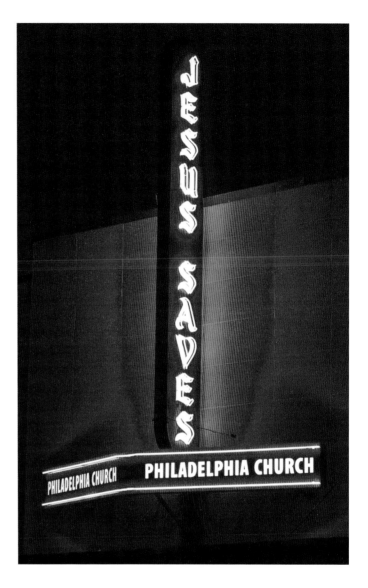

10.
North of Lake Union

Fremont

The gateway to Fremont, "Center of the Universe," is the **Fremont Bridge**. In a window of the bridge's northeast tower, neon figures illustrate Rudyard Kipling's "How the Elephant Got Its Trunk." A neon Rapunzel stands in the northwest tower, her long golden hair flowing down from the window. Artist Rodman Miller created these works, and with the aid of the Fremont Arts Council pressed the city to allow the "temporary" installations. That was in 1995, and both pieces are still there. (Fremont Ave. N. at N. Northlake Way, rodmanstudio.com, 1995)

From 1930 to 1991, **Auditorium Cleaners** occupied the prominent ground-floor space at the narrow end of a historic "flatiron" building, Odd Fellows Lodge #86. Naming themselves for the fraternal order's meeting

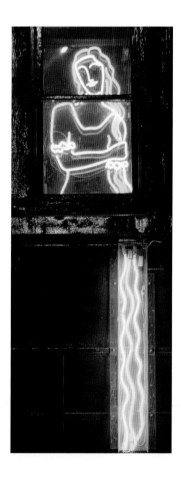

room upstairs, the dry cleaners hung an enormous neon sign over their door, a sign wider than the front of the building itself—its ends protruded over the sidewalk on either side. With this prominent location, the sign was well known and appeared in movies: the 1989 teen romance *Say Anything* and the 1992 psychological thriller *The Hand That Rocks the Cradle*, which includes a pivotal scene set inside the dry cleaning shop itself.

Though the cleaners are long gone, the building owners gave the sign a weird kind of afterlife, relocating it to the alley behind the building. Stripped of its glass tubing, the sign was mounted to the rear wall, where it can be glimpsed by

passersby on the Fremont Avenue sidewalk. (3501 Fremont Avenue N., 1930)

Doric Lodge No. 92 of the Free and Accepted Masons built the **Doric Masonic Temple** in 1909, and continue to hold meetings here. The name "Doric" comes from classical architecture, describing columns with subtle tapering and simple square capitals, symbolizing strength and masculinity. The upper story of the lodge includes a traditionally-appointed Masonic meeting room, while the ground floor tenant is a steampunk-themed tea shop. Masonic emblems and murals decorate the sides of the building. (619 N. 36th St., doric92.org, 1909)

High Dive is a music venue that hosts national acts as well as upcoming local bands. Their neon sign was inspired by the figures of diving women that mid-century motels would use to advertise the presence of a pool. The ripples where the diver enters the water are an atypical but well-executed addition. (513 N. 36th St., highdiveseattle.com, 2005)

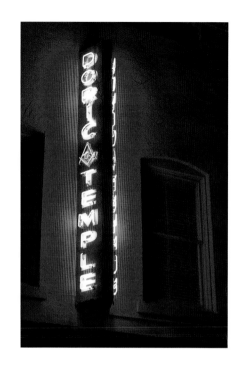

After twenty years as a bar, pool hall, and pizza restaurant with late night dancing, **The Ballroom** closed in September 2020. It soon reopened as **Talarico's Pizza**. The pizzeria kept the neon, but added a border reading "Talarico's Pizza," and a (non-illuminated) pizza held aloft by the dancing woman. (456 N. 36th St., talaricosfremont.com, 2000)

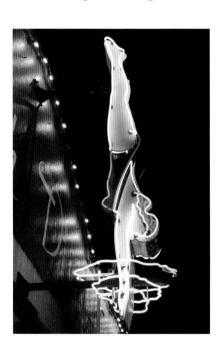

Located about a block from the Lake Washington Ship Canal, the rooftop neon at **People's Storage Ballard Fremont** was easily visible to motorists on the Ballard Bridge. Around 2020, the facility changed hands to become StorQuest, and the neon has gone dark. (4213 Leary Way N.W., storquest.com, 1945)

Throngs of patrons drink in the beer garden at **Fremont Brewing Company**, under the blue rooftop sign. Behind this is one of their two breweries, called Fremont East. Included on the neon sign is a depiction of the company logo, a Great Blue Heron, a beautiful

wading bird found along the shorelines of the Pacific Northwest. In November 2021, brewery co-owner Sara Nelson was elected to a four-year term on the Seattle City Council. (1050 N. 34th St., fremontbrewing.com, 2009)

Under the ivy, the abandoned sign reads "Sleep Off the Hi-Way—BRIDGE MOTEL." This roadside neon pointed the way to the **Bridge Motel** about three blocks south. A retired policeman had built the motel around 1952 to house weary business travelers, but by the 2000s it became known as a place of drug activity and prostitution. After the motel shut down to make way for new townhouses in 2007, a group of artists took it over for a one-night farewell, transforming various rooms into art galleries and performance spaces. (sign at 3933 Aurora Ave. N., motel formerly 3650 Bridge Way N., motelmotelmotel.com, 1952)

The space-age sign of **Marco Polo Motel** features neon tubes, no longer functional, along the edges of the silver blade. Nirvana front man Kurt Cobain, who is thought to have purchased heroin on nearby Aurora Avenue, stayed in Room 226 in the days before his

suicide in 1994. (4114 Aurora Ave. N., 1958)

French seafood and steak restaurant Le Coin occupies the ground floor of a 1908 building that's instantly recognizable to neon enthusiasts and drinking enthusiasts: the **Buckaroo Tavern**.

"The Buck" opened in 1938 and had only three owners during its 72-year run. A neighborhood dive and biker bar, it was known for the neon cowboy on a bucking bronco, projecting from the second floor, and for the row of motorcycles parked in front. Inside there were pool tables, wood paneling, graffiti going back to the 1940s carved into the woodwork, a multitude of neon beer logo signs, and a smaller neon cowboy over the bar—a replica of the exterior sign. The movie *10 Things I Hate About You* included scenes filmed inside and outside the Buckaroo, with Heath Ledger playing a high school student drinking, smoking, and shooting pool.

Though bar owner Donna Morey had no plans to close, in 2010 the building owners declined to renew

the Buckaroo's lease. The cowboy vanished as the space was transformed into Roux, an award-winning Creole and Cajun restaurant, then in 2018 became Le Coin. The neon cowboy spent a decade in storage, and then, restored with all new glass, was installed inside Seattle Tavern and Pool Room in Georgetown (*see* Industrial South). (4201 Fremont Ave. N., lecoinseattle.com, 2018)

Eyes on Fremont sells eyeglasses and fights evil. While the latter seems an unusual role for a spectacle shop, they do indeed battle an evil hidden in plain sight—an international conglomerate with a powerful grip on the eyewear industry, one that uses dozens of brand names to create the illusion of choice and keep prices high. With their "Fight Evil" motto proudly on display everywhere you look, Eyes on Fremont instead offers frames from small, independent makers, reasonably priced. (4254 Fremont Ave. N., eyesonfremont.com, 1996)

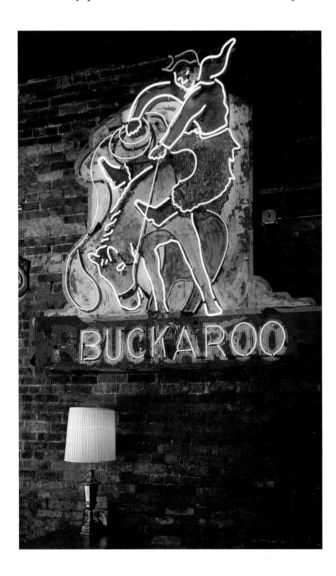

Phinney Ridge

Zeeks Pizza started in 1993 in Queen Anne, later growing to 19 locations in Seattle and Western Washington, many with neon signs. While most of these illustrate their logo, a letter "Z" with an orbit (*see* West Queen Anne), the Phinney Ridge neon has a different design, two-sided like a theatre marquee. (6000 Phinney Ave. N., zeekspizza. com, 1995)

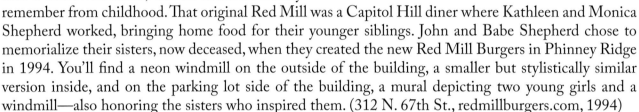

The modern incarnation of **Red Mill Burgers** uses a borrowed name, one its founders fondly remember from childhood. That original Red Mill was a Capitol Hill diner where Kathleen and Monica Shepherd worked, bringing home food for their younger siblings. John and Babe Shepherd chose to memorialize their sisters, now deceased, when they created the new Red Mill Burgers in Phinney Ridge in 1994. You'll find a neon windmill on the outside of the building, a smaller but stylistically similar version inside, and on the parking lot side of the building, a mural depicting two young girls and a windmill—also honoring the sisters who inspired them. (312 N. 67th St., redmillburgers.com, 1994)

Bakker's Fine Cleaners originated as Overlake Cleaners in Bellevue in 1947. Ernest Bakker purchased the operation and changed the name in 1977, then opened additional shops around the area. (7114 Greenwood Ave. N., bakkersfine-drycleaning.com, by 2007)

Greenwood Hardware & Glass started as Gowan Hardware in 1952, operated by Ron and

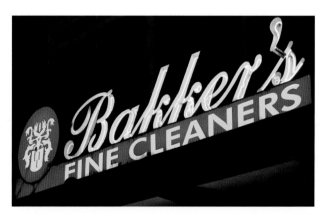

Helen Gowan until they sold the store in 1977. The abstract geometric neon sign has been present since at least the early 1980s. Beneath, a letter-board displays messages ranging from the mundane to the community-minded, such as "Be safe, maintain space, cover your face" and "Everything is weird. We are open." (7201 Greenwood Ave. N., greenwoodhardware.com, 1952)

Although Seattle is nationally known for its coffee culture, Phinney Ridge based **Herkimer Coffee** takes its name from the opposite side of the country—the small town of Herkimer, New York. Michael Prins, formerly of Caffe Vita (*see* Lower Queen Anne), sold his stake in that company to his former

partner and then created Herkimer Coffee, naming it for his father's place of birth. A 1903 trolley bridge in Herkimer, made up of a series of stone arches, inspired the cafe's logo and is illustrated on their neon sign. (7320 Greenwood Ave. N., herkimercoffee.com, 2003)

Jeff Eagan came to appreciate the traditional neighborhood pub when visiting his wife's family in England in the 1980s. Returning to Seattle, he worked in a Capitol Hill bar for a few years before opening an English-style pub of his own, **74th St. Ale House**, partnering with chef Jeff Reich to provide a menu that was a substantial improvement over traditional pub grub. "The Jeffs" (as employees called them) then opened two more ale houses, in Queen Anne and Columbia City. Upon Eagan's semi-retirement in 2019, 74th Street Ale House was purchased by two long-time managers. (7401 Greenwood Ave. N., 74thst.com, 1991)

Duck Island Ale House takes its name from a tiny undeveloped island in Green Lake, about two blocks away. One of the first bars in Seattle with a rotating draft selection, they now have 27 taps of beer and cider. (7317 Aurora Ave. N., duckislandalehouse.com, 1996)

Wallingford

With a red neon sign reading "4 hr. Ramona Cleaning," **Ramona Cleaners** was a neighborhood icon for many years. Their sign even inspired the name of a rock band, "4 Hr. Ramona," that released three albums and made several TV appearances in the nineties. Because the shop was on a quiet corner some blocks away from Wallingford's main street, I had not yet photographed the neon when Seattle went into lockdown in early 2020 to slow the spread of coronavirus. A few months later, Ramona perma-

nently closed. When I finally visited the site, the building was empty and the neon had vanished. (formerly 4001 Wallingford Ave N., by 1990s)

Another sorely missed neon landmark stood atop a factory on 34th street, just north of Gas Works Park. The immense rooftop sign, 220 feet long with 30-foot high letters, read "**GRAND-MA'S COOKIES**" along the length of the 1912 Buchan Bakery building, and was visible across Lake Union at night. The sign, which had been there since at least the 1940s, was dismantled by crane in February 1978, and the factory demolished about 2015. (formerly 1800 N. 34th St.)

Hyen Sook Kang and her husband Tae Park purchased **Sun Drive-In Cleaners** in 1985. Their antique sign, which combined neon and incandescent lighting, is no longer operational. (1600 N. 45th St., 1955)

Briefly glimpsed at the start of the 1989 movie *Say Anything*, **Wallingford Custom Framing** operated from a house one block west of Sun Cleaners. Blue neon letters spelled out the business name over the front windows, until this disappeared about 2015. (formerly 1423 W. 45th St.)

Even to those not from Seattle, **Archie McPhee** is a familiar name, from the novelty catalogs passed furtively around schools since

the 1980s. They're the leading supplier of boxing nuns, devil ducks, horse head masks, weird action figures (a librarian, a pigeon-headed man, and Pope Innocent III), and tiny rubber hands. Greatest of all novelties is the rubber chicken—they've sold over a million, in varying styles— and one corner of the shop is now a rubber chicken museum, filled with such things as historic rubber chickens, a stained-glass art piece depicting a chicken, a signed photo of Chicago horror host Svengoolie, and the world's largest rubber chicken (shoppers are encouraged to pose for selfies with it). Mark Pahlow started selling oddities under the name Accoutrements in the 70s, changing it to Archie McPhee when he opened a retail store in Fremont in 1983; the real Archie McPhee was Pahlow's wife's great uncle, a jazz band manager. The shop relocated to Wallingford in 2009. (1300 N. 45th St., mcphee. com, 1983)

Butcher Frank Wald opened Wald's Market in a converted residence on the corner of 45th and Wallingford Avenue in 1948. Two years later Wald and business partner Leo Haskins changed the name to Foodland, and put up a new building on the site with a rooftop neon sign reading "Foodland" in cursive script. By 1958, Foodland had outgrown this second building and construction began on a third, directly behind the original site. The new store was called **Food Giant**, and the eight-year-old Foodland was torn down to make way for Food Giant's front parking lot.

A store this size needed neon of appropriate scale—they put "FOOD GIANT" on the roof in individual red-outlined white neon letters that remained for almost 40 years. In 1996, then-owner Randall West retired and sold Food Giant's four locations to Bellevue-based **Quality Food Center (QFC)**. Neighbors feared the worst—would the Food Giant sign disappear? For a time it did, another apparent casualty of corporate branding.

As it turned out, QFC wasn't the villain preservationists had been expecting. They kept the letters, and in 2009 restored them to their rightful place, in a sense. The letters of FOOD GIANT were rearranged (and some added) to spell out the name of the neighborhood. The new sign has become, like the old, an iconic symbol. If you'd like to see the original Food Giant neon, it's shown in the opening titles of *Singles*. (1801 N. 45th St., qfc.com, 1948)

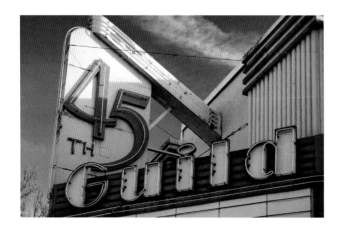

The once-splendid Art Moderne styled **Guild 45th Theatre** was abandoned and left to decay, its doors and windows covered with graffiti. In 2017, employees arrived at work on a seemingly ordinary day, only to find a corporate representative handing out severance checks and a printed notice claiming that the theatre was closing "for renovations." It never reopened.

The Guild opened in 1921 as the Paramount Theatre, built by Paramount Pictures, which was then creating numerous Paramount-branded

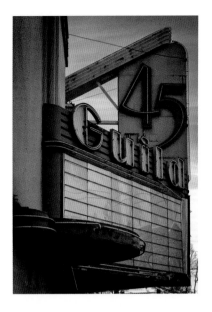

theatres throughout the United States. When the much larger and grander Seattle Theatre downtown was renamed the Paramount Theatre in 1930, the one in Wallingford became Bruen's 45th Street Theatre, with a new neon sign showing this name. In 1955, under new ownership, the theatre was renamed the Guild 45th, showing foreign and art films. Landmark Theatres, a national chain, purchased the theatre in 1988, operating it until its abrupt shutdown.

Guild's neon marquee may be seen in its full glory in the film *Say Anything* (1989), as John Cusack drives past the theatre at night. In this scene, the title shown on the marquee is *Tapeheads* (1988), which also starred John Cusack.

The vertical sign included a large green "45th" on each side, in the same lettering style as the 1930s Bruen's 45th sign. The front edge and the angled support beam glowed pink. On the marquee, the name "Guild" glowed orange. Yellow neon tubes under "Guild"

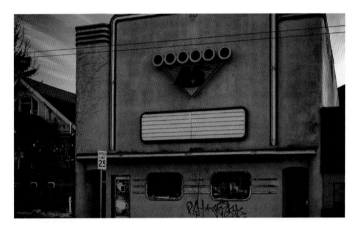

matched the yellow neon on the canopy that spanned the length of the building. Red neon "Tickets" and "Entrance" signs marked the doors. All of this went dark in 2017, abandoned to the elements, and soon the neon tubes were broken and dangling. In January 2022, the neon marquee was pulled from the building and destroyed, the first step in the building's demolition. (formerly 2115 N. 45th St., 1921)

Guild 45th owner Randy Finley added an additional screen to his theatre in 1983, building **Guild 45th Theatre II** two lots west of the original (the house in between, then a pizza place, later became the Octopus Bar). The "45th" logo glowed red, and pink neon tubes outlined the entire front of the building and the canopy over the front doors. Like its 1920s counterpart, this building too is locked and decaying. (2105 N. 45th St., 1983)

One of the best pieces of contemporary neon art in Seattle went into storage in late 2019, when **The Octopus Bar** lost their lease on a 100-year-old ramshackle house between the two Guild Theatre buildings. Floor to ceiling, the Octopus was decked out with vast quantities of nautical decor—ropes, nets, floats, life preservers, maps, ships' wheels, and portholes in the walls. Forced to move, they picked up their impressive collection of flotsam and jetsam, taking everything two doors to the east. The Octopus Bar reopened in early 2021, with its gorgeous neon sign

back in service, and an attached restaurant, The Salty Shack. (2121 N. 45th St., theoctopusbar. com, 2014)

The fourteenth location of **Ezell's Famous Chicken** (*see* Minor) opened here in 2016, bringing with it an impressive quantity of neon. (2300 N. 45th St., ezellschicken.com, 2016)

An old-school dive bar, **Al's Tavern** has been pouring beer since 1940, in a small nondescript building identifiable only by the four silver stars above the windows. To make the place a bit easier to find, they added this highly visible blue neon sign in 2017, also replicating the four stars on its underside. Inside, you'll find murals depicting Shilshole Bay. (2303 N. 45th St., 1940)

The Wallingford **Dick's Drive-In** is the original Dick's Drive-In, as Dick Spady and partners started the fast food hamburger restaurant on this spot in 1954. It was a roaring success, and the very next year they opened a second location on Capitol Hill. The original Wallingford location became a template for the next two restaurants, Holman Road and Lake City, which are nearly identical in layout and signage to the first. Just about everyone in Seattle eats at Dick's, including Bill Gates, who was photographed standing in line here in 2019. (111 N.E. 45th St., ddir.com, 1954)

Green Lake

Spud Fish & Chips was torn down in 2020, to the horror of Mid-Century architecture enthusiasts enamoured of its "Googie" butterfly roof. English-born brothers Jack and Frank Alger started Seattle's first fast food fish-and-chips restaurant in a converted Alki garage in 1935. They opened a second in Green Lake in 1940, relocating it to this building in 1959. Long-time employee Pam Cordova purchased the Green Lake branch after Jack Alger's death, finally selling it to make way for a new apartment building. Called **Spud Apartments** (for now), the new property will have space for the restaurant on the ground floor, and the vintage neon sign is expected to be restored and moved inside. (formerly 6860 East Green Lake Way N., spudgreenlakewa.com, 1940)

Brother and sister Sergio Uvence Lopez and Rosa Anaya started **Rosita's Cocina y Cantina** in 1979, serving Mexican comfort food with handmade corn tortillas, beer, and margaritas. A recent 40th anniversary celebration slashed prices to 1979 levels and raised funds for Seattle Children's Hospital. (7210 Woodlawn Ave. N.E., rositasrestaurant.com, 1979)

Before **Latona Pub**, this was Latona Tavern, which opened just after Prohibition. Robert Breslin purchased the old tavern in 1987, remodeled and renamed it, adding live music and craft beer. (6423 Latona Ave. N.E., latonapub.com, 1933)

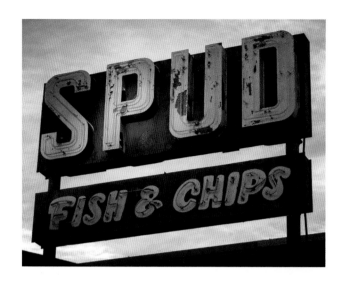

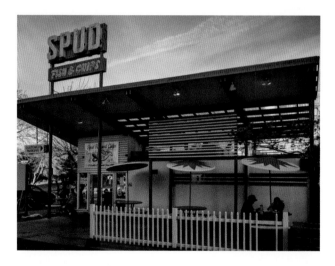

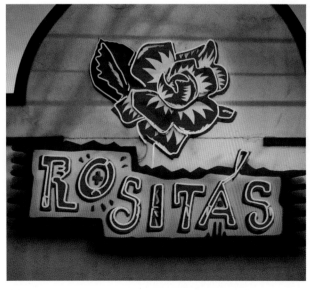

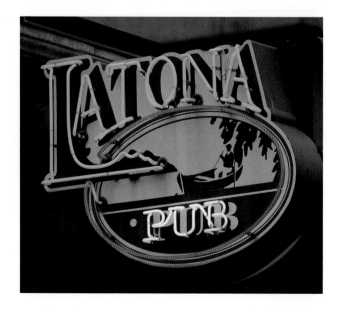

11.

University District

University District

"Sorry, we're open" reads a sign in the window of the infamous **Blue Moon Tavern**, which set up in 1934 exactly one mile from the University of Washington campus, the minimum distance required by law. Mere months after the end of Prohibition, Henry Reverman and Monty Fairchild started the tavern in a former garage, naming it for a large neon sign they'd purchased from the Blue Moon Cafe. Initially reading "Blue Moon" to the left of the crescent moon and "Cafe" on the right, this was later modified to simply "Blue Moon."

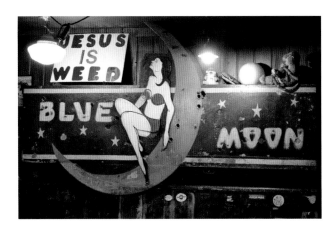

The two founders each sold their shares in the tavern within five years. A series of new owners welcomed all who would drink, including Black servicemen during World War II, then beatniks and hippies in the postwar years. The Blue Moon became a regular hangout for poets and writers, including Richard Hugo, Carolyn Kizer, Stanley Kunitz, David Wagoner, and Theodore Roethke, for whom the adjacent alley, Roethke Mews, is now named.

Novelist Tom Robbins, who had heard of Seattle's legendary beatnik bar from his native Virginia, moved here in 1962 and became a Blue Moon regular for most of the sixties. On a bet, after obtaining Pablo Picasso's home phone number, Robbins placed an international collect call from the tavern's pay phone to the artist's home, only to be hung up on by someone speaking French—a servant, he assumed, but perhaps Picasso himself.

As the Blue Moon's 50th year approached, the 1930s neon sign was found to be

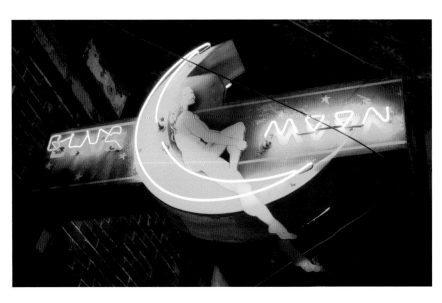

severely corroded. The tavern commissioned a replacement, a faithful replica of the original, but smaller due to then-current city regulations. On April 14, 1984, the tavern celebrated their anniversary with a "Lux Sit" (the UW motto, meaning *Let there be light*) ceremony. Dressed in full Scottish Highlands regalia, Bert Grant of Yakima Brewing threw the switch, illuminating the new neon. The original sign, without its glass tubing, was

brought inside and mounted to the wall, where it remains today.

Artist Mike Nease reworked and repainted the sign in 2003, with fellow artist and long-time Blue Moon bartender Mary McIntyre as the model. This new version keeps the same basic elements,

lettering style and coloring, but with a critical difference—the lunar beauty, who initially wore a two-piece bathing suit, is now unclothed, for a less inhibited century. (712 N.E. 45th St., thebluemoonseattle.com, 1934)

University Inn was built for the 1962 World's Fair, then greatly expanded in 1992 with a new "deluxe wing" to the south of the older building. The neon sign on the roof was present in the sixties and can be seen in contemporary postcards advertising the hotel and its heated swimming pool. The new section also includes neon, a vertical blade sign over the sidewalk. (4140 Roosevelt Way N.E., staypineapple.com, 1962)

You won't see this neon sign in the University District anymore. It's now part of the collection at the Trigger Building (*see* Industrial District), but its historic home was here on Roosevelt Way. Vito "Vic" Rosi opened **Vic's G & R Grocery** in 1935 with a partner who soon departed, the now-forgotten "G." Vic Rosi then ran the store by himself for

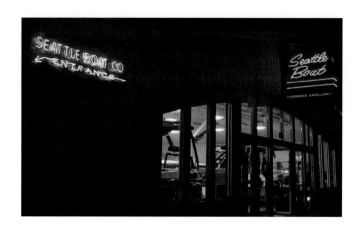

60 years, living in an apartment upstairs. The grocery closed in 1995 when Rosi, 92 years old, was no longer able to work; he died the following year. (formerly 4100 block of Roosevelt Way N.E., 1935)

There's neon on every side of the building at **Seattle Boat Company**, but you'll have to go across the Ship Canal for a good view of the sign on their dry stack storage rack. They're a full-service operation, offering boat sales, maintenance, storage, parts, and fuel. (659 N.E. Northlake Way, seattleboat.com, 1984)

On a rear corner of the College Inn, a historic Tudor-style hotel built to house fairgoers at the Alaska-Yukon-Pacific Exposition of 1909, this neon arrow points to the stairway down to

a windowless basement bar, **College Inn Pub**. After more than 40 years pouring pints, the pub shut down in 2020 with the coming of Covid, causing generations of UW alumni to mourn—but with a campus now practically deserted due to fewer in-person classes and reduced dorm occupancy, the bar's owners couldn't see any way to stay afloat. It didn't remain closed for long, as two former patrons and a friend with restaurant experience reacted to the sad news

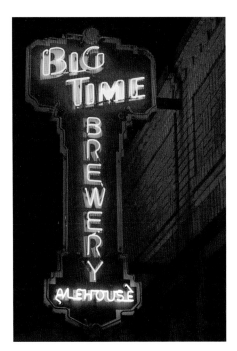

by making an offer. The pub reopened under the new owners in 2021. (4006 University Way N.E., thecollegeinnpub.com, 1974)

After operating a "music-blasting" coffee cart on Broadway in Capitol Hill for most of the nineties, Joel Wood and Doug Sowers upgraded to a permanent space on The Ave in 2001. **Cafe Solstice** isn't just about espresso, though—they're as much about community as coffee, and strong supporters of local artists, whose work decorates the cafe walls and is available for purchase. (4116 University Way N.E., cafesolsticeseattle.com, 1993)

Big Time Brewery & Alehouse opened with three of their own brews on tap in a traditional pub setting of

brick walls, dark wood, and an antique bar. While this would be an unremarkable story today, this happened in 1988, when most of the country was drinking lager made with corn or rice, and craft beer was a niche concept—then, Big Time was something new and different, Seattle's first brewpub since Prohibition. They now make upwards of 30 different beers each year, with a rotating selection of twelve taps (one of them usually a cider) and a hand-pumped cask-conditioned real ale. (4133 University Way N.E., bigtimebrewery.com, 1988)

Fadi Hamade opened **Flowers Bar & Restaurant** in 1992, naming the new Mediterranean restaurant for the vintage neon sign that wraps two sides of the corner building. Undoubtedly splendid in its time, the neon has been non-operational since the early 2000s, and some of the glass tubes are now broken and dangling. The sign reads "Flowers by Wire," a mid-century term for networks of local florists that exchanged orders with those in other areas, allowing customers to send gifts of flowers anywhere in the country.

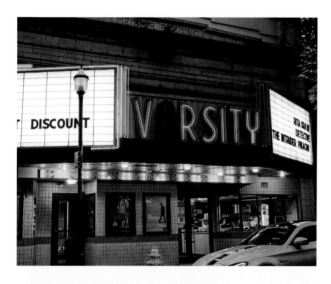

The flower shop was **Flowers by Ness**, owned by Nessim Joseph Peha in the thirties and forties. Trade publication Confectionery and Ice Cream World reported in 1947 that the shop had recently added a candy department, offering boxed chocolates and candy baskets as gift options. Ness Peha's son Joseph Ness Peha eventually took over the business (later known as Ness Flowers), operating it until his own death in 1990. The shop closed shortly after, but one more relic can still be seen: in the film Singles (1992), struggling musician Cliff has a day job driving a Ness Flowers delivery van. (4247 University Way N.E., 1934)

The Varsity Theatre opened with one screen in 1940 in a one-story former grocery, the 1921 Meister Building. In 1955, the auditorium and lobby were stripped to bare walls and floor for a major remodeling, documented in a two-page spread in *Boxoffice* magazine. The article includes a photo of the marquee and notes that it was unchanged by the project—the marquee of 1955 looked exactly like it does now, disregarding the missing neon tube in the letter "A."

When they needed to expand in the eighties, there was nowhere to go but up—the Varsity built two more auditoriums above the original, increasing the height of the building with add-on stories that don't quite match the original cast stone facade. (4329 University Way N.E., farawayentertainment.com, 1940)

The family-owned **U-Neptune Theatre** opened in 1921 as a "photoplay palace," initially showing silent films accompanied by a Kimball pipe organ. A simple and unadorned rectangular canopy then sheltered the entrance. The theatre changed operators in 1943, resulting in removal of the grand organ, a change in name to **Neptune Theatre**, and an enlarged rectangular marquee with the name NEPTUNE in neon over the letter boards on every side.

This marquee was replaced by 1951. The new triangular marquee included the Neptune name in neon on two sides in simple block capitals. Sometime after 1956, these were upgraded to a more stylish font, with that design incorporating a trident, its tines forming the terminal "E." This marquee survived into the twenty-first century, though its size proved problematic—as it projected out further than the narrow sidewalk below, it was struck and dented several times by passing trucks, and employees standing on ladders to change titles on the letter boards were understandably wary of suffering the same fate.

Landmark Theatres operated the Neptune from 1981 to 2010, making several improvements. It was during this era that the theatre became known for a 14-year run of weekly midnight showings of *The Rocky Horror Picture Show*, the longest-running film in Seattle history, and a record that was equalled by only three other theatres worldwide.

In 2011, Craig Thompson, a descendant of the original owners, leased the Neptune to Seattle Theatre Group, the non-profit that operates the Moore (*see* Belltown) and Paramount (*see* Downtown Core). STG converted the movie theatre to a live performance space, ripping out much of the seating to enlarge the stage, while still retaining the equipment to show films—in a nod to continuity, they reopened with a screening of *Rocky Horror*, and still show the cult classic annually.

Meanwhile, the historic yet dangerous marquee was rusted and rapidly deteriorating, as an STG

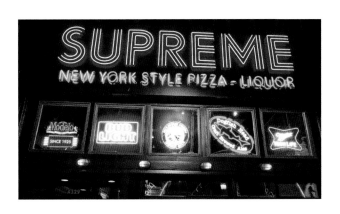

director demonstrated for a TV news crew by flaking bits of it off with his bare hand. In 2018, it was replaced with an entirely new marquee, shown here. While not an exact replica, the overall design is similar to its 1950s predecessor, and the neon "NEPTUNE" and trident are exactly the same style and color as before. The most welcome change is that the movable letter boards have been replaced with computer-controlled LED screens, so that titles may be changed without putting anyone's life in danger. (1303 N.E. 45th St., stgpresents.org, 1921)

This was the original Pagliacci Pizza location, from 1979 to 2018. Upon their departure, West Seattle's **Supreme Pizza** took over the space, offering New York style thin crust pizzas, garlic knots, beer, and alcoholic slushies. Though the focus is as much on the alcohol as on the pie, they maintain a small section of seating for the under-21s. (4529 University Way N.E., supreme.bar, 2019)

Lucky Dog on the Ave is the second physical location of premium men's thrift shop Lucky Dog, started by "two cousins and their dog Frank." While students at Western Washington University in 2013, Jordan Stevens and Gus Hohlbein sold pre-owned shoes, jackets, and T-shirts on Ebay and Instagram, eventually opening a store-

front in Greenwood. To make things more convenient for student customers, they came to University Way (a.k.a. "The Ave") in 2019. The current company mascot is a younger bulldog, Squish, who can often be found at either of the two shops. (4542 University Way N.E., luckydog.clothing, 2019)

Red Light Vintage & Costume sells "your granddad's clothes," as described by Seattle rappers Macklemore and Ryan Lewis, whose 2012 "Thrift Shop" video was partially filmed here. Red Light specializes in a carefully curated selection of vintage clothing and accessories from the 1970s and before, organized by theme—Hawaiian shirts, military coats, wedding dresses, "wacky pants," and more. On the walls inside, look for a neon clock and an antique neon shoe repair sign. (4560 University Way N.E., redlightvintage.com, 1996)

University Seafood & Poultry closed on the last day of 2019, after 75 years owned and operated by the same family. In 1944, then-owner Louis Israel wanted out of the business after his son was killed fighting overseas, and sold the shop to one of his wholesale suppliers, Louis Erickson. Erickson was joined by his wife, Leona, and their three sons, including Dale, then about sixteen. In 1951, Dale Erickson married his high school sweetheart, Jeanette, who then came to work in the shop. Dale and Jeanette would eventually take over the business and operate it for the remainder of its 75-year run.

No ordinary fishmonger, University Seafood also dealt in poultry, eggs

(including duck and quail), and meats. These ranged from the uncommon but generally accepted—rabbit, elk, goat—to the truly exotic—kangaroo, alligator, llama, iguana, camel, and python, a $40 per pound delicacy which Dale described as tasting like "mild nothing." They shipped caviar to Reagan's White House, king crab to Kirk Douglas, and supplied the city's most exclusive clubs and best restaurants.

In 2019, the Ericksons, 91 and 89 years old, made the tough decision to close permanently. The work was physically exhausting, and although a grandson was willing to take over, trouble was looming in the form of new construction that would make on-street parking next to impossible for their customers. When they made the announcement in December, news media and longtime customers alike flocked to the seafood shop to say goodbye. (formerly 1317 N.E. 47th St., 1944)

There are two **Shawarma King** restaurants on University Way, just a few blocks apart. It's the one north of 52nd that has this neon, proudly displaying the Egyptian origin of their cuisine. (5241 University Way N.E., shawarmakingus.com, 2016)

Mohammed Arfan Bhatti, owner of **Taste of India**, learned the restaurant trade from his father, Mohammed Bhatti, former owner of Cedars Restaurant just off University Way. Taste of India offers a wide range of vegetarian and non-vegetarian Indian cuisine, including a large selection of tandoori items roasted in a traditional clay oven. The senior Mr. Bhatti now operates Saffron Grill at Hotel Nexus (*see* Northgate). (5517 Roosevelt Way N.E., tasteofindiaseattle.com, 1991)

Rodriguez and Erickson bicycles are made and sold only here, at **R+E Cycles**. Angel Rodriguez and Glenn Erickson, who had both worked as bicycle mechanics while studying zoology and oceanography, respectively, met at bike racing events and began planning their own repair shop. They quit school, rented a storefront, and within a year were performing frame repair, then building custom frames.

R+E Cycles' neon sign is, of course, a bicycle. It's full size, and the spokes of the wheels are animated, each segment lighting up in turn to give the illusion of rotating wheels. (5627 University Way N.E., rodbikes.com, 1973)

12.
Northeast Seattle

Roosevelt

GLO Cleaners has been a family business at this same location since 1955. They now emphasize their new environmentally-friendly cleaning process. When I visited the site at night recently, only the word "Cleaners" was in working order; for now, at least, this sign looks best during the day. (7857 Lake City Way N.E., glocleaners.com, 1955)

The neon signs in the windows of **Zaina Food Drinks & Friends** are all readily found elsewhere, as none appear to be custom made. What makes this tiny restaurant so impressive is the quantity—at least sixteen neon or imitation neon (LED) signs on the front, twelve more on the back and sides, at latest count. And, yes, they have gyros. (8000 Lake City Way NE, 2013)

Standard Radio and Electric Company is long gone. The radio shop and repair center had relocated several times in the 1930s and 40s, finally settling on their final location at 1028 N.E. 65th St. in 1947, a one-story building with a facade of "Vitrolite" high-strength pigmented glass. Standard installed a neon sign that spanned the width of the building, with long glass tubes that followed the curvature of the Vitrolite canopy. In 1987, long-time employee Jim Goff purchased the business and renamed it **J n S Phonograph Needles**, but the "Standard" neon remained until the shop closed in 2010.

The phonograph shop and neighboring buildings were then condemned to make way for a new light rail station, connecting the Roosevelt neighborhood to downtown Seattle and the airport. Standard's neon sign and part of the Vitrolite facade were salvaged,

restored, and placed in the concourse of the new **SoundTransit Roosevelt Station**. The station opened to the public in October 2021. (1034 N.E. 65th St., soundtransit.org, 1932)

Bus Stop Espresso & Gyros began as a coffee cart next to the Green Lake Park & Ride lots under Interstate 5. Two years later, they found a permanent home in the former copy center building on the corner. In 2013, the family that owns Taki's Mad Greek Restaurant took over the coffee shop, adding gyros and falafel to the menu. (800 N.E. 65th St., busstopespresso.com, 1993)

With forty taps, **The Toronado Seattle** was a beer bar. Experienced bar manager Matt Bonney created Toronado, named for a legendary beer bar in San Francisco, with the encouragement and support of the original Toronado's owner. Bonney died unexpectedly in his sleep in 2019, at the age of 45. The following year, Covid shut down all of Washington's drinking establishments, and Toronado Seattle announced that their closure would be permanent. (formerly 1205 N.E. 65th St., 2014)

Miniature palm trees combine with neon to form the crown atop **Royal Palm Thai Restaurant**, located on the upper level of the Roosevelt Court building. The restaurant has been family-owned for 30 years. (6417 Roosevelt Way N.E., royalpalmseattle.com, 1990)

Ravenna

General Porpoise Doughnuts is part of a larger theme: "Sea Creatures," a group of restaurants owned and operated by chef Renee Erickson, all with nautical names. Their huge pink neon sign is visible from several blocks away. (4520 Union Bay Place N.E., gpdoughnuts.com, 2018)

In sociology, a "third place" is an environment separate from the home and the workplace, such as a club, a park, a church, or a bookshop, that forms an anchor of community life. **Third Place Books Ravenna** is the second location of the regional chain named for this concept. (6504 20th Ave. N.E., thirdplacebooks.com, 2002)

This is the original **Burgermaster**, started by Phil Jensen in 1952. After closing his original restaurant downtown when he lost the lease, Jensen was invited by property owners Don and Bud Mowat to create something new at this location near University Village. Phil's wife Mary, an avid gardener, designed and planted the flower garden surrounding the neon steer. Burgermaster has since expanded to five locations, managed by Phil and Mary Jensen's descendants, most with similar neon steers. (3040 N.E. 45th St., burgermaster.biz, 1952)

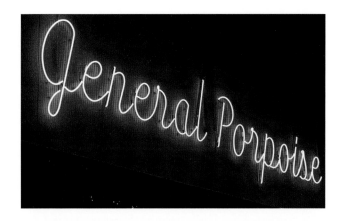

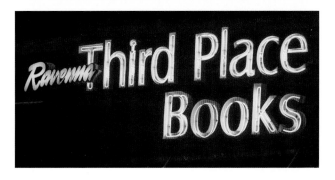

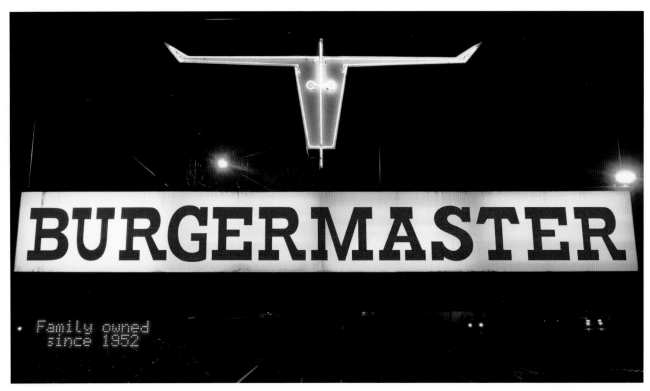

This was the second **Mioposto** pizzeria to open, after the original in Mount Baker (*see* Rainier Valley). The vertical neon sign reading "Pizzeria" and "Bar" is identical to the original, but this northern outpost adds additional horizontal neon with the Mioposto name. (3426 N.E. 55th St., miopostopizza.com, 2014)

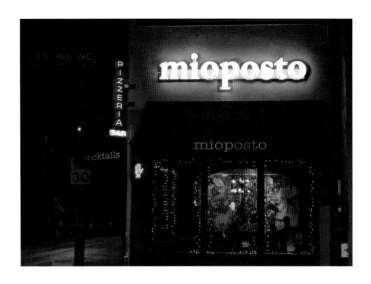

Laurelhurst

Not a name but an acronym, "JaK" refers to the steakhouse's two creators, Jeff Page and Ken Hughes. The original **JaK's Grill** started in West Seattle in 1996. This one has been grilling since 2003. (3701 N.E. 45th St., jaksgrill.com, 2003)

The neon logo of **Avanti Sports** includes the tricolor Italian flag. The only specialty tennis shop in Seattle relocated from Mountlake Terrace to Laurelhurst in 1992. (3501 N.E. 45th St., avantisports.com, 1984)

Museum Quality Framing has several picture-framing shops around the city with identical neon. The lettering is in a labor-intensive serif

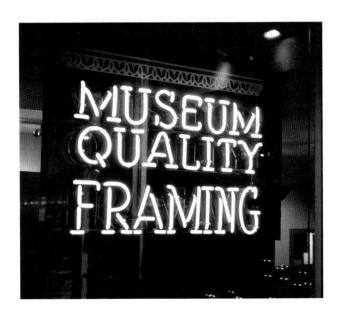

font, an unusual choice for small neon signs, but one that conveys the traditional and dignified atmosphere of a museum. (3717 N.E. 45th St., pnwframing.com, 1988)

Bryant

With a name like **Seattle Sunshine Coffee**, this cafe seeks to dispel the myth that it rains all the time here. Inside, the shop is bright and spacious, with a Chihuly-style hanging glass sculpture dominating the dining room. (5508 35th Ave. N.E., seattlesunshinecoffee.com, 2016)

Windermere

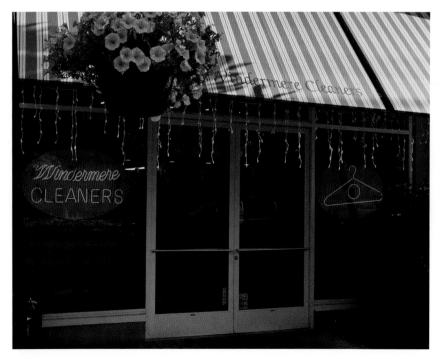

The upscale residential neighborhood of Windermere doesn't have much of a business district, as it's just a short drive to University Village. The only custom neon is in the windows of **Windermere Cleaners**. (5410 Sand Point Way N.E., 1984)

Wedgwood

"Make bread, Not war" adorns the takeout bags at **Grateful Bread Baking Company & Cafe**. The pastry and sandwich shop further expresses a hippie aesthetic with vividly colored murals of farming scenes, a movable folk art "Open" sign, and a life-sized cut-out portrait of Jerry Garcia drinking coffee. The winged bread logo appears in the paintings, and is also rendered in neon over the main entrance and atop a pole in the parking lot. (7001 35th Ave. N.E., gratefulbreadbaking.com, 1996)

Marshall Jett and Errin Byrd started selling pizza at the Ballard Farmers' Market in 2004, baking it in "Terracotta Baby," a portable applewood-fueled pizza oven they'd built themselves. They opened their first permanent **Veraci Pizza** location in Ballard, then this second in Wedgwood in 2016. In their neon sign, the tube illustrating the flame is filled with beads to give a "crackle" effect, with the light constantly flickering and changing as the electrical charge seeks new paths between the glass surfaces. (7320 35th Ave. N.E., veracipizza.com, 2016)

Previously located across the street from GLO Cleaners, **Wild West Cars & Trucks** moved here around 2008, taking their neon cowboy hat and longhorn bull horns to the new lot. At the time of my visit, the neon was no longer operational. (8830 Lake City Way N.E., wildwestcarsandtrucks.com, 2003)

Growing up on a farm, Walter Haines had always wanted to be a musician, but his promising career as a tuba and bass player was cut short by the Great Depression, when no one had the money to attend live performances. This was 1933, the same year that Prohibition ended, and all across the country new

taverns were opening. Walt found the idea appealing, and built **Fiddler's Inn** from the ground up, including living quarters in the back. He sold the bar in the 1960s to pursue a new business venture, manufacturing musical spoons with his business partner, television bandleader Lawrence Welk. (9219 35th Ave. N.E., thefiddlersinn.com, 1934)

13.
Lake City

Meadowbrook

In the window of **European Psychic**, the seven chakras are illustrated in neon, each in its characteristic color. Palm reading, tarot cards, crystals, or chakras—whatever your preference, whether in the Eastern

or Western tradition, they'll read your fortune. (10550 Lake City Way N.E., european-psychic.business.site, 2010)

The previous neon sign here read "Pacific Northwest Carpet & Flooring," with only "CARPET" in neon. In 2005, the carpet shop combined with a nearby paint and tile store, and the company became **Pacific Northwest Flooring**. Now with a broader variety of flooring options available, the neon was replaced with a new sign, of a similar size and design, with the emphasis on "FLOORING." (11724 Lake City Way N.E., 1990)

Victory Heights

Husband and wife Corry and Janet started Sunshine Carpet Cleaners in 1967. In 1971, they purchased the former Lake City Cleaners at this location, changing the name to **Corry's Fine Dry Cleaning**. Corry's now has eight locations in Seattle, Edmonds, and Tacoma. (12025 Lake City Way N.E., corryscleaning.com, 1971)

Seattle's favorite burger chain, **Dick's Drive-In**, opened their fourth location here in Lake City in 1963. The building, its neon logo, and the freestanding sign with neon directional arrow and revolving top are nearly identical to those at the original restaurant (*see* Wallingford). (12325 30th Ave. N.E., ddir.com, 1963)

Olympic Hills

Crew Cuts Hair Salon has two locations in Lake City, just a few blocks apart. (12500 30th Ave. N.E., by 2008)

Cedar Park

Lake City Power Sports started as "Honda City" in 1965, selling and servicing Honda bikes. In 1995 they added the Kawasaki brand. Their brilliant neon logo has become a neighborhood landmark, often used as a backdrop for news reports, and was even featured on the cover of a novel. (12048 Lake City Way N.E., lakecitypowersports.com, 1965)

In 2011, Ezell Stephens, eponymous cofounder of Ezell's Famous Chicken (*see* Central Area), parted ways with his original fried chicken restaurant chain after years of financial and trademark disputes soured the relationship with his former

business partners (his ex-wife and her brother). As part of the settlement, the locations personally owned by Ezell became **Heaven Sent Fried Chicken**—because, as Ezell said upon first seeing people lining up for his chicken back in 1984, "This is heaven sent." (14330 Lake City Way N.E., heavensentfriedchicken.com, 2011)

14.
Northgate

Maple Leaf

Reservoir Bar & Grill, or "The Rez," has been across the street from the actual Maple Leaf Reservoir since 1934. This neon sign is a recent upgrade, installed after 2011; the older design displayed only "Reservoir" in simple blue capitals. If you came here for public art as I did, be sure to also check out the impressive mural of Mount Rainier on the tile shop next door. (8509 Roosevelt Way N.E., 1934)

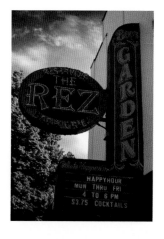

"Burn Netflix," reads the banner in front of **Reckless Video**, and with good reason, as streaming video services have destroyed local video rental businesses. Reckless Video was one of the last two holdouts in Seattle, having survived a devastating fire in 2002 at its original location across the street. Through the 2010s, business declined, and the shop eventually was operating at a loss—kept afloat only by owner Mike Kelley's passion for

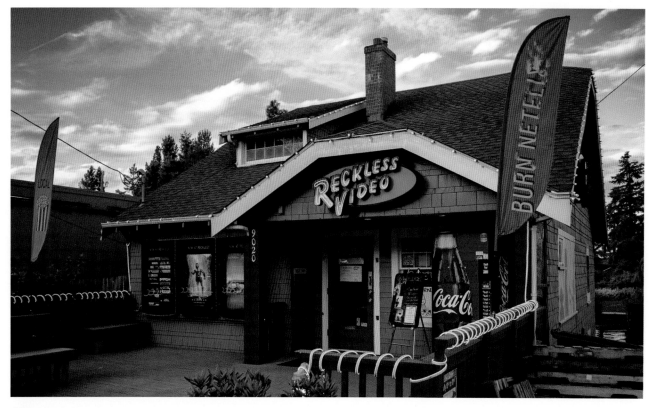

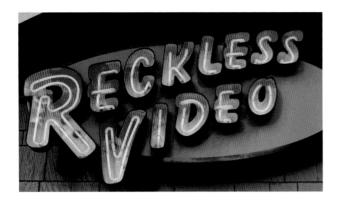

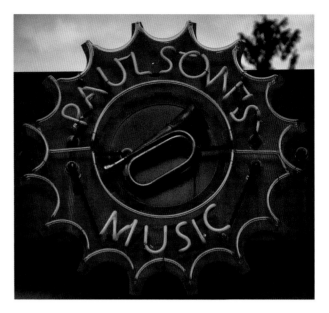

the concept and profits from his nearby hardware store. With the coronavirus pandemic, in-person video rentals declined even further, and in May 2021 Kelley announced that Reckless would permanently close at the end of July.

The video shop's two neon signs have lettering in the style of the *Indiana Jones* movie titles. To achieve a color gradient effect, the artist formed each letter by welding a segment of pink-coated glass tubing to a white-coated piece. (formerly 9020 Roosevelt Way N.E., recklessvideo.com, 1990)

With 35 years experience, Mike Paulson of **Mike Paulson's Brass Masters** is an expert in the repair and customization of brass instruments. As a professional trumpeter, he's also worked with some of the greats, including Quincy Jones, Dionne Warwick, Natalie Cole, and the Four Tops. (9612 Roosevelt Way N.E., mikepaulsonbrassmasters.com, circa 2010)

Northgate Center started in 1950 with 18 shops facing each other across an open-air walkway. By 1952, there were 70 tenants, including a hospital, a 1300-seat movie theatre, and The Bon Marché. In 1973, a series of renovations fully enclosed the central concourse and Northgate Center officially became **Northgate Mall**.

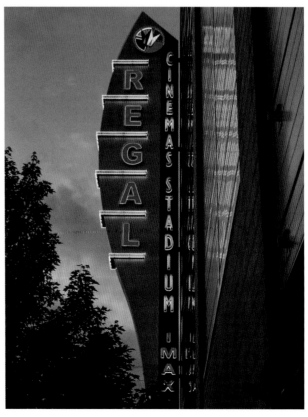

The retail apocalypse of the 2010s hit Northgate hard, with several of the site's anchor stores closing. JC Penney announced their departure in 2018, followed soon after by The Bon Marché (now rebranded as Macy's). Nordstrom closed their store in August 2019, though Nordstrom Rack remained.

Mall owners Simon Property Group were hard at work on an alternate use. They found a partner in the Kraken, Seattle's new professional hockey team. According to plans filed with the city, the

mall buildings will be radically transformed into a mixed-use development of retail, apartments, and an "Ice Centre" hockey practice space. As of Summer 2021, much of the complex has been demolished, but the tower at the south entrance, with its neon, is intact. (300 3rd Ave. N.E., simon.com, 1950)

National theater chain **Regal Cinemas** occupies a sizable portion of Thornton Place, a mixed-use residential and retail building on what was once Northgate Mall's south parking lot. Inside, there's plenty of neon as well, including an enormous "Concessions" sign and multicolored trim at the tops of the walls. (316 N.E. Thornton Pl., regmovies.com, 2009)

Haller Lake

Built in 1968 as a Ramada Inn, this then three-story hotel included a rooftop neon sign with the Ramada Inn name in huge magenta letters. In 2006, with a major renovation, the now-independent hotel rebranded as **Hotel Nexus**. The on-premises restaurant, **Saffron Grill**, replaced the former Berkshire Grill in 2008. (2140 N. Northgate Way, hotelnexusseattle.com, 1968)

Peter Hansen and his wife Metta started the P. Hansen Transfer Company in Pioneer Square in 1890, using horse-drawn wagons to haul customers' freight. They next expanded to the University District. When sons Henry and Jim joined the business it became **Hansen Bros. Moving & Storage**. The company has stayed in the family, with the current owner and president a great-grandson of Peter Hansen. (10750 Aurora Ave. N., hansenbros.com, 1890)

One of many motels that line this stretch of Aurora Avenue, **Nites Inn Motel** is a three-story L-shaped building with exterior walkways, wrapped around two sides of a large parking lot. It's across the street from Evergreen Washelli Cemetery, so guests are at least assured of quiet neighbors. (11746 Aurora Ave. N., by 1994)

With a surname pronounced like "putts," Peter and Alvin Puetz were well suited for a life in the golf business. As children in the 1920s, they got into the sport by caddying at Seattle Golf Club, but had to leave it behind for better paying jobs in a downtown meat market. In 1945, Al quit his butcher job to open a driving range on Aurora Avenue, with Pete helping out part-time. As golf equipment was then generally sold only at golf courses, the brothers saw another opportunity, and began selling clubs and accessories directly to the public. This, plus their low-priced driving range—only sixty cents for a basket of balls—made golf available and affordable to everyone.

The driving range became **Puetz Golf Seattle Superstore**. Their spectacular neon sign stands at the end of the store's driveway, arrows pointing the way. Both brothers lived past the age of 90, with Pete's son David eventually taking over the business. (11762 Aurora Ave. N., puetzgolf. com, 1945)

Pawn shop **Aurora Loans** was owned and operated by the same family for 25 years. In 2020, the company

announced that they would be closing permanently due to losing their lease. The building will be torn down to build condos. (formerly 12220 Aurora Ave. N, 1995)

Where Aurora Avenue meets the northern city limits of Seattle, you'll find this eye-catching neon plunger at **Aurora Plumbing and Electric Supply**. The plunger itself remains stationary as the illuminated box with the company name continuously rotates. (14330 Aurora Ave. N., auroraplumbing.com, 1960)

Pinehurst

You'll find the best of Pinehurst's neon on display indoors—this vintage Budweiser sign over the bar at **The Pinehurst Pub**. (11753 15th Ave. N.E., thepinehurstpub.com, by 2004)

15.
Northwest Seattle

Greenwood

At **Über Tavern** you'll find beer, beer, and Bier (to use their preferred German spelling). With 17 taps and over 200 varieties in bottles and cans, they're specialists in the hoppy stuff, both local and imported. (7517 Aurora Ave. N., uberbier.com, 2006)

When neon advertising signs first began appearing in the 1920s, they were like nothing ever seen before, and the new medium came to be described as "liquid fire." This is aptly illustrated by the neon at **The Wing Dome**, where the glass tubing has been shaped to resemble flickering flames. The hot wing restaurant describes itself as "Seattle's Fire Since 1994." (7817 Greenwood Ave. N., thewingdome.com, 1994)

"Time for Masonry" reads the street clock outside **Greenwood Masonic Lodge #253**, featuring the square and compass symbol at its center. That same symbol appears in neon above the door. Greenwood Lodge began in 1922 and moved into this purpose-built Masonic Temple in 1924. (7910 Greenwood Ave. N., greenwood253.org, 1924)

Before it was a QFC, this was **Art's Food Center**. Together with property owner Dick McAbee, supermarket operator Arthur Case built what would come to be called "Art's Plaza" in 1956. The new supermarket was designed with all the latest high-tech features: conveyor belts at the checkouts, freezer cases, and electronic scales. In the same building would be a drugstore, post office, a restaurant, and an apparel store, making the plaza a full-service shopping destination—an innovative idea at the middle of the century.

At the edge of the parking lot was a towering steel frame, bristling with signage for the businesses in the plaza. At its top was a hollow sphere, about ten feet in diameter, with two red neon signs reading "Art's."

In 1998, two years after Art Case died, Bellevue-based **Quality Food Centers** (QFC) purchased Art's Plaza. As they had recently done at the Wallingford Food Giant, QFC kept the neon sign, with alterations. The sphere remained (the signs for the other businesses, midway up the tower, were long gone), with the red neon "Art's" replaced with blue "QFC" lettering. (9999 Holman Rd. N.W., qfc.com, 1956)

The CubeSmart self-storage facility on Aurora stands on the former site of the **Klose-In Motel**. When the motel was built in 1930, as the Klose-Inn Auto Court, Aurora Avenue was shiny and new, the preferred way for Seattle residents to get away for the weekend. In 1951, Klose-In added a freestanding neon sign with a bold mid-century modern design—red and green neon mounted on yellow cabinets, saying "Klose-In Motel," "(No) Vacancy," "Weekly Rates," with a bent arrow made of hundreds of incandescent bulbs pointing to the door. As if that were not enough, the sign included clock faces on either side, each in a neon circle.

Aurora Avenue lost its luster in the second half of the century. The construction of Interstate 5 meant that Aurora was no longer the best way to get out of town, and it gained a reputation as the seediest part of Seattle. The motels that had once serviced families and business travelers became notorious for drug dealing and prostitution. Klose-In shut down in 2014, shortly after a natural gas explosion severely burned a man and destroyed one of the rooms. The motel was boarded up, and squatters moved in.

Upon hearing that the site was to be demolished, preservationists grew concerned about salvaging the iconic neon sign. The Museum of History and Industry came to the rescue and recovered Klose-In's neon. Though it is not on public display, the sign is safely in storage at a MOHAI warehouse. (formerly 9309 Aurora Ave. N., 1930)

Rich's Custom Upholstery has been in business since 1975. Their two-color neon sign is made all the more striking with the inclusion of the model convertible. (10003 Aurora Ave. N., richscustomupholstery.com, 1975)

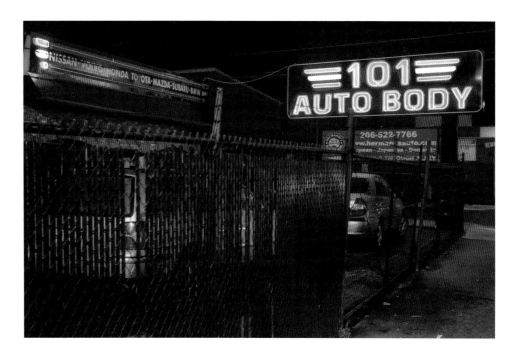

The huge neon sign at **101 Auto Body** is easily visible from several blocks away. There is matching red, white, and blue neon trim on the building itself, but most of this was not functioning at the time of my visit. (10059 Aurora Ave. N., by 1985)

Like several other local Chinese restaurants, **China Dragon Restaurant** uses a simple printed sign, with additional neon only to outline a pagoda-style roof. (10119 Aurora Ave. N., by 2008)

Crown Hill

Sports bar and grill **Goofy's Bar** opened in 1973 and remains a well-liked neighborhood destination. Their unusually large neon installation provides a friendly orange glow across the entire front of the building. On the side next to the parking lot, there's a mural illustrating the activities within—drinking, dancing, billiards, and sports on the TV. (8519 15th Ave. N.W., 1973)

The present **Fire Station 35** was built in 2010, replacing a 1942 fire station on the same site. The city commissioned artist Kay Kirkpatrick to create the neon and metal sculpture, Rescue. The design features a ladder, flames, and the station's number, "35." The artist chose to work with neon in order to complement the 1950s architecture of this part of the city. (8729 15th Ave. N.W., seattle.gov/fire, 2010)

The Holman Road **Dick's Drive-In** was the third Dick's location to open, in June of 1960. The design is similar to the earlier Wallingford and Broadway branches. (9208 Holman Rd. N.W., ddir.com, 1960)

After being laid off from a corporate job in 1995, Karissa Bresheare took a crash course in all things espresso and opened her first **Gourmet Latte** drive-up coffee stand in Lynwood. Bresheare's stepfather helped out by constructing the tiny building at home and trucking it to the site. The company now has 21 such shops around the area. The Crown Hill location was the fifth, one of several that uses this exact design, featuring two stripes of green neon tubing wrapping the edge of the roof on all four sides. (8762 Holman Rd. N.W., gourmetlatte.com, 1995)

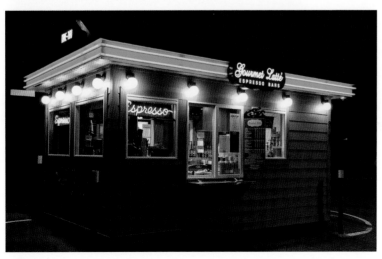

Bitter Lake

The over-the-sidewalk neon sign at **Tim's Tavern** is new, installed in 2012. The tavern itself is not—beer has been served in this space since 1937. Originally Jack's Tavern, then Mackey's, it was the 105th Street Tavern from the 1950s until Tim Arnot purchased the business in 2011, shifting the focus to live music.

In August 2021, Tim's announced that it was permanently closing at this location, due to excessive rent increases during the pandemic. The neon will be going into storage as they search for a new home. (formerly 602 N. 105th St., timslivemusic.com, 2011)

Rickshaw Restaurant has been operating under that name since 1976, when Georgina "Ginger" Luke purchased the former Kowloon Chinese Restaurant, renamed it, and added a prodigious quantity of neon. The Rickshaw has many identities—a restaurant serving Chinese-American food (dine-in or delivery), a neighborhood dive bar serving hamburgers and tacos, and a karaoke lounge.

Ginger Luke's true calling, however, was none of those things. When making deliveries to a regular customer in 2006, Luke's husband Jakob Lueck heard a dog barking in distress with every visit. Ginger investigated and found a mite-infested dachshund that had been confined to a bathroom for eight months, with a collar so tight it dug into his flesh, and an indifferent owner claiming he was a "mean" dog that should be put down. She bought "Barney" on the spot for $50, took him to a veterinarian, and found him

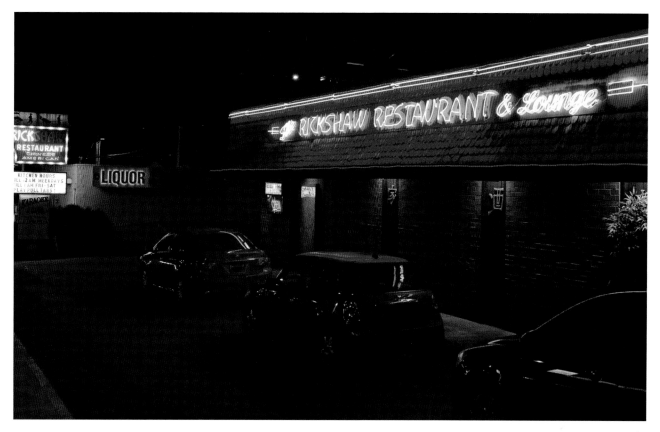

a new home by emailing everyone she knew.

Barney was the first of many. Luke's kindness and persistence soon became well known in the pet rescue community, and she was inundated with requests to rehome other "death row dogs"— those considered too old or disabled to be adopted. Operating from a table in the restaurant, she received and answered hundreds of emails daily, all about dogs in need. Ginger and Jakob were soon driving all over the region with a van full of

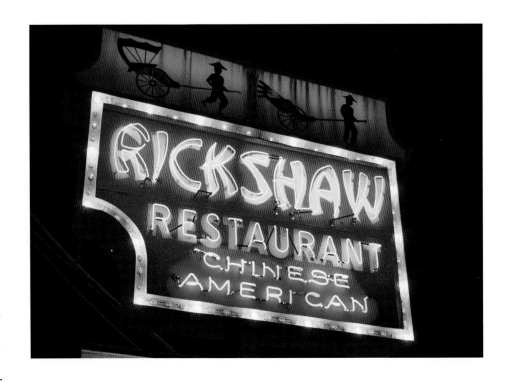

kennels, picking up unwanted dogs and delivering them to volunteers who provided foster homes. Within a year this had developed into Ginger's Pet Rescue, funded in part by profits from the restaurant. In 2014, Luke sold the Rickshaw to focus on rescue work. **Ginger's Pet Rescue**, which has saved over 18,000 dogs, continued under Ginger Luke's active leadership until her death in September 2021. (322 N. 105th St., therickshaw.net and gingerspetrescue.org, 1976)

Emerald Motel was known as Orion Motel until new owners took over in 2015. (12045 Aurora Ave. N., emeraldmotelseattle.us, by 2007)

Immediately south of Emerald Motel is the former **Seal's Motel**, famed for its neon sign—a seal in blue, perched on a red and white circus plinth, balancing a multicolored beach ball on its nose. "Seal's Motel, Kitchenettes & TV" appeared next to it in neon. This much-loved neon sign, the subject of postcards and paintings, disappeared by 2007, replaced with an illuminated plastic box with a simple illustration of the seal.

In 2018, the motel was renamed Seattle Inn Northgate, and one drab plastic box sign replaced another. Underneath, you can still find the original yellow support posts and horizontal message board, the only visible remnants of one of this city's most recognizable works of neon art. (formerly 12035 Aurora Ave. N)

The towering neon sign at **Black Angus Motor Inn** was looking shabby long before the motel permanently closed at the end of 2009. Then called the Seattle Motor Inn, it was considered one of the worst in the city, with 160 incidents requiring police presence in 2008 alone, and enough health violations that the state suspended its license.

Like much of Aurora Avenue North, the motel had a respectable origin before its descent into squalor. Born in Tacoma and raised in Seattle, Stuart Anderson

opened his first hotel shortly after World War II. The hotel included a restaurant, which went through a number of changes of name before becoming the Black Angus in 1964, serving beef from Anderson's own Washington ranch. Anderson had a winning concept, and new Black Angus locations began to spring in Spokane and Bellevue. The fourth branch opened on Aurora Avenue in 1969, sharing a parking lot with the nearby motel—an existing structure that then became Black Angus Motor Inn. The steakhouse theme even extended to the furnishings—an old postcard shows the interior of the motel rooms, with blood-red carpeting and bed covers.

Though the restaurant chain continues to operate elsewhere, the Aurora Avenue location was eventually sold, becoming 125th Street Grill in 1996. The motel, too, changed hands and changed its name, though removing the now-inaccurate neon sign was apparently not a priority for the new owners.

When I visited the abandoned motel in early 2019, it was still standing and even had electric exterior lights functioning, but all doors and windows were boarded up, and the site was surrounded by chain-link fencing, except for the front section where the office was located. Over the office door were some smaller neon signs—"Office," "Register Here," and "Sorry." All of this was dark, with several of the glass tubes broken and dangling. (12245 Aurora Ave. N., 1964)

The brilliant white neon sign of **Kiriba Sushi & Grill** is made all the more striking by the backlit chef's knife. (323 N 145th St., circa 2010)

Gazing at this neon beer stein, I could not help but think that the name of **The Cellar Homebrew** was somehow familiar, though I had never been to this remote corner of the city before. Indeed it was— the homebrew supplies store does much of their business online, and I'd been a customer of theirs over a decade before setting foot in Seattle, when I had ordered brewing supplies to be shipped to my then-home in Chicago. If you need a giant stock pot with a spigot at the bottom, a copper wort chiller, a six-pound jar of malt syrup, or a vacuum-sealed packet of hops, you'll find it here. (14320 Greenwood Ave. N., cellar-homebrew.com, 1972)

Broadview

On the neon sign at **Saltoro**, the two letter O's are animated, bouncing up and down. Chef and co-owner Cesar Mendez began his kitchen career as a dishwasher at the Palisade, working his way up to lead chef. (14051 Greenwood Ave. N., saltoroseattle.com, by 2006)

At **The Pub at Pipers Creek**, the neon angler is animated, drawing his fishing rod behind his back and then casting it forward. As the actual Piper's Creek is in Carkeek Park, a few blocks west of here, the closest "fish" was the one on the roof of the building directly across the street from the pub. From 1951 until 2014, a large metal fish atop Sandy's Sea Foods would hold its mouth in the open position when the fish market was open, closing it when the shop was closed. (10527 Greenwood Ave. N., 1999)

When I arrived at **Bick's Broadview Grill** on a Saturday evening in January 2019, the only sign of life there was this animated neon chef. About once every second, the chef would raise his skillet, flipping a steak into the air and catching it again. Below, the parking lot was empty and the restau-

rant dark and quiet. A note taped to the front door reported that the owners were on a multi-week vacation and the restaurant would soon resume service. However, it never reopened, and local newspapers were

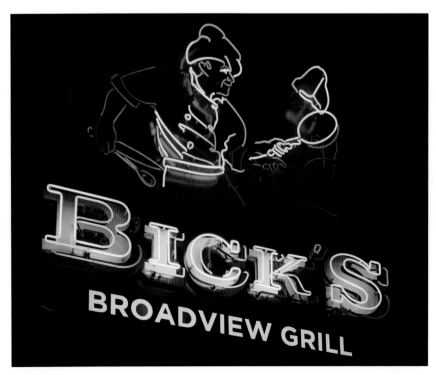

soon reporting that Bick's had permanently closed. Bick's menu featured an emphasis on the hot and spicy, with a grilled habanero appetizer called the "Firestarter" and a collection of hundreds of bottles of hot sauce on display. (formerly 10555 Greenwood Ave. N., 1997)

16.
Rainier Valley and Seward Park

Mount Baker

Taking its name from a distant volcano that dominates the horizon across Lake Washington, the Mount Baker neighborhood began as a planned community in 1905, with tree-lined, curved residential boulevards laid out by the renowned Olmsted Brothers landscape architecture firm. In the 1920s, as the isolated community's population grew, developers saw a need for a shopping center and commissioned the neighborhood's first commercial building, an Art Deco structure of brick and cast stone.

This location proved suitable for a pizzeria inspired by the street cafes of Europe, and it was here that the first **Mioposto Pizzeria** opened in 2006. The restaurant features pizza baked in a wood-fired oven, wines from Washington, cocktails, and espresso. Mioposto has since expanded, with two more Seattle locations equipped with similar neon signs, and one on Mercer Island using a different design. (3601 S. McClellan St., miopostopizza.com, 2006)

On the curved northwest face of that same historic building is **Changes Hair Studio**. The small storefront is dominated by its red and blue neon tubes, combining to produce a purple glow that spills out onto the sidewalk at night. They've been styling here for more than 30 years. (2807 Mt. Rainier Dr. S., 1989)

Columbia City

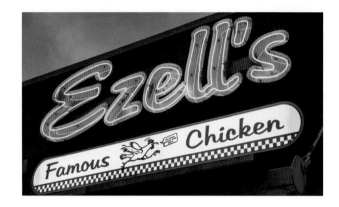

Family-owned **Ezell's Famous Chicken** *(see* Central Area*)* began offering franchise opportunities in 2013. The first such location to open was this one, part of a neighborhood shopping center. (4436 Rainier Ave. S., ezellschicken. com, 2013)

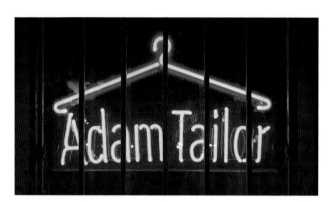

This neon shirt hanger is at the second location of **Adam Tailoring & Alterations**. The tailor shop specializes in traditional Vietnamese formal wear. (4517 Rainier Ave. S., 1984)

Columbia Funeral Home has long been a neighborhood institution, known city-wide for its annual Christmas light display. In 1907, Fred and Georgia Rasmussen purchased a house on this site to start their mortuary business, building on to it as they expanded. The huge neon sign across the front was added sometime before 1940. Longtime employee Wilbert Lewis purchased the funeral home in the 1950s, passing it on to his son Paul, who sold it to the Weeks family in 2006. Columbia has remained family-owned and independent, even as most funeral homes in America have become corporate. (4567 Rainier Ave. S., columbiafuneralhome.com, 1907)

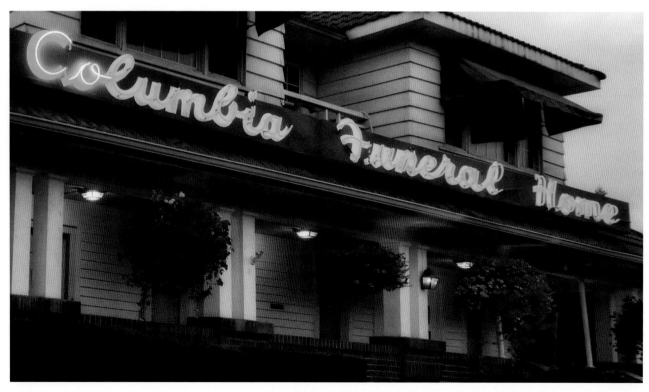

Joe Ackley started what would become **Bob's Quality Meats** in Yakima in 1909, selling meat from a mule-drawn wagon. His son Bob brought the business to Seattle in 1963, eventually taking over another long-standing butcher shop in the present Columbia City storefront. The neon sign was installed around 2010. (4861 Rainier Ave. S., bobsqualitymeats.com, 1909)

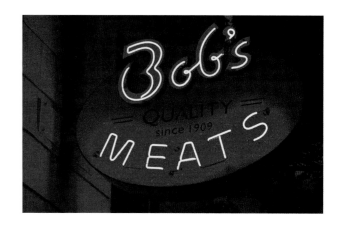

Columbia City Bakery specializes in flavorful bread, made with a "long, slow fermentation process." They also offer such delights as cheese puffs, pretzel bites, and cinnamon rolls. (4865 Rainier Ave. S., columbiacitybakery.com, 2005)

Theo Martin purchased a Caribbean cafe from a friend, combining their island menu with the Louisiana cuisine he'd learned from his father to create **Island Soul Rum Bar & Soul Shack**. You'll find favorite dishes from both regions—jerk chicken, bone-in goat curry, plantains, gumbo, catfish, chicken and waffles, to name a few. Island Soul moved to this Rainier Avenue location in 2007, adding neon a few years later. (4869 Rainier Ave. S., islandsoul-restaurant.com, 2005)

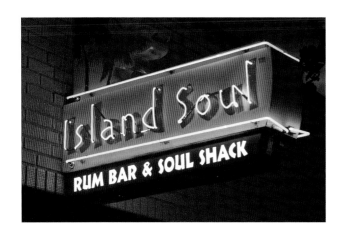

Seattle Gymnastics Academy provides gymnastics instruction and builds kids' self-confidence in four gyms around Seattle. The Columbia City location features two neon gymnasts, a girl and a boy, each of them animated to move through five positions as the neon segments light up in turn. (5034 37th Ave. S., seattlegymnastics.com, 2010)

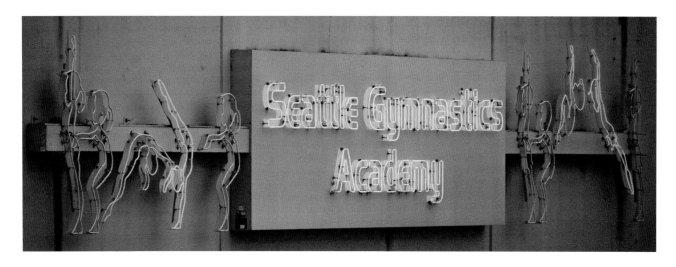

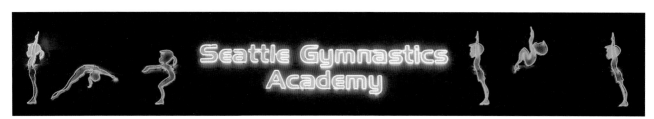

Brighton

Cederstrand Rentals leases and maintains a number of apartment buildings in the South End. (7621 Rainier Ave. S., cederstrandrentalsllc.com, 1970)

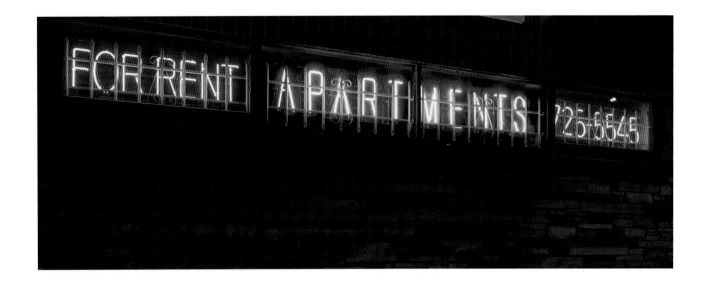

Rainier Beach

A neighborhood bar and Cajun restaurant, **Jude's Old Town** was named for its founder's mother, Judi Brown, whom they describe as "an art maven, piano bar aficionado, devout people-person, and absolute riot of a woman." (9252 57th Ave. S., judesoldtown.com, 2014)

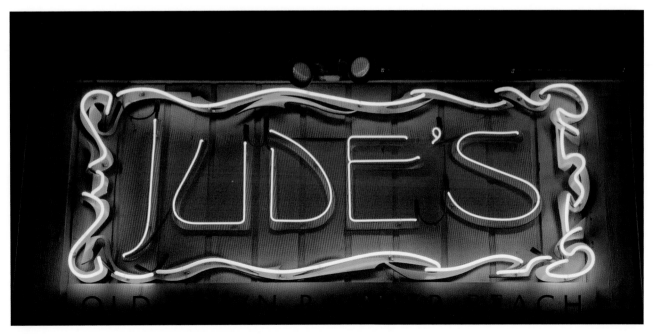

Seward Park

The neon at **Flying Squirrel Pizza Co.** proudly states they use "NO MSG"—a curious declaration for a pizza place, where the question of MSG rarely comes up. But before it was a pizza place, this space was Lee's Chinese Restaurant, and the sign had been left behind by the previous occupants. (4920 S. Genesee St., flyingsquirrelpizza. com, 2009)

Caffe Vita began in Lower Queen Anne in 1995, then expanded throughout Seattle and into Portland and New York. Most of their Seattle shops, including this Seward Park outpost, feature a neon sign depicting Punchinello, a masked clown from the Italian Renaissance. The clown's arm, holding a coffee cup, animates between three positions, raising the cup as if making a toast. (5028 Wilson Ave. S., caffevita.com, 2008)

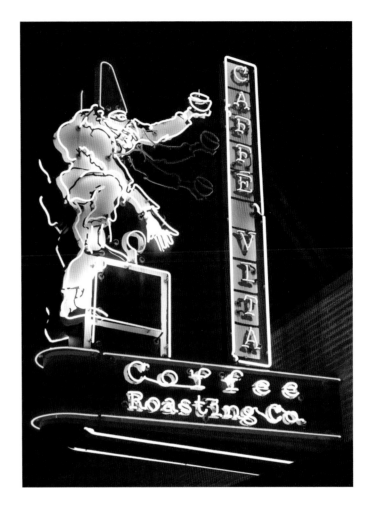

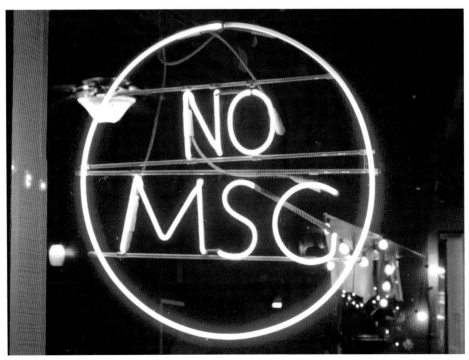

17.
Beacon Hill

North Beacon Hill

Rainier Veterinary Hospital has been providing care for Seattle pets since 1933. Their over-the-sidewalk neon sign has classic Space Age styling, but is unfortunately no longer in working condition. (815 Rainier Ave. S., rainiervet.com, 1933)

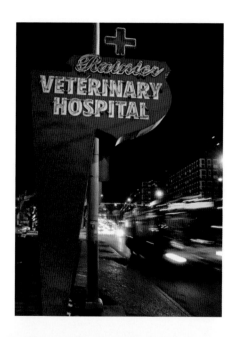

Born in 1889 in the North of Italy, Constantino Oberto arrived in Seattle in 1918. Already a skilled maker of sausage and cured meats—capicola, pastrami, salami—Oberto began selling his products door-to-door, eventually opening a shop on Dearborn Street. Upon Constantino's sudden death in 1943, his sixteen-year-old son Art took over the business. The younger Oberto proved to be a truly gifted manager, and the company expanded and prospered. Art Oberto's larger-than-life personality was also a factor in making **Oberto Sausage Company** a fixture around Seattle—he'd drive the "jerky mobile," a custom-painted white, red, and green Lincoln Town Car emblazoned with Oberto's advertising slogans, and helmed a hydroplane racing boat.

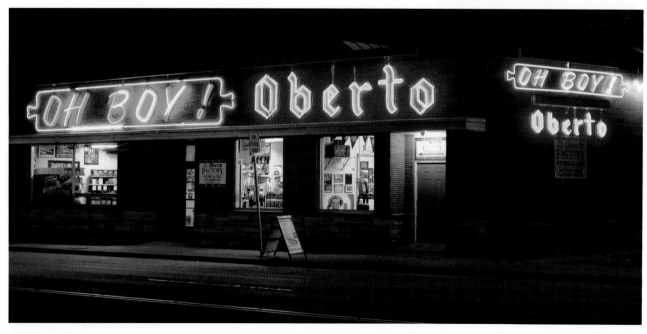

Oberto purchased the Rainier Avenue building in 1953, and it served as their headquarters until 1978, then continued to operate as Oberto's "Rainier Factory Store" until closing in 2021; the building was stripped of its neon and torn down that summer. With the blessing and support of the Oberto family, the site will be used for an expansion of the adjacent Hamlin Robinson School, which serves students with dyslexia and language-based learning differences. (formerly 1715 Rainier Ave. S., oberto. com, 1953)

Family-owned **Stewart Lumber & Hardware Company** has sold tools and lumber here since 1926. It's presently run by brothers Ryan and Matt Young, great-grandsons of the founder. (1761 Rainier Ave. S., thestewartlumberco.com, 1926)

Jun and Susan Despi opened their bakery on Beacon Hill, **Despi Delite Bakery**, in 1988, specializing in Filipino pastries, cake, and bread. In addition to the three outdoor neon signs, look for one inside, behind the counter. (2701 15th Ave. S., despi-delitebakery.com, 1988)

Upon graduating from the University of Washington in 2010, Roberto Salmerón spontaneously decided to bicycle to his home town of Tijuana, Mexico, a trek of 1,300 miles, and then reacquainted himself with the superb street tacos of his youth. Sensing a need for such tacos in Seattle, he opened the first **Tacos Chukís** on Capitol Hill the following year. Today they have four locations in Seattle, and I can personally

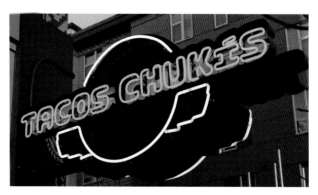

attest that the tacos are of the highest quality. (1608 S. Roberto Maestas Festival St., seattlechukis.com, 2016)

Described by online reviewers as an "old school" barber shop, **Abe's Barber Shop** features this charming window sign with a drawing of the barber himself, hard at work. True to the diversity of Beacon Hill, the illustration portrays an African-American barber with an Asian client. (3065 Beacon Ave. S., circa 2010)

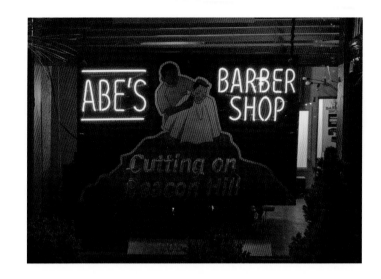

Mid-Beacon Hill

Beacon Hill has long been associated with Seattle's Vietnamese community, and here you will find **Saigon Barber & Beauty Shop**, with neon lettering in English and Chinese. (4856 Beacon Ave. S., before 2007)

Named for the workingman's favorite moment of the day, **Clock-out Lounge** is a bar, a live music venue, and a pizza place—the pizza is provided by **Breezy-Town Pizza**, a project of Windy City Pie, which shares the kitchen and seating area. Inside are numerous neon signs, but the real eye-catcher is the large green "C-O" in the window. Don't be fooled by the two of them in the photograph—the one on the right is only a reflection. (4864 Beacon Ave. S., clockoutlounge.com, 2018)

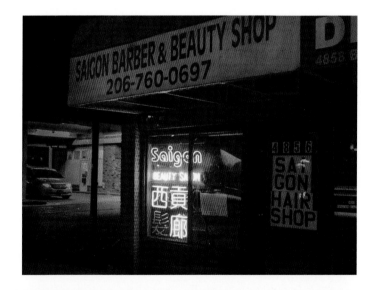

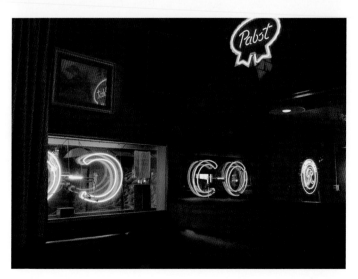

NewHolly

The neighborhood of NewHolly began as Holly Park, a 1940s housing project for defense workers and veterans, converted to public housing after the war. This eventually transitioned to a mixed-income neighborhood and was re-named NewHolly in 1995.

The area has a strong Asian influence, especially around the **King Plaza Asian Shopping Center**. While this plaza includes plenty of neon, most of it is premade "stock neon" signs that simply describe a service—"INCOME TAX" or "PASSPORT PHOTOS"—or the standard brewery logo signs found in thousands of bars throughout the country. The bubble tea shops feature neon that's a bit more pictorial, such as this illustration at **Tammy's Bakery** (7101 Martin Luther King Jr. Way, by 2007).

Foo Lam Chinese Restaurant, also part of King Plaza, displays this Tsingtao Beer dragon in a neon-bordered front window. (7101 Martin Luther King Jr. Way, foolamwatogo.com, 2015)

18.
Industrial South

Industrial District

Until the late nineties, the Seattle Mariners shared the crumbling Kingdome with the Seahawks, an arrangement that satisfied no one. When the Mariners' owners threatened to move the team to another city, the Washington legislature responded with a tax package that would raise funds for a new stadium, and a municipal corporation that would own and manage the facility.

The new ballpark would be built immediately south of the Kingdome. Safeco Insurance purchased the naming rights, and the stadium opened in 1999 as Safeco Field, labeled with huge white neon letters over the rotunda at the southwest corner. For twenty years the park was **Safeco Field**, but in 2019 the insurance company declined to renew the deal.

Bellevue-based T-Mobile bought the naming rights for the next 25 years. Safeco's neon letters came down that December as the site became **T-Mobile Park**, and magenta neon replaced the white. The letters from the historic Safeco sign, each about 11 by 5 feet, were individually sold by auction on the Mariners' website. (1250 1st Ave. S, ballpark.org, 1999).

Clinton C. Filson started C.C. Filson's Pioneer Alaska Clothing and Blanket Manufacturers in 1897, outfitting would-be prospectors on their way to Alaska for the Klondike Gold Rush. Long after the gold rush ended, Filson continued to equip lumberjacks and outdoorsmen for the wet conditions of the Northwest—in 1914 he patented a water-resistant wool shirt, C.C. Filson's Cruiser, a tremendous success for the company, and still included in their modern catalog.

Now known simply as **Filson**, the retailer operated its flagship store in the 4th Avenue building until 2015, then relocated it to a site on 1st Avenue, three blocks away, while keeping the original building for manufacturing operations. Filson continues to illuminate the neon sign atop their old factory, and has placed one at the new site as well—similar in size, color, and design, but with an added neon clock face. (1555 4th Ave. S. and 1741 1st Ave. S., filson.com, 1897)

Elephant Car Wash started here on 4th Avenue South in 1951, the first automatic car wash in Washington, then called **Five Minute Car Wash** *(see* Belltown *for full history)*. A few years later, as the company changed its name, this location acquired a neon elephant—a bit simpler and smaller than its famous sibling in Belltown, perched on the southeast corner of the roof without the ability to rotate.

In its later years, the rooftop elephant was non-functioning and in a state of obvious disrepair, glass tubes broken and dangling. The car wash made do with a tiny neon elephant hanging in a window of the office.

In 2021, this location suddenly closed for unspecified reasons, with the property owner confirming only that the car wash's decades-long lease had ended. By then, its elephants were in good company—the two removed from the Belltown location were now across the street, in the side yard of Western Neon, which will be restoring them for museum display. Western Neon will also be taking custody of this Industrial District elephant, with its eventual fate yet to be determined. (formerly 2763 4th Ave. S., elephantcarwash.com, 1951)

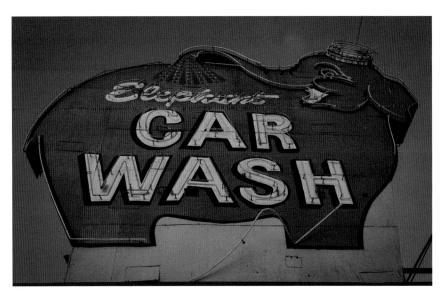

By's has been selling fish and chips, burgers, and milkshakes here since 1954. The fast food restaurant now shares both their parking lot and their classic A-frame neon sign with a "bikini barista" espresso drive-through; the disc-shaped part of the sign previously read "Instant Service." (2901 4th Ave. S., bystogo.com, 1954)

Another A-frame neon sign of almost exactly the same design stood at 828 Rainier Avenue South until

just a few years ago. This belonged to a rival purveyor of burgers and fish, Stan's Drive-In, but was stripped of its neon in 2017 or 2018; it now advertises The Green Door, a cannabis shop.

Western Neon is everywhere in Seattle—they've created, restored, or serviced many of our historic and iconic neon signs, including Caffe Vita's animated clowns, Rachel's Ginger Beer bottles, Uncle Ike's rainbow script, Wonder Bread and Troy Laundry's restorations, The Octopus Bar, Filson, City Light, and the old Rainier Brewery's replacement "R." When Bea Haverfield's pink elephant was cut down after sixty years of rotating over Denny Way, it was Western Neon that performed the work, and it is here on 4th Avenue South that the future museum piece will be restored.

For company founders Jay and Michael Blazek, neon was a family tradition. Their father Dean Blazek began working with neon in 1952 in Milwaukee. In 1979, Dean started a neon school in Wisconsin, training over 500 students in the art of bending glass, and authoring Neon ABC, a series of illustrated

guides showing exactly how to create the bends required for several lettering styles. Among these students were Dean's sons, Jay and Michael, who relocated to Seattle in the eighties to start Western Neon, while continuing to collaborate with their father—Dean and Michael co-authored *Neon: The Next Generation*, a manual detailing all the knowledge needed to set up a neon workshop.

André Lucero, who came to work and train at Western Neon in 2004, became owner and president of the company in 2012. He moved the office and workshop from its previous location, 2700 1st Avenue South, to this 4th Avenue space, kitty-corner from the original Elephant Car Wash, and set up a non-profit educational institution, Western Neon School of Art, to teach students to explore light-based media and interactive technologies.

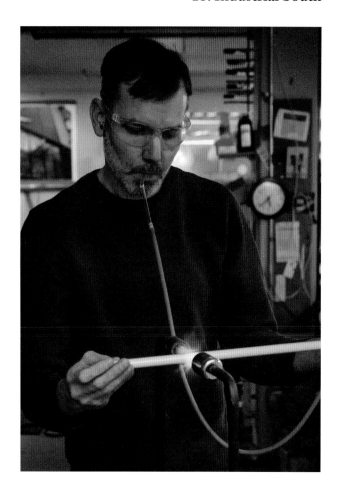

The Western Neon headquarters includes an extensive workshop for all kinds of signage, with industrial-sized printers and metal cutting and shaping equipment—they fabricate the "cans" that house the electronics and support the glass tubing. It includes classroom space for the School of Art. And it has a showroom, where prospective clients can see all the options available—a wall of neon tubes in every color imaginable, sample crackle tubes (neon tubes filled with tiny glass beads or cylinders, causing the gas to flicker as the electricity constantly seeks a new path through the maze), neon clocks and chandeliers and channel lettering. It's also a miniature museum of abandoned neon, signs pulled from businesses that no longer needed them—a Mediterranean restaurant, a medical clinic, a coffee shop, a soda manufacturer, a cruise boat operator, a bookshop, a bakery, all now kept in perfect condition as examples of neon art and technology.

I toured the showroom and workshop in early 2020 at the invitation of William Kirtley, lead glass bender at Western Neon, who is pictured here using a cannon fire burner. This delivers a hot, concentrated flame, enabling the glass to be bent at sharp angles, which Kirtley demonstrated with a double-back bend, a tight U-shaped 180-degree turn. To prevent the glass from collapsing, he blows air through a rubber tube attached to one end. For gentler curves, a ribbon burner is used, a device that can be adjusted to provide an equal flame across a longer section of the glass. The softened tube is then placed on a wire mesh over a full-size blueprint and quickly bent to shape.

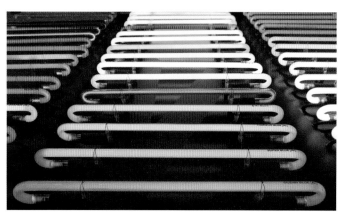

After a tube is bent and cut, it is capped with electrodes at either end and filled with gas. Though we commonly refer to this style of lighting as "neon," the gas is most often argon—neon gas is only used when its natural red glow is required. Argon, combined with mercury vapor, produces a glow rich in ultraviolet, that excites a fluorescent

coating on the inside surface of the tube, which then glows in the desired color. The new tube will be electrified for a full day in the workshop, to test and stabilize the color and brightness, before mounting to the sign. (2902 4th Ave. S., western-neon.com and wnsaseattle.org, 1984)

Andrew Hemrich and John Kopp built the Bay View Brewery, so named because of its splendid view of Elliott Bay, below the west slope of Beacon Hill in 1883, expanding the facility as business boomed. By 1893, they'd merged with other brewery operators to create Seattle Brewing and Malting Company, and acquired the **Rainier Beer** brand, produced both here and at the Georgetown plant. Rainier Beer was an enormous success, and by 1912, this was the largest brewing operation west of the Mississippi and sixth largest in the world.

Prohibition came to Washington in 1916, forcing the brewery to switch to soda pop and near-beer. When that experiment ended, Fritz and Emil Sick acquired the brewery, and, a few years later, the rights to the Rainier Beer name.

Rainier had redesigned their logo around 1906

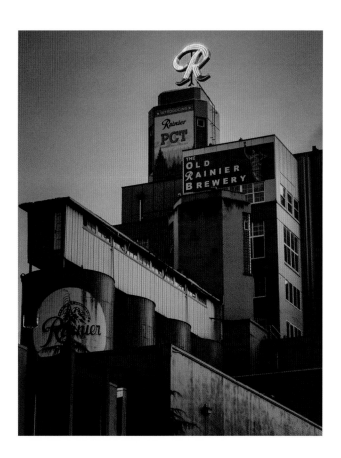

to include an oversized capital "R" in a distinctive script font. In 1953, this became part of the skyline in the form of a neon sign on the highest rooftop at the brewery. The "R" was illuminated only on one side, with red neon around the perimeter and hundreds of blinking light bulbs filling the surface.

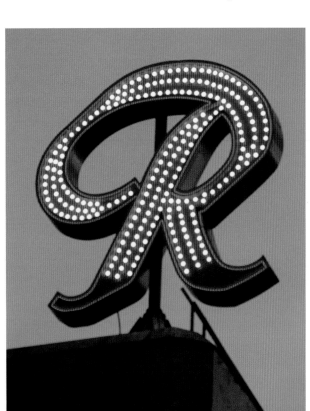

It rotated, until a city sign code change around 1970 forced the operators to shut off the motor. The sign remained highly visible, as Interstate 5 passes directly behind the brewery, making it an unofficial landmark to the tens of thousands who passed under it each day.

Both the brewery and the Rainier Beer brand ended up in the hands of national conglomerates in the seventies. Though ever popular here, Rainier Beer would no longer be brewed or bottled in Seattle, and the brewery closed in 1999. Tully's Coffee leased the massive plant and, in 2000, replaced the red "R" with a green "T." This proved to be an extraordinarily unpopular move, reminding Seattleites daily that the city's history was being erased. The neon "R" went to Western Neon for repairs—where they discovered several decades-old bullet holes—and then to the Museum of History and Industry, where it can still be seen today, prominently displayed atop a two-story stack of exhibits (*see* South Lake Union).

In 2003, a developer purchased the property to convert it to an event space, storage, and live/work lofts, under the name **The Old Rainier Brewery**. As Tully's lease was drawing to a close in 2013, MOHAI and Rainier brand owner Pabst decided to put things right, engaging Western Neon to create a replica of the original sign. The new version would not rotate, but is instead illuminated on both sides. The red neon remained, but the light bulbs were replaced with long-lasting and energy-efficient LEDs—470 of them.

Rainier promoted the project with a "Restore the R" campaign and a "neighborhood 'R' crawl," trucking the new sign around the city for photo opportunities. The events culminated with a ceremony at the brewery on October 24, 2013, when the "R" was hoisted to the rooftop by crane and illuminated for the first time, accompanied by music and a cheering crowd. (3100 Airport Way S., rainierbeer.com and theoldrainierbrewery.com, 1883)

"Big Andy" Nagy built **Andy's Diner** in 1949 in an old railway car, the wheels removed, the interior gutted and converted to a restaurant. Keeping to his chosen theme, Andy decorated the diner with railway photographs and equipment. As the business grew, he added more railcars to the site, eventually reaching a total of seven, including one used by President Franklin Roosevelt during the 1944 campaign. In 1958, he was joined by nephew "Little Andy" Yurkanin, who managed the diner after Big Andy's death in 1980, until his own retirement in 1996.

Eventually, as the city and the neighborhood changed, the diner's traditional American menu of steak and potatoes fell out of favor. Andy's Diner closed in 2008. Later that year, Gun "Ed" Ting rented the property, changing the menu and the name as the site became **Orient Express**. With only small changes, the neon sign remained. Though spectacular in its day, it is no longer illuminated. (2963 4th Ave. S., seattleorientexpress.com, 2008)

PICK-QUICK Drive In started in 1949 in Fife, serving burgers, fries, and milkshakes. They expanded to Auburn in 2011 and Seattle in 2016. Both of the modern restaurants faithfully replicate the look of the 1940s original, including the neon sign and neon trim on the buildings. (2990 4th Ave. S., pick-quick.com, 2016)

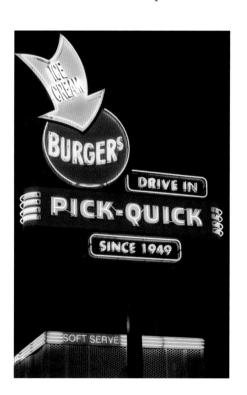

A sports bar with a focus on darts, **Siren Tavern** has been serving cold beer and cocktails since 1963.

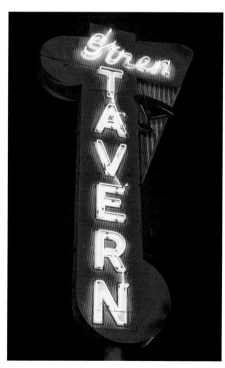

You'll find a better-than-average collection of neon beer logo signs inside, too, and even a small neon sign for their in-house "dart shop." (3403 4th Ave. S., 1963)

The SODO Busway runs 1.5 miles long through the SoDo neighborhood, in line with 5th Avenue South, and is a major transit corridor for both buses and trains. The buildings on its west side all face west, fronting on 4th Avenue, and it was along the massive blank canvas of their rear walls that the Sodo Track art project. Over three years, 62 artists decorated these walls with murals, including **EVLOVE** by Zach Yarrington. This mural, augmented with neon lettering, is designed to be read in either direction by drivers on the nearby Spokane Street Viaduct, either as they approach or in their rearview mirrors after they pass, delivering two slightly different but related messages. (behind 3450 4th Ave. S., sodotrack.com, 2017)

Seattle City Light, the public utility providing electrical power to the city and nearby suburbs, placed neon signs atop multiple facilities around the region in the 1920s. All were eventually removed. The last survivors were a pair of signs on the South Service Center, facing east and west, a landmark for motorists on the Spokane Street Viaduct and Interstate 5. In 2016, these too were removed, but replaced with LED rope lighting that replicates the look of the original neon. (3613 4th Ave. S., seattle.gov, 1905)

The old **Sunny Jim** peanut butter factory was located next to Interstate 5, making its rooftop neon sign a familiar landmark to decades of motorists. The sign spelled the brand's name in large neon letters, accompanied by their logo, a grinning boy—modeled on Lowell, a son of Pacific Standard Foods founder Germanus Wilhelm Firnstahl.

The factory shut down after the Sunny Jim brand was acquired in 1979. In the nineties, the city acquired the building, using it for the Department of Transportation, which left the sign dark but intact. In 1997, an accidental fire started by a roofer's torch destroyed the sign, but spared the building. In 2010, years after the city had essentially abandoned the building, a fire started by a camp stove destroyed everything else on the site. (formerly 4200 Airport Way S., 1930s)

This building was never a "Flying A" service station—it wasn't even built until 1976, ten years after

the brand was retired. "Flying A" was one of several brand names used by Tidewater Petroleum from 1932 until 1966, when Phillips Petroleum purchased the company, converting all their newly acquired properties into the Phillips 66 brand. Only vintage sign enthusiasts display the Flying A logo today, and that's who you'll find here: **Artco Sign Company**. Damon Moore started the sign-making company in 1971, eventually passing it on to daughter Melissa, the present CEO. They moved their headquarters here from Belltown in 2006. (108 S. Brandon St., artcosigns.com, 1971)

Aside from the neon sign and neon clock over the second-floor windows, this 1920s industrial building looks much like the others in the neighborhood—until you step inside and see a legendary collection of historic neon. This is the work of Scott Andrews, dental surgeon and property investor, who purchased the site in the nineties and made it a landmark for local history and neon enthusiasts.

Built in 1923, this structure was originally the Electric Machinery Sales and Storage Building for C.K. Hillman. Hillman's machinery company remained there until the early eighties, after which it became the Dickey & Liebes Barber Supply warehouse. Dr. Andrews purchased the property in 1996 and undertook a major renovation project—then installing part of his collection of vintage neon signs, some so large they could only be hoisted into place when the roof and windows were absent. The perimeter of the former warehouse became offices, with the spacious interior gallery a neon museum that would delight the tenants and their guests alike. Andrews chose a new name, the **K.R. Trigger Building**, adding a neon sign and clock to the facade.

Though the property changed hands several times in the 2000s and 2010s, the neon collection remained, in part due to the difficulty of moving the largest pieces. Now the **Trigger Building**, it's owned and operated by the H.O. Seiffert Company, a four-generation family-owned business, and continues to provide "exceptional office space" built around an unsurpassed collection of vintage neon.

The neon signs presently on display here come from all across the Puget Sound area, much of it from defunct businesses. The list includes Vic's G & R Grocery (*see* University District), Morris Flowers,

radio maker Philco, Fuller Paints, The Spot Cafe, the St. Vincent De Paul Society, a Plymouth dealership, a pharmacy's "Rx," and several other pieces. The two most outstanding works of neon art, Kitsap Lake Drive-In and Harborena, are described next. (3201 1st Ave. S., triggerbuilding. com, 1923)

Unlike most of the names on the neon inside the Trigger Building, **Harborena Roller Rink** is still in business at its original location in Hoquiam, a coastal town two hours west of Seattle. Ernst Boeholt, born in 1904 in Denmark, built the roller rink himself in the forties, driving pilings into the wet earth to support the concrete floor. The Boeholts operated the rink as a family business, and it eventually passed to Ernie's son, Jens, and his wife, Ruth—they had met when Ruth took a job at Harborena. Together, the couple operated it for sixty years, until Ruth Boeholt's death in 2020 prompted Jens to retire, selling the business to the Nazario and Shaw families.

Though the giant neon skate has been at the Trigger Building since the 1990s,

Harborena continues to use it as their logo. Their current sign, much smaller, is an illustration of the winged skate, and the rink sells T-shirts with the design. The neon Harborena sign is animated, with sections of the floor under the wheels rapidly lighting up and moving backwards, as if the skate were rolling forward. (2112 Simpson Ave., Hoquiam, WA, harborena.com, 1948)

The pride of the Trigger Building collection is the sign from the **Kitsap Lake Drive In Theatre**, so large that parts of it are embedded in the ceilings of the offices at either end.

The two-screen drive-in theatre opened in 1953, across the road from Kitsap Lake in Bremerton. Their animated neon sign, with the same illustration on both sides, stood atop three 20-foot columns. Immediately below the neon was a reader board, as big as the neon sign itself. The drive-in shut down in 1982 when the owner elected to close it in favor of his Rodeo Drive-In, also in Bremerton. The vacant theatre property was later purchased by Puget Sound Energy, becoming their Kitsap Service Center.

Now dark and abandoned, the neon sign remained on the property, of no interest to the power company. Mark Diefendorf, a sign collector who had grown up in Bremerton, saw it crumbling and knew it deserved a better home—he brought it to the attention of Scott Andrews, who convinced the landowners to part with the historic neon.

After more than a decade of disuse, it needed extensive repair work. Both sides of the sign received new glass, and all of the neon is now in working order. The bow and arrow were originally animated, with the bow flexing as the Native American chief pulled back the unseen string, and the arrow would then fly forward when released. This feature was no longer operational, and now both positions of bow and arrow are lit at all times. The chief's elbow and the arrowhead, which extended beyond the rectangular background, are now hidden within the Trigger Building's walls. One side of the sign was fully repainted, but the paint on the reverse side was left as-is, faded and peeling, as a reminder of its long history. (formerly 6522 Kitsap Way, Bremerton WA, 1953)

A few years after refurbishing the Trigger Building, Scott Andrews purchased the smaller building immediately to its south. He gave it a new name, the **Vertigo Building**, inspired by an Alfred Hitchcock film, and called upon neon artist Roger Ligrano to design a neon sign with a likeness of Vertigo's star, Jimmy Stewart.

Ganja Goddess, the first woman-owned cannabis company in Seattle, moved into the space in 2014, adding a rotating neon sign with their name above the existing artwork. (3207 1st Ave. S., ganjagoddessseattle.com, 2000)

The **Sailor's Rest** neon anchor has puzzled a number of photographers and bloggers who have come across it—what could it be for? It's attached to the Markey Machinery Building, a large industrial building without any shops, restaurants, or other typical neon-using businesses.

This, too, is the work of Scott Andrews. The original Sailor's Rest was a tavern in Hoquiam, said to have had a brothel upstairs. The neon sign that hangs here in SODO is a 1990s replica of that original. (79 S. Horton St., 1917)

Georgetown

New La Hacienda Motel owns two neon signs, both splendid examples of Mid-Century neon design, combining multiple colors of neon with directional arrows made of incandescent bulbs. One is on a corner of the motel itself, on 1st Avenue South. The other, off the property, points the way to La Hacienda from two blocks east.

This second sign stands in the former front yard of **The Vac Shop**. While on a psychedelic mushroom trip, Dave James had a vision of God, who told him to quit the drugs, get sober, and get a job. He purchased the vacuum repair shop in 1996 and then offered a free Bible to anyone who would ask—giving away 20,000 a year, at its peak. James and his staff decorated the yard in an eccentric folk art style, building robots and a model Space Needle from vacuum cleaner parts. After his death in 2009, his family continued to run the vac shop until closing it in 2020, citing the decline in demand for repair services. When I revisited in 2021, all that remained of the unique decor was the red-nosed reindeer on the roof—and the neon. (5414 1st Ave. S. and 402 S. Lucile St., lahaciendamotelseattle.com, 1954)

A Texas-style roadhouse, **Slim's Last Chance** is known for hot chili, cold beer, and live music. (5606 1st Ave. S., slimslastchance.com, 2008)

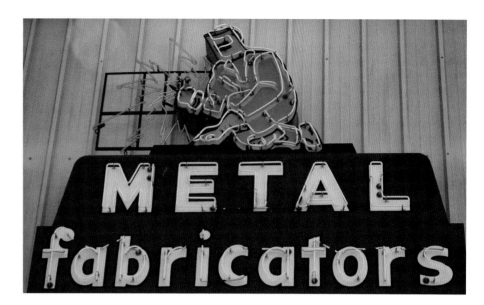

Metal fabricator **Capital Industries** occupies a massive industrial building three blocks long, stretching from 1st Avenue to 4th Avenue. Their neon sign features a metalworker with a protective face shield. Originally mounted on a pole, this rotated, with the text "Capital Industries" on one side and "Metal Fabricators" on the other. In 2014, this was removed, restored, and the two sides of it mounted on separate faces of the building. You'll find one piece of it on the west wall of the building, and the other, with additional neon added to form a message of welcome, on the north. (5801 3rd Ave. S., capitalind.com, 1953)

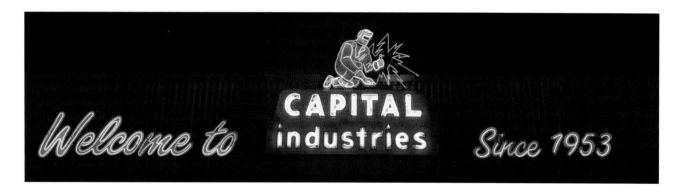

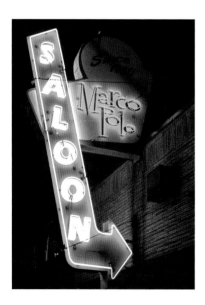

A neighborhood saloon and sports bar, **Marco Polo Bar & Grill** is known for "world famous" fried and broasted chicken. (5613 4th Ave. S., marcopolopub.com, 1950).

From 1941 to 2006, this was **Kettells Corner**, a grocery and restaurant with a neon sign that included a clock and an owl, the owl signifying their 24-hour service. The owl appeared on T-shirts, too, alongside the grocer's flippant slogan, "Kettells Corner: Where the Customer Is Never Right."

The grocery shut down in 2006, leaving the building vacant until it became **Kittens Cabaret** in 2013. The vintage neon sign was reworked for the new business: "Kettells" became "Kittens," "Lounge" became "Gentlemen's Club," and a black cat replaced the owl. (5800 4th Ave. S., kittenscabaret.com, grocery 1941, cabaret 2013)

The historic Fred Marino building, on Airport Way opposite the

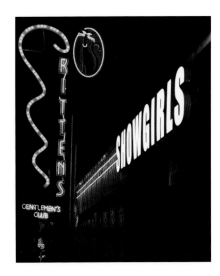

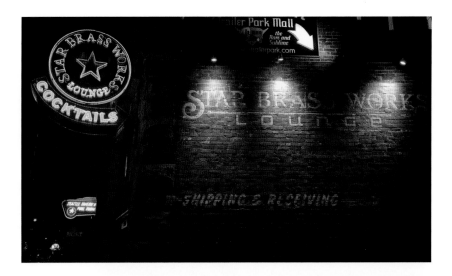

old Seattle Brewing and Malting Company's massive plant, is a well-preserved turn-of-the-century classic with much of its original stonework intact. Fred Marino operated a saloon here in 1905 and, from 1911, the Palace Hotel.

This was also the corporate headquarters of Star Brass Works, a brass foundry and machine shop founded in 1913. They specialized in the testing and repair of steam safety valves, and until 1948 manufactured their own Star Safety Valve. The company ceased operations by 2008, but their name is memorialized by one of the pubs now on the site—**Star Brass Works Lounge**. The painted Star Brass Works name on the side of the building, and the letters affixed to the beam over the front windows, are both relics of the original brass works.

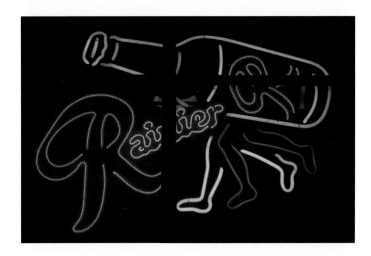

Like most bars, Star Brass Works features a window sign or two with the logos of popular beers. Rainier signs can be found everywhere, but the one here is a less common design—a Rainier beer bottle with human legs, illustrating the beer company's seventies-era "Wild Rainiers" advertising campaign. (5813 Airport Way S., starbrassworkslounge.com, 2013)

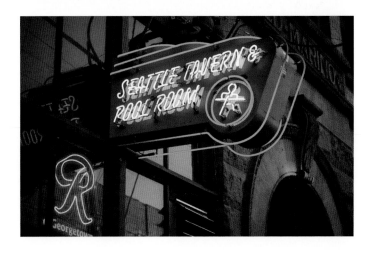

Both Star Brass Works Lounge and **Seattle Tavern & Pool Room**, in the same building, are owned and operated by Scott Horrell, who also runs three other bars and restaurants in Georgetown and South Park. On display in the pool hall are three pieces of historic neon collected and restored by John Bennett, owner of the Fred Marino Building. One of these is the Fluckinger Machine Works sign (*see next entry*), which now hangs over the pool room's bar. In 2021, the famous Buckaroo Tavern neon sign (*see* Fremont) was restored and placed here—in two parts, with the cowboy and horse on an inside wall in the dining

area, and the detached "Tavern" affixed to the exterior. (5811 Airport Way S., seattletavern. com, 2016)

Inventor of a plywood making machine, Sam Fluckinger started **Fluckinger Machine Works** in the late 1940s. The business operated from a building on Airport Way South, the same road as the tavern that now holds their sign, from the 1940s until at least the 1990s. Before its removal from the original site around 2011, the sign had lost all of its original glass tubing, requiring a complete restoration. (formerly 4800 Airport Way S., 1940s)

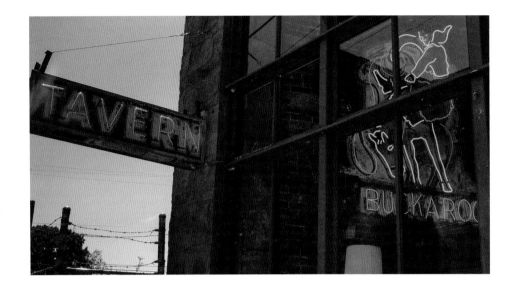

Georgetown Records sells every format of vinyl records, but few CDs—the only compact discs here are those by local artists, as supporting the Seattle music community has always been a high priority for this inde-

pendent record store. Martin Imbach and some friends got together in 2004 to buy a few thousand records in bulk and start this brick-and-mortar store, providing the sort of curated selection and expert advice that the online music sellers cannot.

In 2016, a summer intern suggested taking Georgetown Records back to her hometown—Mexico City. Imbach agreed, personally driving a truckload of 1,200 records across the border. Now owned by Alex Bautista, Georgetown CDMX in Mexico City is legally independent from the original Georgetown Records (as setting up an international corporation involves a lot of fees and paperwork), but maintains close ties, even using a neon sign that's almost identical to the

one in Seattle. And if the style of the sign looks familiar, it should—the "R" is the same as that of the iconic Rainier Beer logo. (1201 S. Vale St., georgetownrecords.net, 2004)

Georgetown Records is located in the historic Horton Hotel, built in 1914 by Georgetown's namesake, George Horton. The largest neon sign on that building is easily missed—it wasn't really meant to be seen from the sidewalk. Instead, the **Shhhhhhhh, Georgetown** neon is on the rear (south) wall of the Horton building, perfectly situated to be noticed by motorists on the elevated I-5 on-ramp behind the building. Its mysterious "Shhhhhhhh" message is often interpreted to mean that Georgetown is Seattle's best-kept secret, a neighborhood with industrial roots that is now a destination for dining and nightlife.

A tiny metal plaque attached to the bricks below gives the sign's origin. The neon is the work of graphic designer Kathryn Rathke, funded by a Seattle Arts Commission grant for artwork that would serve a community need—such as promoting the neighborhood. The art was installed in September, 2003, and is maintained by the Georgetown Community Council.

The neon is animated, with the woman's hand alternately pointed forward or raised to her lips as the "Shhhhhhhh" lights up from beginning to end. Underneath are neon illustrations of Georgetown's historic sites—Georgetown City Hall, Hat n' Boots gas station, the Gessner Mansion, and the Seattle Brewing & Malting Company. (6014 12th Ave. S., kathrynrathke.com and georgetowncommunity-council.com, 2003)

Built as a Masonic hall in 1927, this building hosted Hansen's Florist shop beginning in 1945. **Korean Central Baptist Church** purchased it in the 1980s, using the upper floors for services and classes while allowing the flower shop to remain there until 2008, when the church needed additional space. The church departed in 2016, and the building has been recently purchased by a psychiatric clinic. (1201 S. Bailey St., 1980s)

Rock and roll manager Charles Smith became a wine aficionado while touring Europe in the nineties. A visit to Washington's wine country in Walla Walla gave him the idea to start a winery of his own. Smith's wines are now for sale at **Charles Smith Jet City Winery**, a

building that used to be a Dr. Pepper bottling plant. The "Jet City" part of the name could not be more relevant, as they're located directly under the flight path of planes taking off from Boeing Field's runway 32L, across the street. (1136 S. Albro Pl., charlessmithwines.com, 2015)

Marine mammals are greatly loved by Seattle residents—there's even talk of changing our city's terrible flag to a new design based on an orca's toothy grin. At **Orca Car Wash**, a neon orca exhales a mass of wet air, also rendered in neon, from its blowhole. (551 S. Michigan St., by 2008)

South Park

A bridge over the Duwamish Waterway leads to the neighbor-hood of South Park. Just after crossing the bridge, visitors will see a commercial plaza with two neon clocks, side-by-side. Both are the work of Scott Andrews, who purchased these buildings and added the clocks in 2000.

The clock on the left, dark and non-functional at the time of my visit, reads "Andrews Building" in red neon. The site is presently in use by **Seattle-Lite Brewing Company.** (8520 14th Ave. S., seattle-lite.com, 2000)

The neon clock on the second building displays the friendly message of "Welcome to South Park." The building houses **South Park Suds**, a laundromat, and **Left Bank**, a wine bar. (8526 14th Ave. S., leftbankseattle.com, 2000).

They sell "pizza for your pie hole" at **South Town Pie**, with a thin and foldable crust in the New York style. Chef Sam Crannell started the pizzeria in 2018, finding South Park more spacious and more affordable than his previous restaurant's home in Queen Anne. (8611 14th Ave. S., southtownpie.com, 2018)

All-day breakfast place **Tasty's T&M's** became **Tasty's Bar & Grill** a few years ago, when they added the neon sign. They operate from two adjacent storefronts, the smaller of which serves chicken and waffles as **Tasty's To Go**. (8605 14th Ave. S., 2015)

When Thrillist published a list of "The 100 Best Burgers in America" in 2017, the "Tavern Burger" at **Loretta's Northwesterner** came in at number 4—much to everyone's surprise, as South Park is not a neighborhood known to tourists. The burger is simple (cheese, onions, pickles, and special sauce) but, according to reviewers, perfect. Scott Horrell, who also owns Star Brass Works and Seattle Tavern in Georgetown, named Loretta's for his mother. (8617 14th Ave. S., lorettasnorthwesterner.com, 2007)

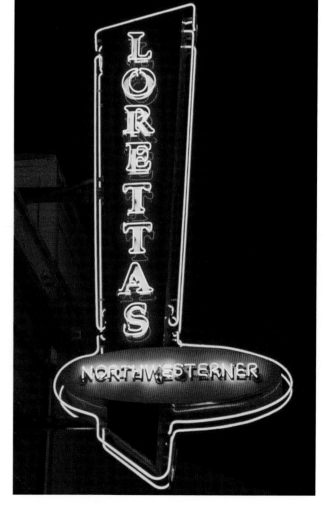

19.
Delridge and White Center

North Delridge

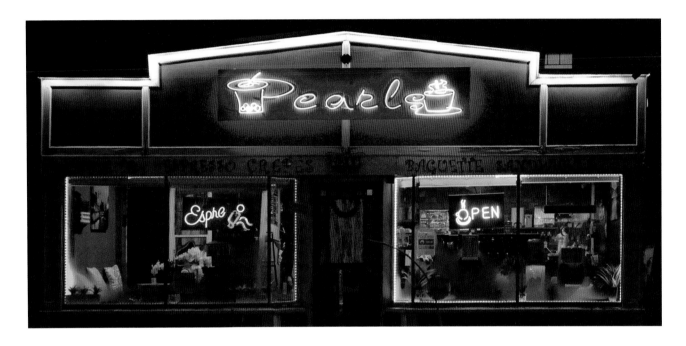

The "Pearls" of **Pearls Tea & Cafe** are boba, for this is a bubble tea shop. Operated by Vietnamese immigrants, Pearls also serves coffee, crepes, and bahn mi sandwiches. (4800 Delridge Way S.W., ca. 2008)

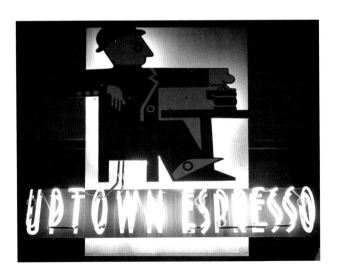

Uptown Espresso has an ancestral connection to the beginnings of Seattle's obsession with coffee. Dock worker Oscar Delaloye began selling coffee door-to-door in 1895, eventually setting up shop as "Seattle Tea & Coffee" at Pike Place Market. Ninety years later, Oscar's great-grandson Dow Lucurell started working at the newly-opened Uptown Espresso on Queen Anne, eventually buying the shop and expanding to six locations. Be sure to ask about their "Velvet Foam." (3845 Delridge Way S.W., uptownespresso.com, by 2006)

South Delridge

Rising over a gas station and vape shop, this directional sign is one of two that point the way to **Westwood Village**, about four blocks to the west. The shopping center opened in 1966, built by the same developers who created University Village. (9001 Delridge Way S.W., westwood-villagecenter.com, 1966).

The pastries are a fusion of Japanese and Western styles at **Fresh Flours**. Husband-and-wife team of Keiji Koh, baker, and Etsuko Minematsu, business manager, loaded their two dogs into a rental truck and drove from New York to Seattle, where they opened their first bakery in Phinney Ridge in 2005. They now have four locations around the city. (9410 Delridge Way S.W., freshfloursseattle.com, 2016).

Mac's Triangle Pub is named for owner Geoff "Mac" McElroy as well as its triangular building and triangular lot. Prominently located where the main streets come together, and right at the city limits, the pub stands at the heart of the South Delridge and White Center business district. (9454 Delridge Way S.W., macstrianglepub.com, 2006)

White Center

White Center, an unincorporated area south of Delridge and West Seattle, is outside the city limits yet remains an important part of the neighborhood identity—so much so that patrons at Mac's Triangle Pub, after learning the scope of my project, urged me to include it.

The entrance of **Dottie's Double Wide** is through the side of a real trailer, its skin attached to the building's facade (the other side of the trailer frames the kitchen's service window). The tavern and Tex-Mex eatery was designed with a

1970s vintage style. Inside, you'll find wood paneling, couches with plastic covers just like the one at Grandma's house, and more neon art. (9609½ 16th Ave. S.W., dottiesdoublewide.com, 2018)

Proletariat Pizza serves "The pizza that made White Center famous." The family-friendly pizzeria's name wasn't chosen to evoke Marxist thought, but as a nod to the working-class people of the neighborhood. They make a quality pizza, with the *New York Times* naming Proletariat as one of the top five places to go in Seattle. (9622 16th Ave. S.W., proletariatpizza.com, 2009)

Roxbury Lanes and Casino combines a casino, bowling alley, bar, and American-Chinese restaurant under one roof. Red and yellow neon tubes wrap around two sides of the building just under the roof, and a matching neon sign stands over the parking lot. (2823 S.W. Roxbury St., roxburylanesbowl.com, 1960)

After more than sixty years in business, **Roxbury Complete Auto Supply** was forcibly shut down by King County in 2018, when the structure was deemed "unsafe." Concrete blocks at a rear corner of the building were visibly crumbling, leading to concerns that the roof joists would collapse. According to the owners, "nobody goes back there," and the damage was the county's own fault, caused by the work crew on a recent sidewalk project. Over a year later, the damage to the wall was still visible, and the building and its neon sign were both dark. (2839 S.W. Roxbury St., by 1955)

20.
West Seattle

Alki

Built as Novelty Flour Mill in the 1890s, this waterfront structure on concrete pilings became a restaurant called The Beach Broiler in the 1950s. Gerry and Kathy Kingen purchased it in 1985, remodeled, and renamed it Salty Pickerel's & Angus McHereford's—eventually simplified to **Salty's on Alki Beach**. Next to the parking lot you'll find the remnants of an icon of Seattle history: the wheelhouse and rudder of the *MV Kalakala*, a one-of-a-kind Art Deco ferry that serviced the city from 1935 until 1967. (1936 Harbor Ave. S.W., saltys.com, 1985)

Blue Moon Burgers is located just steps from Alki Beach. The gourmet burger chain moved into the former Alki Auto Repair building in 2015, replacing the mechanic's pole-mounted neon sign with one of their own. (2504 Alki Ave. S.W., bluemoonburgers.com, 2015)

Il Nido occupies a landmark 1904 log cabin, originally built as a private house. Called "Fir Lodge," it was soon acquired by Seattle Auto and Driving Club and made into a supper destination for early-1900s

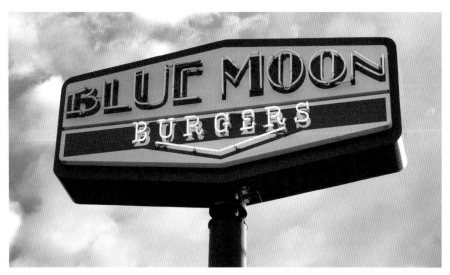

motor enthusiasts. In 1950, it became **Alki Homestead Restaurant**, then gaining its rooftop neon. A 2009 fire (caused by too many Christmas lights overloading the circuit) greatly damaged the structure, forcing the restaurant to close for a decade. In 2019, it became Il Nido, retaining the neon sign—newly restored—which continues to display the historic Alki Homestead name. (2717 61st Ave. S.W., ilnidoseattle.com, 1950)

North Admiral

Spring House Thai Kitchen and Pho was Pailin Thai Cuisine from 1992 until new owners purchased the restaurant in 2019. They kept the existing neon sign, reworking it to show the new name. (2223 California Ave. S.W., springhousethaikitchenandpho.com, 2019)

The Portola Theatre began showing silent films in 1919. The theater upgraded their pipe organ in 1924 to a 60-piece orchestral model that was then the largest in suburban Seattle. John Danz purchased the Portola in 1938, shutting it down and hiring prolific cinema architect B. Marcus Priteca to rebuild it in the Streamline Moderne style. A vote conducted by the West Seattle Herald gave the former Portola its new name, **Admiral Theatre**. Inside and out, Priteca added a wealth of nautical decor—portholes in the facade, seahorses on the chandeliers, starfish carpeting, even a mast with a crow's nest on the roof. The new marquee was shaped like a ship's prow, extending over the sidewalk, with neon ADMIRAL lettering above letter boards bordered by neon and chase lights.

In 1973, the Admiral was "twinned," its auditorium split in two, the rooftop mast removed, and the glorious neon marquee replaced with a much simpler version having just a touch of neon on either side. (2343 California Ave. S.W., farawayentertainment.com, 1919)

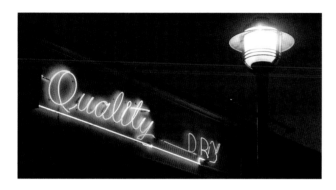

According to original owner Walter Klein, **Quality Drive-In Cleaners** was one of the first dry cleaning shops on the West Coast to provide drive-in service. The neon sign presently reads "Quality DRY Cleaners," but the "Cleaners" part has been dark for years. The neon appears to have been altered, as "DRY" is in a distinctly different and much simpler font, with large amounts of wasted space on either side. It's likely that this word replaced an earlier "Drive-In" that may have been in a more harmonious style; historic photos show that the sign had its present appearance by 1987. The business closed in 2020, and the building is now listed for sale. (2601 California Ave. S.W., 1949)

Freshy's is modern, but the sign with its arrow pointing to the entrance is delightfully retro. Patrons have likened the coffee and sandwich shop to the cafe from *Friends*, with plenty of big overstuffed couches scattered through the wood and brick dining room. (2735 California Ave. S.W., freshyscafe.com, 2005)

West Seattle Runner sells running supplies—shoes, clothing, supplements, and safety gear. The "NN" on their sign pulls double duty as an illustration of Seattle's hilly terrain. (2743 California Ave. S.W., westseattlerunner.com, 2010)

Westside Barber Shop has been "Saving the Westside from Salons since 2003." They specialize in men's classic and vintage cuts in a shop with a distinctive mid-century barbershop vibe. (3443 California Ave. S.W., westside-barbershop.com, 2003)

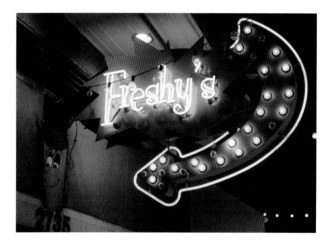

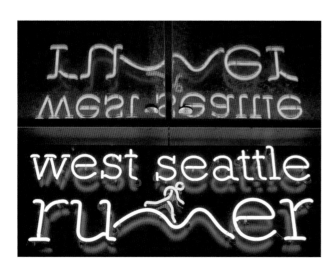

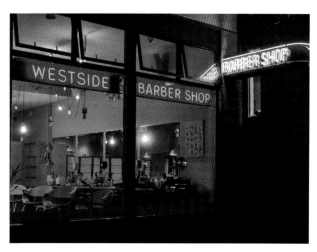

Genesee

After taking a year off, Jon Daniels, former owner of the oldest fish shop at Pike Place Market, purchased **Seattle Fish Company** in 2011, expanding the fresh fish market to include a restaurant. Their seared halibut was declared the best sandwich in Washington State by *Food & Wine Magazine* in 2021. (4435 California Ave. S.W., seattlefishcompany.com, 2002)

A satisfied man in the moon graces the neon sign at **Shadowland**, a neighborhood bar and restaurant with a focus on seasonal Northwestern ingredients and local beers. (4458 California Ave. S.W., shadowlandwest.com, 2007)

It's a bottle cap, of course, for a bottle shop. **The Beer Junction** started with a mere 640 varieties of bottled beer, since expanded to over 1,200 beers from 50 countries, with another 45 available on tap. You can drink your pint at the bar in front or have them fill growlers to go. (4511 California Ave. S.W., thebeerjunction.com, 2010)

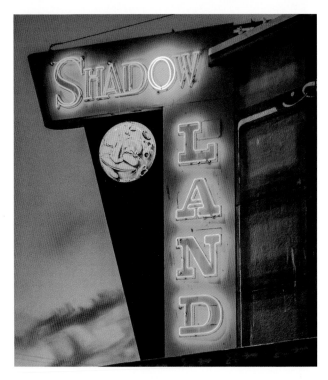

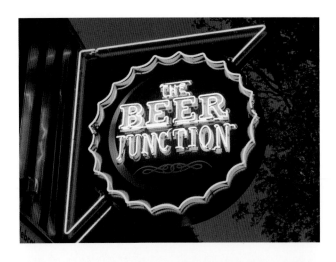

Widely considered one of the best record stores in America, **Easy Street Records & Cafe** has won accolades from *Rolling Stone* and *Time Magazine*. Matt Vaughan, a 19-year-old university student in 1987, worked at two local record shops, both on the brink of failure. Vaughan convinced both owners to let him take over, augmenting the inventory with his impressive personal collection of over 3,000 records. The following year he moved the new Easy Street Records into the landmark Hamm building, its present location. In 1999, Easy Street expanded into the neighboring storefront, which became a cafe and bar.

Vaughan cultivated relationships with local artists and labels, which paid off as the "Seattle Sound" became a national sensation in the 1990s. The new location offered enough space for live performances, including internationally known artists like Lou Reed and Elvis Costello, and local notables such as Pearl Jam and Macklemore.

The twenty-first century brought more challenges to record stores as electronic media displaced traditional formats. Easy Street became one of the first to participate in "Record Store Day," a semi-annual event created by independent record store owners and held every April and November to promote their local shops and the love of vinyl. (4559 California Ave. S.W., easystreetonline.com, 1987)

This building started as a Chinese restaurant called New Luck Toy in 1950, which then continued for an impressive 55 years. **Talarico's Pizzeria** took over the space in 2006, reworking the neon sign—only the "Restaurant" portion is from New Luck Toy—adding an illustration of the co-owner's great grandfather, for whom the

restaurant is named. Their specialty is 14-inch thin and crispy "Huge Pizza" slices in the East Coast style. (4718 California Ave. S.W., talaricospizza.com, 2006)

Herman Miller, a cattle breeder turned refrigerator salesman, opened his Edgewood Farm grocery store at 4735 California Avenue in 1932 or 1933. Business was slow until Miller bought a second hand ice cream machine, installing it near the front window where potential customers could see it in action—and be lured inside. The ice cream fountain's speciality was the "Husky," a huge scoop of chocolate-dipped ice cream rolled in peanuts, served in a cone. This proved popular enough that, in 1937, Edgewood Farm Store was renamed **Husky**.

In 1969, Husky moved to their present location, on the same block as before. Now **Husky Deli & Catering & Ice Cream**, it's still in the Miller family today, with Herman's grandson Jack Miller in charge, and the next generation working the ice cream and sandwich counters. They have more than 50 flavors of ice cream listed, all of it handmade. (4721 California Ave. S.W., huskydeli.com, 1932)

The square and compasses honoring the Great Architect of the Universe are rendered in neon at the **Alki Masonic Center**, constructed as a Masonic meeting hall for Alki Lodge #152. (4736 40th Ave. S.W., alki152.org, 1950)

Fairmount Park

Luna Park Cafe and the adjacent **Boysen Apartments** are owned and operated by John Bennett, the same neon enthusiast who revitalized Airport Way in Georgetown. The cafe is decorated, inside and out, with vintage neon that Bennett collected during his years managing an antique store. Most are of unknown origin, but a few can be traced to specific locations around West Seattle.

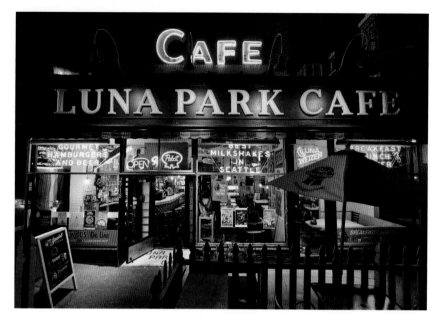

The Luna Park name comes from the amusement park that operated at Duwamish Head, the northernmost point of West Seattle, beginning in 1907. Built on pilings over the water, the park included a carousel, the "Great Figure 8" roller coaster, two theaters, a natatorium with saltwater and freshwater swimming pools, and a very large and well-stocked bar. West Seattle residents who were concerned about unruly drunks at the park sought annexation to the City of Seattle in the hopes that a law-and-order mayor would crack down, though this accomplished little, as the mayor had other priorities. When the park closed in 1913, the rides were disassembled and the carousel taken to San Francisco. The natatorium continued to operate until it was destroyed by fire in 1931. Of the actual park, only fragments of the pilings remain, visible at low tide. (2918 S.W. Avalon Way, lunaparkcafe.com, 1989)

A rescued neon sign on the side of Luna Park Cafe features an owl wearing a kilt, sporran, and tam o' shanter hat. This came from **Avalon Auto**

Sales, a Volkswagen dealership in South Delridge that shut down in the 1980s. Appropriately enough, the Avalon sign is now attached to a building on Avalon Way. (formerly 9420 16th Ave. S.W.)

The little building next to Luna Park Cafe has been a coffee shop since 1996, as Java Bean, then The Shack, and now **The Spot West Seattle**. On the building itself, you'll spot an interesting architectural detail: the Green Man, a carved face sprouting leaves and flowers, a legendary symbol of nature and regrowth since the Middle Ages.

John Bennett acquired the neon sign in the 1980s from **The Shack Drive-In** at 1333 Harbor Avenue. Restaurateur Neal Saffer had set up the Shack after the end of 1962 World's Fair, transporting the building from the Seattle Center fairgrounds to the location near Duwamish Head. There, the Shack sign was at the top of a tall pole, over a series of smaller neon signs reading "Hot Dogz," "Hamburgers," "Chicken," "Fish n' Chips," and "Malts," all no longer present. (2920 S.W. Avalon Way, thespot-westseattle.com, 1983).

A rotating neon pig can mean only one thing: BBQ. Ron and Debra Weiss started **Pecos Pit Bar-B-Que** in 1980 on 1st Avenue South, serving slow roasted pork shoulder and beef brisket. With great confidence in their sauce recipe, they offered only one variety, though you could get it in mild, medium, or hot. Salty's proprietor Gerry Kingen brought the Pit to West Seattle in 2016. (4400 35th Ave. S.W., pecospit.com, 2016)

James Sweeney started **Alki Lumber & Hardware** in 1921 near Alki Point. His son Bill carried on the business after his father's death in 1938, relocating to Avalon Way. "Tell it to Sweeney" was their motto, printed on the sides of the company's trucks. In 1957, the entire building was moved across the street to its current location, where Sweeney's great-granddaughter Lynn manages the lumber yard today. (4422 36th Ave. S.W., alkilumber.com, 1921)

"Go West, young man," newspaperman Horace Greely famously urged just after

the Civil War. **Rudy's Barbershop** (*see* Capitol Hill), did exactly that, expanding to West Seattle in 2015. They installed this neon sign to express pride for their new neighborhood. (4480 Fauntleroy Way S.W., rudysbarbershop.com, 2015)

Ellis Thompson started Service Court Station in 1926 in Idaho Falls, Idaho. In 1940, he relocated to West Seattle and opened **West Seattle Brake Service** on Alaska Street, moving it to its present location in 1950. Ellis's son Bill "Red" Thompson took over management of the family business in 1967, with son John succeeding him in 1989. (4464 37th Ave. S.W., 1940)

The name **Wardrobe Cleaners** appears in archives of the *West Seattle Herald* as early as 1929, with an address on California Avenue in the West Seattle Junction. By 1950, they had moved to the present location on Fauntleroy, and were appearing in advertisements as "Ray Olson's Wardrobe Cleaners." The building carries an impressive amount of neon, but most of it is now dark. (4500 Fauntleroy Way S.W., by 1950)

Seaview

Fate and humor combined to make Rick Cook the "psychic barber" of West Seattle. Rick began cutting hair in 1976, opening **Rick's Barber Shop** in West Seattle two years later. Around 1992, he relocated to a now-demolished building at 5251 California Ave.

Fifteen years later, a fortune-telling family leased the adjacent storefront, installing a neon sign reading "Psychic" in white. It immediately became a local landmark, and Rick started telling people that his shop was next to the psychic. He soon took the joke a step further, commissioning a neon sign of his own with lettering reading "Barber" in the same style, color, and size. Installed side-by-side, with Rick's shop on the right, they'd look like "Psychic Barber" to anyone passing by.

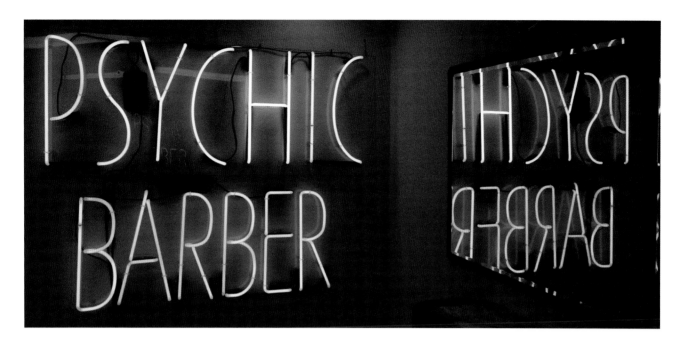

The psychics failed to foresee the ultimate failure of the business. Unable to pay the rent, they abandoned their storefront and the neon sign, which went dark. The barber shop customers lamented its absence, and eventually Rick purchased the sign from the landlord, installing it in his own window, with "Psychic" now above "Barber."

When the building was torn down in 2012, Rick moved his shop and his neon further south on California Avenue, placing both signs in a window as before. Forced out by development once again, in 2019 he moved to the present location, a storefront that, in a bizarre coincidence, had been previously occupied by a different psychic, with a barber to their immediate right.

The narrow windows at Rick's current location are unable to accommodate the large neon signs, so these are now mounted on an interior wall, with smaller neon letters in the windows— still reading "Psychic Barber," of course. (4845 California Ave. S.W., 1978)

Luck Toy, a Chinese restaurant on 16th Avenue in White Center, was gutted by fire in the early 1950s. When it reopened at a new location in West Seattle Junction, it became New Luck Toy, a name it kept until it closed for good in 2005 (the building became Talarico's Pizza).

The present **New Luck Toy** is not a direct successor to the original. It is, instead, a tribute to a long-standing neighborhood institution, connected

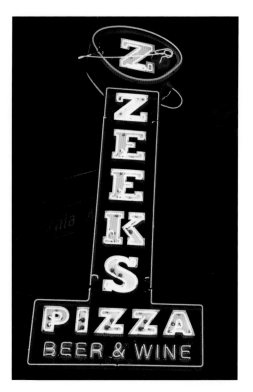

only in name. Though primarily a bar, they have a limited menu of Chinese appetizers, fried rice, and chow mein. The white and red neon sign is new, inspired by the typographic style of American Chinese restaurant logos of the fifties. (5905 California Ave. S.W., newlucktoy.bar, 2016)

The Bridge lost the lease at their original location in the shadow of Alki Lumber in 2013. They found another in the former home of Chuck and Sally's Tavern, shuttered in 2007, and extensively remodeled the building. Demonstrating respect for the site's history, the old Chuck & Sally's sign now hangs inside. (6301 California Ave. S.W., thebridgeseattle.com, 2013)

The seventh location of **Zeeks Pizza** opened here in 2009. The neon sign is identical to the one at their Belltown pizzeria, with a rotating "Z" logo at the top. (6459 California Ave. S.W., zeekspizza.com, 2009)

Gatewood

West Seattle Thriftway is an independent grocer, locally owned since 1988. (4201 S.W. Morgan St., westseattlethriftway.com, 1988)

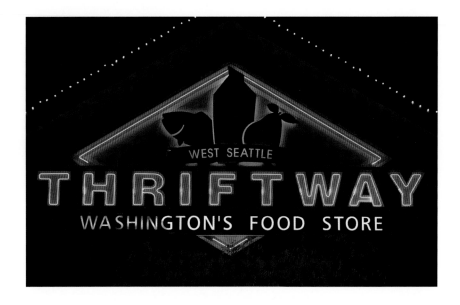

Fauntleroy

One of two directional signs pointing the way to **West-wood Village**, this one stands in the parking lot of Dere Auto. The shopping center is about six blocks east, in Rox-hill (Delridge). (neon at 9201 35th Ave. S.W., westwood-villagecenter.com, 1966)

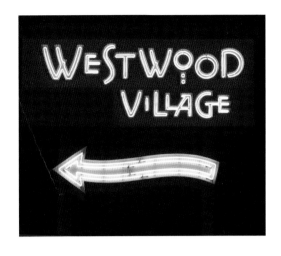

Endolyne Joe's takes its name from the end of the line—the trolley line, that is, which terminated a block south of here in the early 1900s. "Endolyne" became a nickname for the neighborhood, and "Endolyne Joe" for a particular hard-drinking trolley conductor. (9261 45th Ave. S.W., endolynejoes.com, 2004)

For the present work, this, too, is the end of the line.

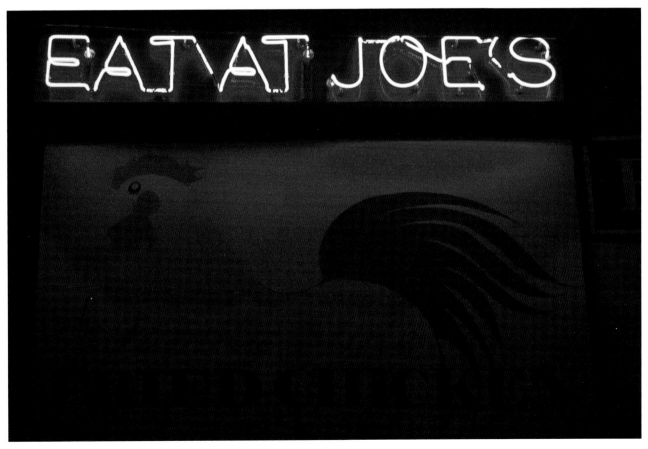

Afterword

The intent of this book is to celebrate neon, particularly vintage neon, and to uplift and honor those who have chosen to preserve and maintain these works of art. No disrespect is intended towards any of the businesses or civic organizations, or their owners, mentioned here—I thank each and every one of them for keeping their neon intact and on display.

Any errors or omissions in the historical narrative are mine. I welcome corrections and will seek to include them in a future update.

Not every neon sign in the city could be included here, and there are literally hundreds that I have reluctantly omitted, for reasons of space and time alone. I have made an effort to include every part of the city, so that remote neighborhoods are represented even if not as brightly lit as Belltown or Capitol Hill.

Finding Neon

For this project, I cataloged and mapped approximately one thousand locations within Seattle that presently have one or more neon signs, not counting off-the-shelf "Open" signs or beer logos, or places that once had a significant piece of neon art, now gone, such as Grandma's Cookies or Sunny Jim.

I found many of these via the "Neon Signs of Seattle" group on Flickr, the "Seattle Vintage" group and "Vanishing Seattle" page on Facebook, Debra Jane Seltzer's RoadsideArchitecture.com, and Steve Cummings's 2014 book *Neon Seattle*, which helpfully included street addresses for each entry. Using Google Maps, I identified the main business streets in each neighborhood, then used Google Street View to virtually walk the street without leaving my desk, zooming in on anything that looked like neon in order to add to my list.

Some of my favorite discoveries were signs I saw from the window of a bus, late at night, on my way home from an expedition—this was how I found New Luck Toy, Eyes on Fremont, and the restored and relocated Standard Radio, all of which were too new to have been widely photographed before.

Equipment and Technique

Almost all of these photos were shot with a Fuji X-T20 mirrorless camera and Fuji XF 18-55mm f/2.8-4 lens. Less frequently, I would switch to an XF 55-200mm telephoto or XF 10-24mm ultra-wide. A handful of the earliest photos, around Queen Anne and Ballard, were shot with a Nikon D750. I'd been a Nikon DSLR user for many years, but quickly found that the mirrorless Fuji was perfectly suited to nighttime use, due to its live exposure preview and auto-bracketing, and by the end of the first month I was using the Fuji exclusively.

I chose a shutter speed of 1/60 second, ISO of 200 to 1600 depending on sunlight, and then used the aperture ring as a brightness control. By enabling auto-bracketing and electronic shutter, each press of the shutter button resulted in three exposures—1/60, 1/15, and 1/250—and I could then choose the best or even combine them. The underexposed 1/250s frames were rarely usable as the high speed electronic shutter sometimes combined with the neon's own flicker to produce dark bands, but were nevertheless useful as reference photos to learn the true color of a neon tube that might be otherwise overexposed. 1/60 second was the sweet spot, fast enough to handhold and freeze motion, while still providing sufficient light.

The intense brightness of neon compared to the darkness of its surroundings at night required shooting in raw mode, followed by post-processing to balance the tones. Processing was done in Adobe Lightroom and NIK Color Efex Pro. On rare occasions I used Photoshop to remove an intrusive object from a scene, replace a featureless sky, or repair a broken sign—borrowing segments of neon tubes from the parts that were functioning correctly, to fill in the parts that weren't.

Acknowledgments

I give my thanks to everyone who allowed me to shoot their neon: the many business owners, managers, bartenders, and servers who let me wander through their establishments, who switched on neon signs after close of business so I could get the shot, and who let me onto balconies to photograph neon across the street.

I am especially indebted to those neon enthusiasts and property owners who spoke with me at length and gave me access to their incredible collections: Scott Andrews, John Bennett, Mark Diefendorf, Doug Dixon, and Joe Sievers. This book, and Seattle's neon landscape, would be far weaker without their efforts.

My special thanks to William Kirtley of Western Neon, who invited me to tour the shop and photograph him in action, then helped me as an informal technical adviser, answering my frequent questions about neon sign materials and techniques, as well as historic Seattle neon and new works in progress.

I learned where the best neon signs are (or were) from Steve Cummings's Neon Seattle, Debra Jane Seltzer's RoadsideArchitecture.com and Vintage Signs of America, Flickr's "Neon Signs of Seattle" group, and Facebook's "Seattle Vintage" group. I thank the admins of the Seattle Vintage group in particular for letting me share my work in progress.

This project could never have happened without Sharon Woodhouse, my publisher and editor, who first suggested the concept of a photographic tour of neon signs in Seattle. Though I hadn't paid much attention to neon before that point, I thought it a fun project and accepted; it has now become an obsession. Thanks, too, for putting up with me, as we experienced the curse of "living in interesting times."

I thank my friends and family, in Seattle and elsewhere, for their ongoing support and encouragement.

Sources

Many of the sites featured in this book are relatively unknown outside their neighborhoods. Bars and restaurants, even those in operation for decades, might have little mention in the press. Often, the only available history was on the business's own website, generally just a few lines on an "About Us" page, or a short description that the owners provided when claiming their Yelp or Google listings. In some cases, profiles of the business owner in local newspapers and magazines provided more of a backstory. The many crowd-sourced photos on Yelp and Google helped to answer my questions about a business's current offerings, physical layout, or interior decor. On more than one occasion, I discovered the year a business opened or the name of its proprietor by zooming in on a snapshot of its menu on a review site.

For the more famous locations, I found HistoryLink.org invaluable. This curated encyclopedia of regional history includes articles about, and historic photos of, many of our most cherished institutions and most colorful characters and events: every significant theater, the big downtown hotels, major attractions like Pike Place Market and Miner's Landing, the Rainier Brewery, the stadiums, Ivar's, Oberto Snacks, Dick's Drive-In, the World's Fairs, the Great Seattle Fire, and more. Descriptions of the architecture and history of the buildings on the Seattle Department of Neighborhoods website often provided additional details about the buildings where the neon was found, including other tenants of interest.

Museums, Databases, Encyclopedias
- Cinema Treasures, http://cinematreasures.org
- HistoryLink, https://historylink.org
- Roadside Architecture, https://www.roadsidearchitecture.com
- Oldest Bars in Washington State, http://www.peterga.com/kbar-oldwa.htm
- Pacific Coast Architecture Database, http://pcad.lib.washington.edu
- Seattle Bar Project, http://www.seattlebars.org
- Seattle Clock Walk, http://www.zombiezodiac.com/rob/ped/clock/citywide.htm
- Seattle Department of Neighborhoods: Seattle Historical Sites, https://web6.seattle.gov/DPD/HistoricalSite/Default.aspx
- University of Washington Libraries Digital Collections, https://digitalcollections.lib.washington.edu
- Wikipedia, https://en.wikipedia.org

Blogs and Online Resources
- Capitol Hill Seattle Blog, https://www.capitolhillseattle.com
- Columbia City Source, https://columbiacitysource.com
- Eater, https://eater.com
- Neon Signs of Seattle (Flickr group), https://www.flickr.com/groups/462072@N25
- Seattle's Comet Tavern as "Marketplace Vernacular", http://courses.washington.edu
- Seattle Now & Then, https://pauldorpat.com
- Seattle Vintage (Facebook group), https://www.facebook.com/groups/379569529068459
- Vanishing Seattle, https://www.facebook.com/vanishingseattle

Seattle NEON

- Wallyhood Blog, https://www.wallyhood.org
- Wedgwood in Seattle History, https://wedgwoodinseattlehistory.com
- West Seattle Blog, https://westseattleblog.com

News Media
- The Business Journals, https://www.bizjournals.com
- *Crosscut*, https://crosscut.com
- *Grays Harbor Talk*, http://www.graysharbortalk.com
- KING 5 TV, https://www.king5.com
- *Seattle Magazine*, https://www.seattlemag.com
- *Seattle Met*, https://www.seattlemet.com
- *Seattle Refined*, https://seattlerefined.com
- *Seattle Times*, https://www.seattletimes.com
- *Seattle Weekly*, https://www.seattleweekly.com
- *Seattle Post-Intelligencer*, https://www.seattlepi.com
- *The Stranger*, https://www.thestranger.com
- *WestsideSeattle*, https://www.westsideseattle.com
- *West Seattle Herald* Archive, http://wsh.stparchive.com

Books
- Collins, James Madison. *Seattle Then and Now.* Thunder Bay Press, 2000.
- Cummings, Steve. *Neon Seattle.* Blurb, 2014.
- Crowley, Walt. *Forever Blue Moon.* HistoryLink, 2004.
- Eals, Clay, editor. *West Side Story.* West Seattle Herald/White Center News, 1987.
- Davidson, Len. *Vintage Neon.* Schiffer Publishing, 1999.
- Dorpat, Paul. *Seattle Now & Then.* Tartu Publications, 1984.
- Dorpat, Paul. *Seattle Now & Then*, Volume III. Tartu Publications, 1989.
- Flood, Chuck. Lost *Restaurants of Seattle* (American Palate). The History Press, 2017.
- Humphrey, Clark. *Vanishing Seattle.* Arcadia Publishing, 2006.
- Ketcherside, Rob. *Lost Seattle.* Pavilion Books Group, 2013.
- Ribbat, Christoph. *Flickering Light: A History of Neon.* Reaktion Books, 2013.
- Rupp, James M. Art in *Seattle's Public Places: An Illustrated Guide.* University of Washington Press, 1992.
- Seely, Mike. *Seattle's Best Dive Bars: Drinking & Diving in the Emerald City.* Gamble Guides, 2009.
- Seltzer, Debra Jane. *Vintage Signs of America.* Amberley Publishing, 2017.
- Wong, Marie Rose. *Building Tradition: Pan-Asian Seattle and Life in the Residential Hotels.* Chin Music Press, 2018.

Index of Locations and Signs

About the Author

Author and photographer **Matt Hucke** is drawn to disappearing and endangered historic places and artifacts, some of them hiding in plain sight. His first book, *Graveyards of Chicago* (with Ursula Bielski), explored the history and personalities behind (and beneath) Chicago's best cemetery monuments. Now in Seattle, he's brought this same idea to a newer form of historic art: vintage neon signs.